Printmaking

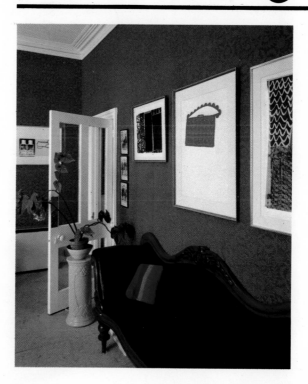

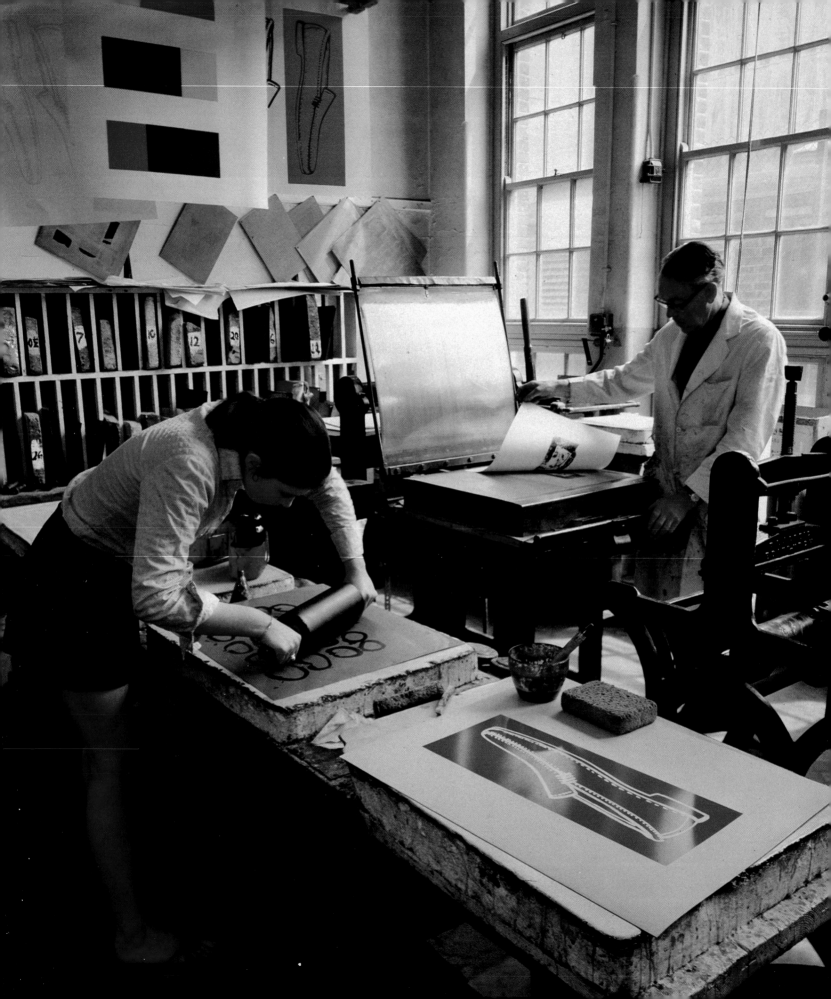

Printmaking

Harvey Daniels

A Studio Book
THE VIKING PRESS
New York

© copyright The Hamlyn Publishing Group Limited 1971

Published in 1971 by The Viking Press, Inc.
625 Madison Avenue, New York, N.Y. 10022

SBN 670-57757-X

Library of Congress catalog card number: 77–146054

Printed and bound by Toppan Printing Company (HK)
Limited, Hong Kong

For my Mother and Father

1/*half title page*
An interior with framed
contemporary prints.

2/*frontispiece*
A lithographic studio with a
student rolling up a plate and a
print being taken. In the
foreground a plate is rolled up
ready for printing.

Preface

I wish to thank all the artists who have so kindly given me permission to reproduce their work, and the gallery and museum authorities who have allowed works in their charge to be reproduced.

My wife, Judy Stapleton, gave me invaluable help on the manuscript, and Lilian Knox took great pains in preparing the typescript.

Thanks are due to the Principal and colleagues at Brighton College of Art, where most of the working photographs were taken; to all the printmaking staff who have been so helpful, and especially to Silvie Turner, who supplied some of the children's work, and for her reading of the manuscript; to Bert Latham for giving me the benefit of his experience; and to Peter Hawes, Selma Nankivell and Trevor Allen for their support.

I am indebted to Michael Holford for his excellent photographs and to Tony Truscott for the diagrams and design of the book.

The short bibliography at the end of the book is intended to help the reader; it comprises only a few of the many books that have helped me in the writing of this one. To the authors of all of these I am grateful.

Contents

List of Colour Plates

Acknowledgements

The print in Illustration 49 is published by gracious permission of Her Majesty the Queen.

The Publishers would like to thank the museums, galleries, artists and collectors for kindly allowing their prints to be used in this book. The Publishers are also grateful to the following for supplying photographs: Artia Publishers, Prague Ill. 39; Art Wood Photography, London 127, 172, 175; Bibliothèque Nationale, Paris 40, 130; Bibliothèque d'Art et d'Archéologie, Université de Paris 56; British Museum, London 15, 148; Brooklyn Museum, New York 101; Leo Castelli Gallery, New York 100; Jean Dubuffet, Paris 58; Editions Alecto, London 106, 107, 124; John Freeman Ltd, London 50, 140, 190; Galerie der Spiegel, Cologne, 97, 99; Galerie Maeght, Paris 138; Gemini G.E.L., Los Angeles 123, 131; Grabowski Gallery, London 76; Hamlyn Group 194–196; Rod Harman, London 48; Michael Holford, London 1–6, 8–10, 12, 13, 16–27, 30–38, 42–45, 47, 51–55, 57, 60–62, 64–66, 70–74, 75, 77–81, 87–89, 96, 102, 105, 108, 109, 114–122, 125, 126, 128, 129, 136, 137, 139, 142, 144, 145, 147, 149–156, 167, 170, 171, 173, 174, 177–187, 189, 191–193; London Graphic Art Associates, London 98; Marlborough Fine Art (London) Ltd, London 103; Metropolitan Museum of Art, New York 29; Munch Museum, Oslo 41, 67, 68; Museum of Fine Arts, Boston 146; Museum of Modern Art, New York 7, 14, 55, 57, 63, 69; 141, 176, 188; Victoria and Albert Museum, London 28; John Webb, London 46, 104. Ills 40, 57, 64, 69, 75, 114, 154 © 1971 SPADEM, Paris. Ills 7, 56, 58, 130, 138, 141 © 1971 ADAGP, Paris.

The Publishers are also grateful to the following for permission to quote from their books: Max Ernst, *Beyond Painting* (George Wittenborn, New York); Weber, *History of Lithography*, and Sotriffer, *Printmaking History and Technique* (both Thames and Hudson Ltd, London); Carl Zigrosser & Christa Gaehde, *A Guide to the Collecting and Care of Original Prints* (Granada Publishing Ltd, London, and Crown Publishers Inc., New York, sponsored by the Print Council of America); Felix Man, *150 Years of Lithography* (William Heinemann Ltd, London); Osbert Sitwell, *A Free House or the Artist as Craftsman* (Macmillan & Co. Ltd, London); Brunner, *Handbook of Reproduction Processes* (Alec Tiranti Ltd, London); Peter Green, *Creative Printmaking* (B.T. Batsford Ltd, London); S.W. Hayter, *About Prints* (Oxford University Press, London); Donald Karshan, 'American Printmaking 1670–1968' (*Art in America*, no. four, July-August 1968); *Shiko Munakata* (Kodansha Ltd, Tokyo, and Charles E. Tuttle Co, Rutland, Vermont); Carl Zigrosser, *The Book of Fine Prints* (Peter Owen Ltd, London); Rudi Blesh and Harriet Janus, *Collage* (Sir Isaac Pitman & Sons Ltd, London); Michael Rothenstein, *Linocuts and Woodcuts* (Studio Vista Ltd, London).

Bibliography

(a) *Printmaking*

Ivins, William M., Jr.

How Prints Look,
Metropolitan Museum of Art, New York, 1943.
Hayter, S.W.,
New Ways of Gravure,
Routledge & Kegan Paul Ltd, London, 1949.
Stephenson, Jessie Bane,
From Old Stencils to Silk Screening,
Charles Scribner's Sons, New York, 1953.
A good history of the stencil.
Biggs, John R.,
Woodcuts,
Blandford Press, London, 1958.
Hasuda, Yojuro, Editor.
Shiko Munakata,
Kodansha Library of Japanese Art No. 12,
English text by Oliver Statler,
Charles E. Tuttle Co., 1958.
Zigrosser, Carl,
The Book of Fine Prints,
Crown Publishers Inc., New York, 1958.
Peterdi, Gabor,
Printmaking,
Macmillan, 1959.
Gorbaty, Norman,
Print Making with a Spoon,
Reinhold, New York, 1960. Printmaking for children.
Rasmusen, Henry,
Printmaking with Monotype,
Chilton Company, 1960.
Trivick, Henry,
Auto-Lithography,
Faber and Faber, 1960. A good technical book.
Zigrosser, Carl, and Christa M. Gaehde,
A Guide to the Collecting and Care of Original Prints,
Arco Publications, London, 1960.
Carr, Francis,
A Guide to Screen Process Printing,
Vista Books, London, 1961.
Brunner, Felix,
A Handbook of Graphic Reproduction Processes,
Alec Tiranti Ltd, London, 1962.
Hayter, S.W.,

About Prints,
Oxford University Press, 1962.
Printmaking by an eminent printmaker.
Rothenstein, Michael,
Linocuts and Woodcuts,
Studio Books, 1962.
Stubbe, Wolf,
History of Modern Graphic Art,
Thames and Hudson, 1963.
Green, Peter,
Creative Printmaking,
B.J. Batsford Ltd, London, 1964.
Erickson, Janet Doub, and Adelaide Sproul,
Print Making Without a Press,
Reinhold Publishing Corporation, New York, 1966.
Heller, Jules,
Printmaking Today,
Holt, Rinehard, Winston, 1966.
Rothenstein, Michael,
Frontiers of Printmaking,
Studio Vista, 1966.
Sotriffer, Kristian,
Printmaking History and Techniques,
Thames and Hudson, 1966.
Weber, W.,
History of Lithography,
Thames and Hudson, 1966.
Wechsler, Herman J.,
Great Prints and Printmakers,
Thames and Hudson, 1967.
'American Printmaking 1670-1968',
in *Art in America,*
July-August, 1968. Art in America Co. Inc., New York.

(b) *Related reading*

Vollard, Ambroise,
Recollections of a Picture Dealer,
Little Brown & Co., Boston, 1963.
Sickert, Walter,
A Free House,
Editor Osbert Sitwell, Macmillan & Co. Ltd, London, 1947.
Ernst, Max,
Beyond Painting,
Wittenbern, Schultz Inc., New York, 1948.

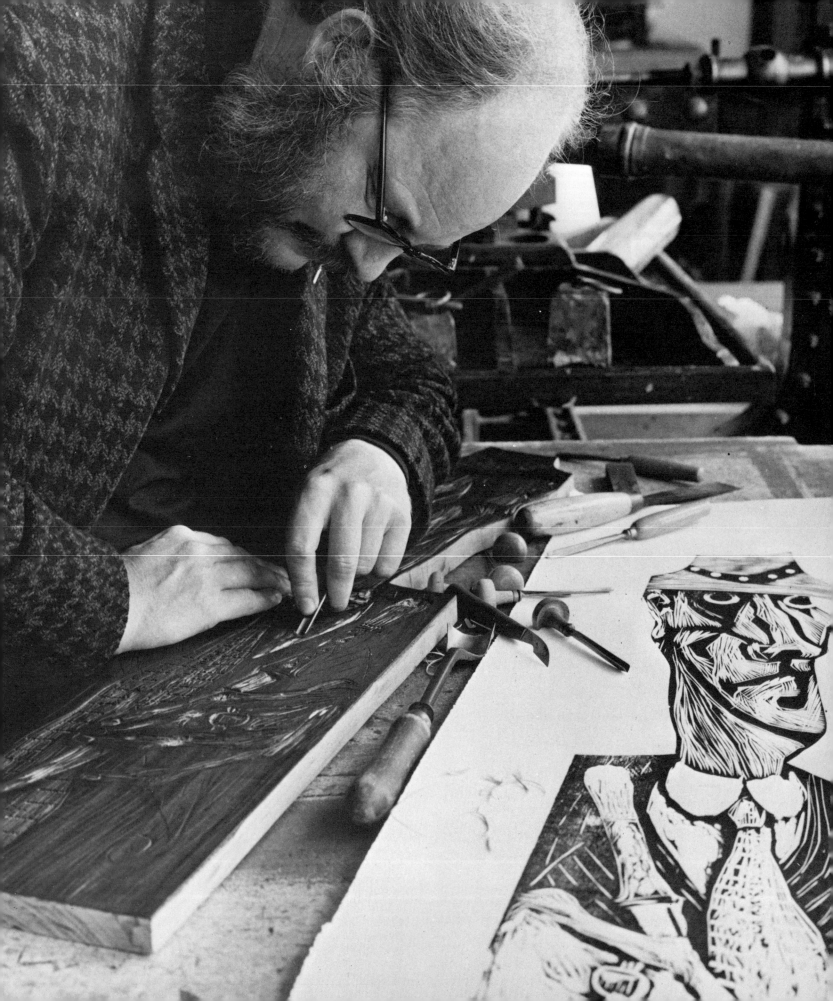

I

Introduction

'Printing a surface can be a process of discovery, in which we are curious about the quality of a surface and by printing it discover its visual nature. We begin to see through a sense of touch, as in braille, and this 'seeing' becomes visual when printing.' Peter Green

Original prints are increasingly regarded as examples of a major art form. More interest is now centred on the print than could have been predicted even ten years ago. Printmakers are invading art galleries, and new print galleries are springing up in many modern cities. Prints are much cheaper to buy than paintings, and many people who could not afford to buy an oil painting can and do buy original etchings, lithographs and other kinds of prints. People who would never previously have thought of buying art in any form now seem to be buying prints.

One factor in all this is the immense variety from which one can choose, from the line drawn figurative lithograph by Ann d'Arcy Hughes (Ill. 144) to the completely abstract work of Vasarely (Ill. 97). For the collector it provides the thrill of discovery as well as aesthetic satisfaction. Anyone can take part, can share the excitement engendered by various visual effects and go on to experiment with the many printmaking techniques. Practically any surface or object can be printed on or from; for example the prints taken from two gloves (Ills 30, 31). A huge new market for prints is being tapped, it seems, and new collections are being started. An atmosphere of intense interest is spreading, thanks to the

activities of museums and art galleries; also important is the influence of dealers who are, for instance, visiting universities with travelling exhibitions of prints. By keeping the prices of prints low, the democratic as well as the original nature of the print, as produced by today's artist, is being realised.

Definitions

One definition of a print, taken from Webster's Dictionary, is: 'a mark made by impression; a line, character, figure or indentation made by the pressure of one thing on another.' Only a few years ago a given print could easily be classified in terms of the method by which it was executed. Today, when a new finished work is often technically more complex than its predecessors, it is difficult to recognise or separate the processes involved. My definition of a print is: a piece of art work which has been made as a printed impression on to paper, from blocks or plates which the artist himself has created. This impression is an image or idea conceived by the artist as a work of art in its final result. There may be no original drawing or design. The creative process consists of the artist working, usually by hand, on the various blocks and plates that go to make up the finished work, which is then printed by the artist himself or under his supervision. Even this definition will obviously not cover all the work of modern printmakers, and should therefore be used only as a general guide.

Initially the motive that led printmakers to make a print was the fascination of the

3
Cutting plank wood with a chisel. The cuts made by the gouges can be clearly seen. In the foreground there is a proof of the block entitled *Assassin*.

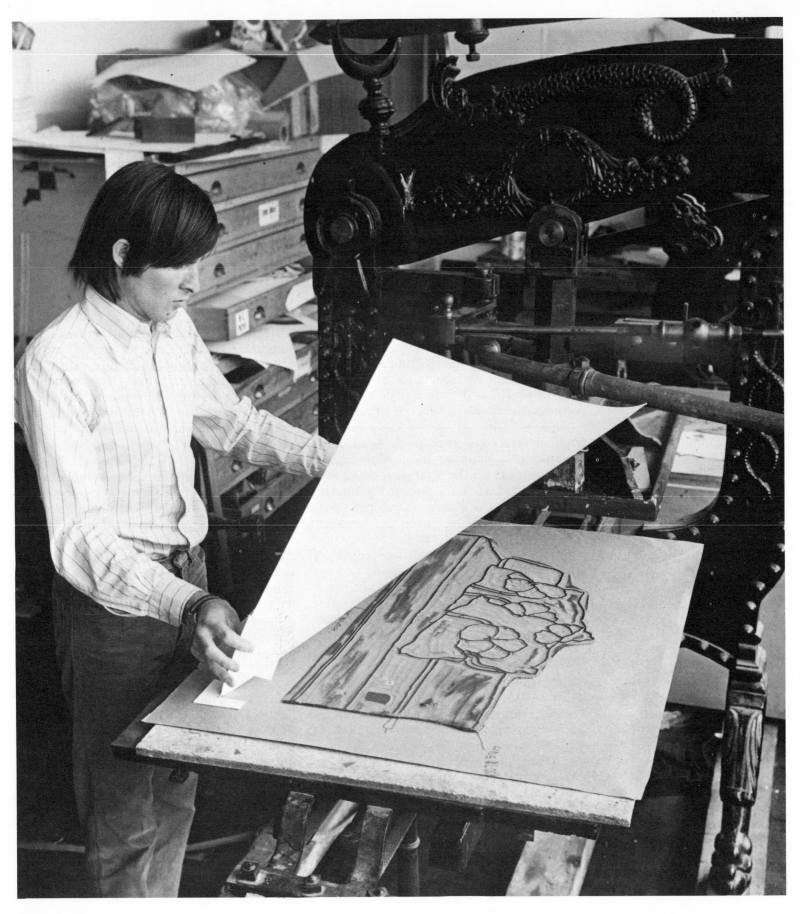

technical processes involved. These inspired the early craftsmen, who were chiefly engaged in making reproductions or narrative illustrations. The prime example of this can be seen in the early woodcut (Ill. 29). Eventually this fascination led artists to appreciate the various processes for their own particular qualities, an attitude that has developed to such an extent that the print can now stand in its own right as a work of art, on a par with a painting or a piece of sculpture.

The whole question of whether or not a print is an original work is a new one. It is only artists of relatively recent times who have made so much of the individuality of the print; many early European prints were not signed at all. In 1965, the French National Committee of Engraving stated that original prints must exclude 'any and all mechanical or photo-mechanical processes', but this is hardly a satisfactory view. Many of the prints in this book defy this definition yet may well be considered original graphic art today.

A good standard definition of an original print given by a society comes from the Print Council of America, which has done very cogent work in redefining the print. A fuller text is given in Zigrosser and Gaehde's *Guide to the Collecting and Care of Original Prints*, but the most relevant passage lists three conditions that a print should generally satisfy in order to be accepted as an original:

'1. The artist alone has created the master image in or upon the plate, stone, wood block or other material for the purpose of creating the print.
2. The print is made from the said material by the artist or pursuant to his directions.
3. The finished print is approved by the artist.'

A reproduction differs from the original print in that it is the result of a photomechanical way of producing a facsimile copy in thousands, of no original merit as distinct from the work reproduced. A painting by Rembrandt in reproduction is obviously not the same as the original oil painting or etching. A woodcut by Munakata (Ill. 14) is only complete when it has been printed on to paper, and shows us the artist's intention absolutely.

Very recently, artists have become interested in the technical aspects of commercial reproduction, which has led to its use whenever it seems desirable to use exact photographic images or to print very large numbers of a particular work. In the July/August 1968 copy of *Art in America*, Larry Rivers the American artist had a lithograph reproduced which was bound into the issue. It was published in an edition of 46,000 and in spite of the number is as original a print as an edition of ten, the only criterion being that each print should represent the artist's intention. Today the artist signs his work, the signature usually in pencil, to show his approval; Whistler (1834-1903) was one of the first artists to do so. Prints also have edition numbers, for example 7/10, which signifies that the print is the seventh in a limited edition of ten. The artist dates his work as a record, both for the purchaser and himself. When the edition is printed, the plates or blocks are destroyed or marked, ensuring that no more are produced (see the chapter on collecting).

Processes and techniques
Broadly speaking, a print is made by one of three processes:
1. The relief process
2. The intaglio process
3. The planographic process

In this book both the very simple methods and the more complicated mechanical methods of work are considered. The processes listed above will be encountered later, but it seems appropriate to give a simple definition of each here.

In relief work the raised surface of the plate or block is the area most important in making the print. This can vary from the image of delicate veins on the back of a leaf to the rough texture of a concrete floor. The impression can be made by many methods; by rubbing with a stick of wax, by roller impression or simply by hand burnishing.

The opposite is true of the intaglio process. It is the lower surface into which the ink is pushed, the top one being wiped clean. This method often produces a raised surface on the paper, such as can be seen in prints from etched or engraved plates.

The result of the planographic process is a flat layer of ink resting on the surface of the printed page, in fact a plane of colour. Serigraphy and lithography are the main methods by which this is produced, each having its own characteristics.

4
Placing a sheet of paper exactly in position on to a lino cut to be printed in a Columbian press.

Prints may be produced with or without a press, and with or without complicated tools and machinery. This book deals with both because there are many people, amateurs, collectors or artists, who would like to indulge in some creative printmaking at home or in a workroom, even if only on a small scale. The first part of the book is therefore devoted to printmaking that can be done at home in this way. Anyone can establish his own 'printing department'. A spare room or even a corner of a room can be utilised for simple printmaking, and one can print successfully with little expense or equipment, and few complications.

Part of the appeal of printmaking is that anyone, young or old, can participate. Therefore all of the sections in the first part of this book can be utilised in schools and are appropriate even in further education. The initial equipment may be simple or sophisticated. It is even possible to use some of the presses and other items mentioned in the second section in schools, many of which are equipped with litho presses.

Exhibitions of major print collections have influenced many education authorities in recent years. Instead of buying the dull, justly ignored reproductions that were once usual in schools, such authorities acquire original prints that allow the school child to see what is happening in art, what problems are being worked on, what is new in materials and ideas, and what new lines of approach are being explored.

The nature of the print and the disciplines involved in printmaking are of great creative and educative value in schools – not just for making pictures, but as a part of training in visual education; that is, in the study of the colour field, repetition, shape, space, imagery, and texture.

Many teachers will, I hope, find in this book something that they can use in their classes. I have taught printmaking at most levels, and I feel that the youngest school child can get caught up in the excitement of simple print-making and experience the awareness and pleasure that it gives.

5
Paul Gauguin,
1848–1903, French.
Cut wood block.

6
Print being taken from a string block, showing block and print:

16

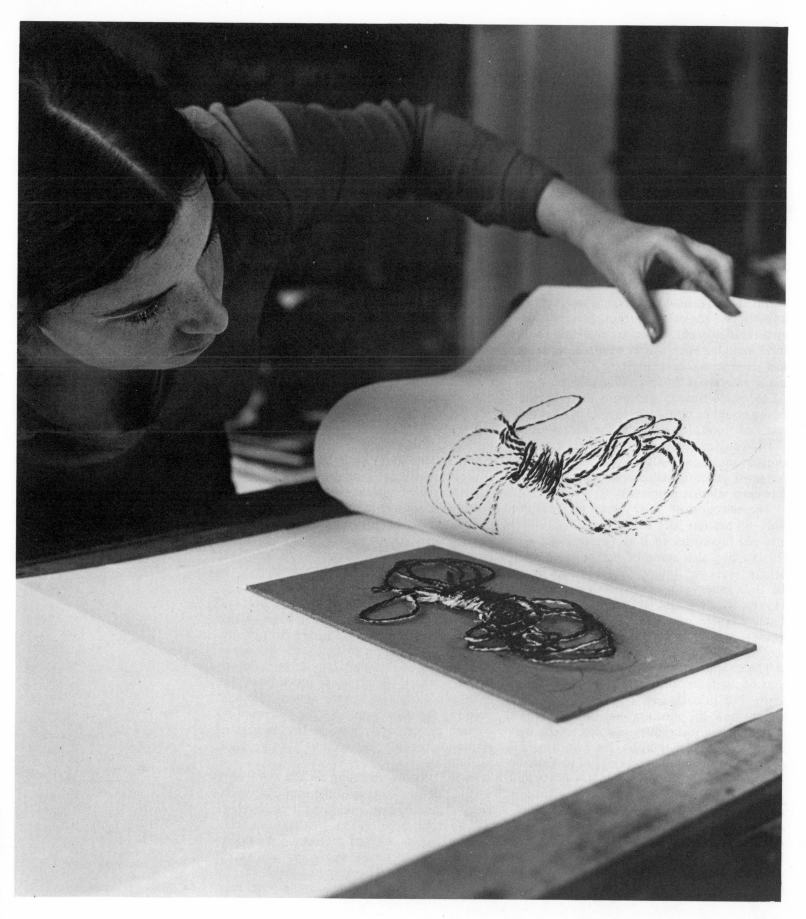

Intentions

I have written this book for many reasons. Those who are generally interested in the print and want to see more of it, whether they are dealers, artists, students, collectors or art lovers, will, I hope, find both text and illustrations stimulating. More particularly, I wanted to give both the artist and the amateur some ideas on how to start printmaking, or on how to develop it, once started, and to illustrate some of the potentialities of such ideas. Furthermore, there was a need to be met: I have not seen a book in which nearly all of the printmaking methods are covered as broadly and with as much illustrative material as I would like.

Barriers are being broken down in the art world. The printmaker has come to be seen as an artist like any other, working in a particular creative field; and to encourage this idea I have included such fringe printmaking activities as frottage and offset prints, and have made references to three-dimensional work. At the same time it is obvious that complete books could be written on subjects I have only touched upon, for example the mezzotint.

I have tried to simplify technical explanations as much as possible while indicating the range of potential developments; these are, I believe, almost infinite.

The selection of illustrations includes not only old masters such as Rembrandt (Ill. 147) and old favourites such as Toulouse-Lautrec (Ill. 8), but also some of the more exciting artists working today (Eduardo Paolozzi, Ill. 102), some younger unknown artists (Peter Hawes, Ill. 187), and students' work (Ill. 66). Each chapter contains explanatory photographs, a brief historical background and a section devoted to practical instruction.

The chapters on printmaking with a press may be slanted a little towards the professional artist, but in each case I have tried to state simply how the medium can be tackled. Of course, some techniques just cannot be described easily. Lithography, for instance, is a comparatively simple process, but to describe it makes it sound very formidable (as would a purely verbal description of how to swim); it must be learnt by demonstration and involvement to be understood completely. But I hope that even those who will never see a lithograph being printed will understand a little more of what went on when they look at an original lithograph such as Bonnard's *Little Laundry Girl* (Ill. 7) in a museum or gallery. In dealing with all of the print media I have provided a simplified explanation and then gone on to explain how to make a plate, a block or a screen.

The last two chapters are aimed primarily at the collector or aspiring collector. Artists may also find them of some value if they are unfamiliar with dealers' practices and so on.

The illustrations have been chosen both to instruct and to give enjoyment. They range from items intended to demonstrate the pleasure one may get from impressions printed from a block to reproductions of works by the most famous masters.

The arrangement of the book into chapters entails a certain amount of overlapping, and things explained in one chapter may be omitted from another to avoid undue repetition. If the general cleaning up process is explained in one chapter or section, it may be taken that rollers etc. may be cleaned up in the same way in other media. Similarly, an illustration of the overprint (Ill. 121) appears in the chapter on lithography, though it may well apply to other media; however, many of the other illustrations show the end result, especially those of works by Ceri Richards (Ill. 142) and Ernst Kirchner (Ill. 74).

Since I have mentioned cleaning up, an extra word of warning here. The studio is likely to become dirty and one's hands are often covered in ink; system and a particular tidiness are needed to stop a workshop from becoming chaotic. A workshop should be planned as efficiently as a good kitchen.

Because of lack of space I have not said much about certain historical ideas which could well be followed up by the historically-minded. There is, for instance, the history of printmaking as it is shown in all popular art, the broadsheet, the primitive block book, the chapbook, artists such as the Mexican Posada, even the Japanese print and the 18th-century protest prints; and there is the subject of printmaking in connection with book illustration.

In the sections detailing techniques I have omitted descriptions of some kinds of machinery and other information; I hope these will be discovered by those enthusiasts who, having read or looked at this book, realise there is no end to the study and enjoyment possible in this ever-expanding field.

Of course, some chapters could have been

7
Pierre Bonnard,
1867–1947, French.
The Little Laundry Girl.
Colour lithograph, 1896.
Museum of Modern Art,
New York.

8/*page 20*
Henri de Toulouse-Lautrec,
1864–1901, French.
May Belfort Holding a Cat.
Colour lithograph, 1895.

9/*page 21*
Harvey Daniels,
b. 1936, British.
Three Parrots.
Colour lithograph, 1966.
30 × 22 in.
Collection E. Inglefield.

18

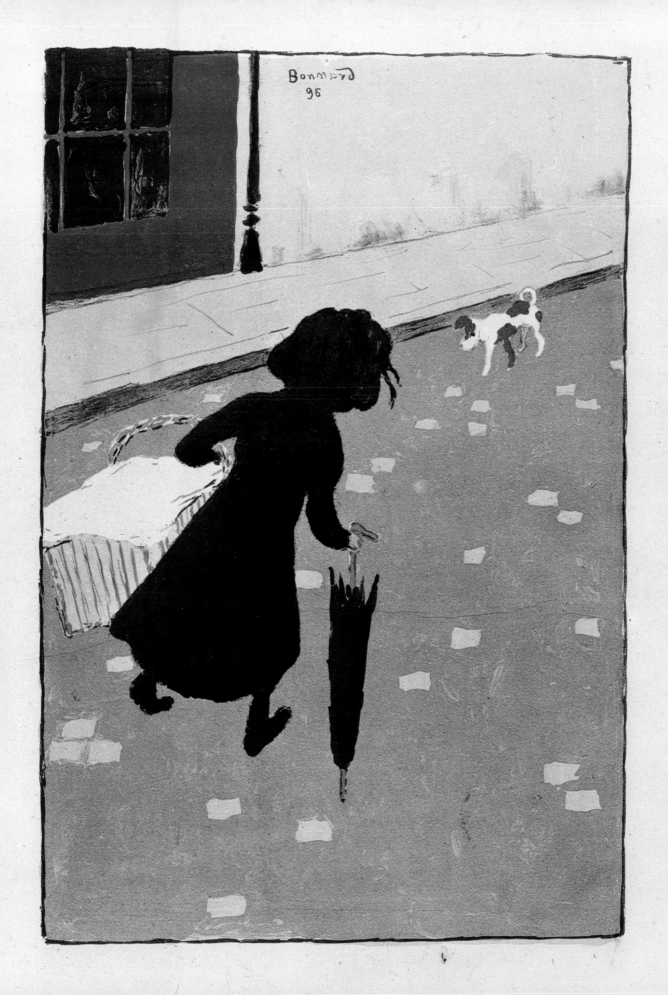

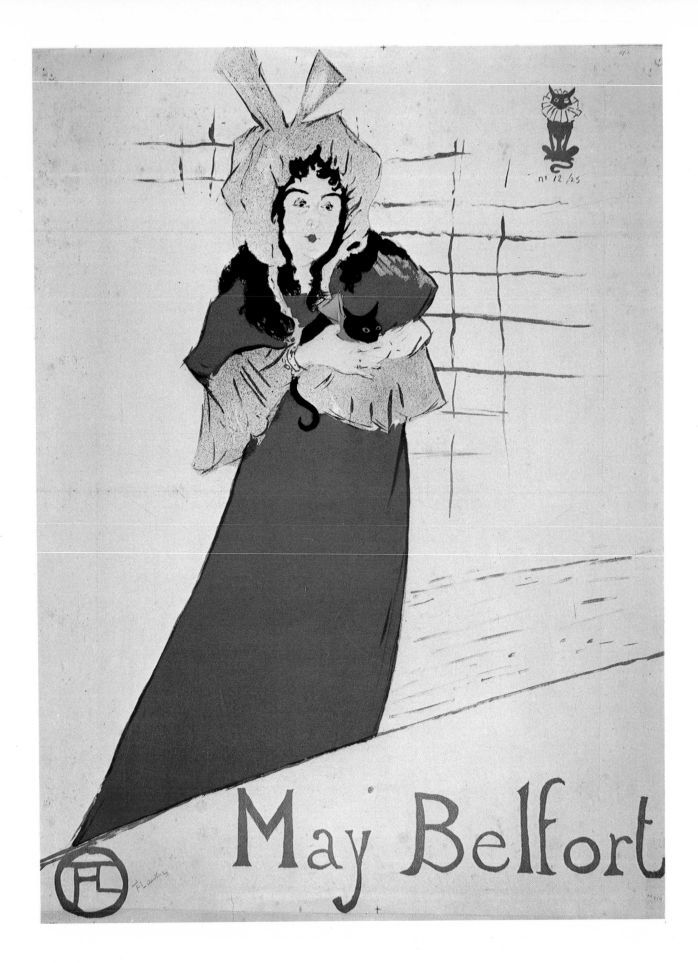

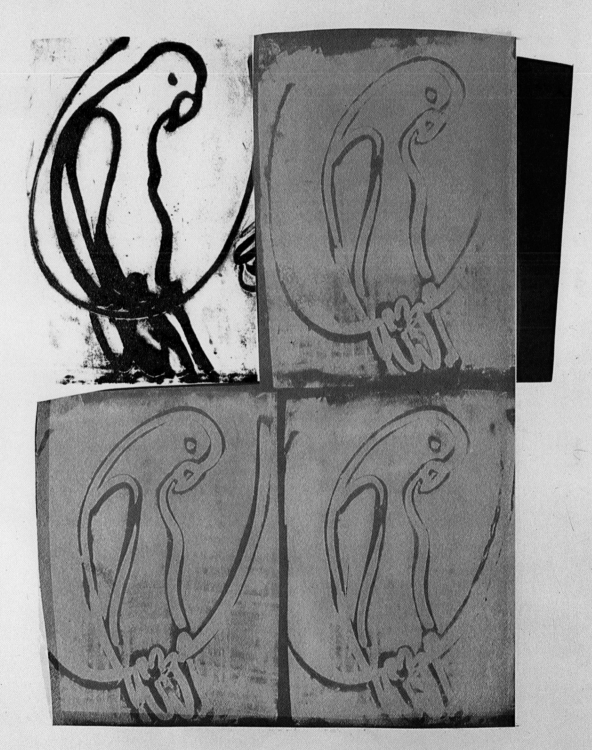

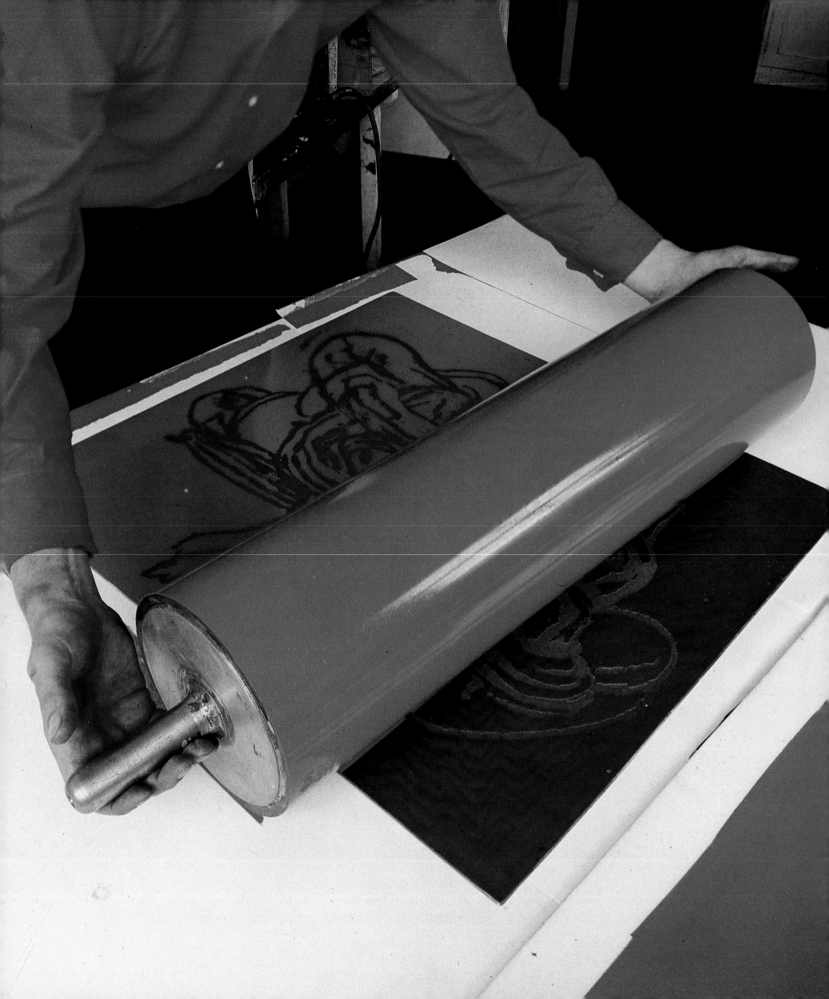

differently organised; there is inevitably a subjective element in any decisions about organisation and emphasis. I have concentrated so much on serigraphy and modern relief printing because I have found that they are usually given insufficient attention in general books; and I have not described the preparation of the stone in lithography in any detail because so many books include it.

Present and future

Much questioning of the validity of traditional work is being done by modern artists and printmakers, who are presenting art in a variety of different ways. Traditional printmakers are still engraving, cutting and printing by hand (Ill. 3), but others are pasting images together and having them photographed and then printed (so that the photographer and printer do much of the work); perhaps it is artists in the second group who are making the more vital and stimulating statements.

With regard to this controversial matter of using photographic imagery, here is a condition from a 1969 entrance form to a print exhibition: 'Each artist may submit two prints or drawings or a combination thereof. Any printing or drawing medium may be submitted (including photomechanical processes); however, the eligibility of an entry will be the responsibility of the juror' – which seems sensible.

New developments are continually taking place, and it is in the field of original prints that some of the most important visual works have been created in the 20th century (Ill. 182). The possibility of many copies of a print being released simultaneously, perhaps in several parts of the world, gives the art the immediacy of mass-communications media. The fact that printmakers usually gather together in workshops, and will pass on ideas and information about what is happening in the world of art, makes it international. New materials are being discovered and there are more opportunities for printmakers to make, sell and exhibit work. In spite of and because of this increased awareness, it seems that at the moment there is a blurring of the frontiers separating the print from other forms, as it tends towards sculpture in the three-dimensional print and develops from the photographic image towards slides and film.

The artist in the 20th century tries to extend his knowledge and continually experiments with new ways of making art. The print is being pushed to its limits and new horizons are appearing. As Kristian Sotriffer, the writer on printmaking, has remarked, 'The aim of all this experimentation is to do justice to the *secret* nature of the material.'

10
A pink, inked intaglio plate being surfaced with blue.

11
Fish stencil.
Japan, *c.* 1700–1800.
Cooper Union Museum,
New York.

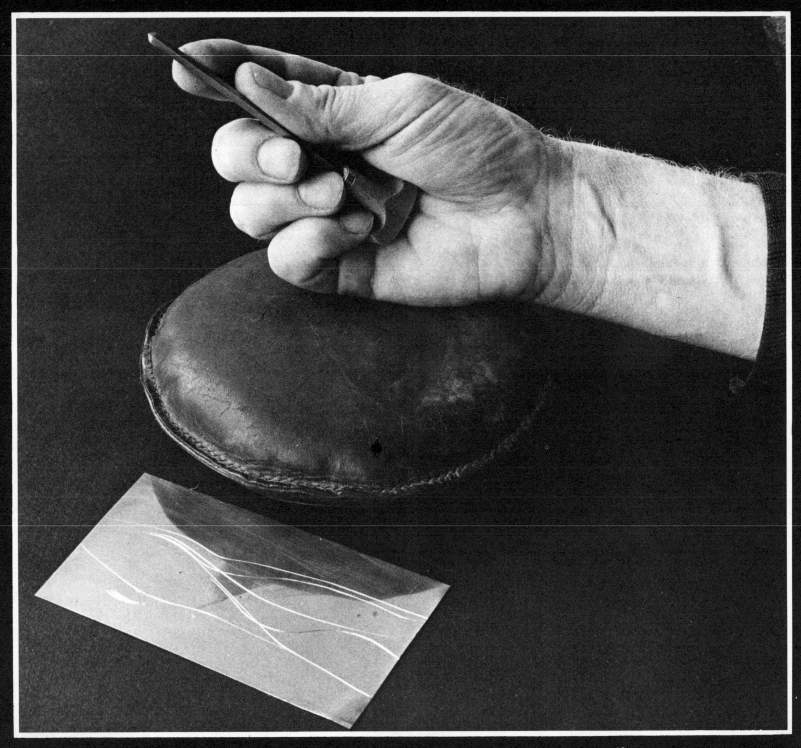

12
How to hold a straight engraving
tool. The hand is resting on a
sandbag.

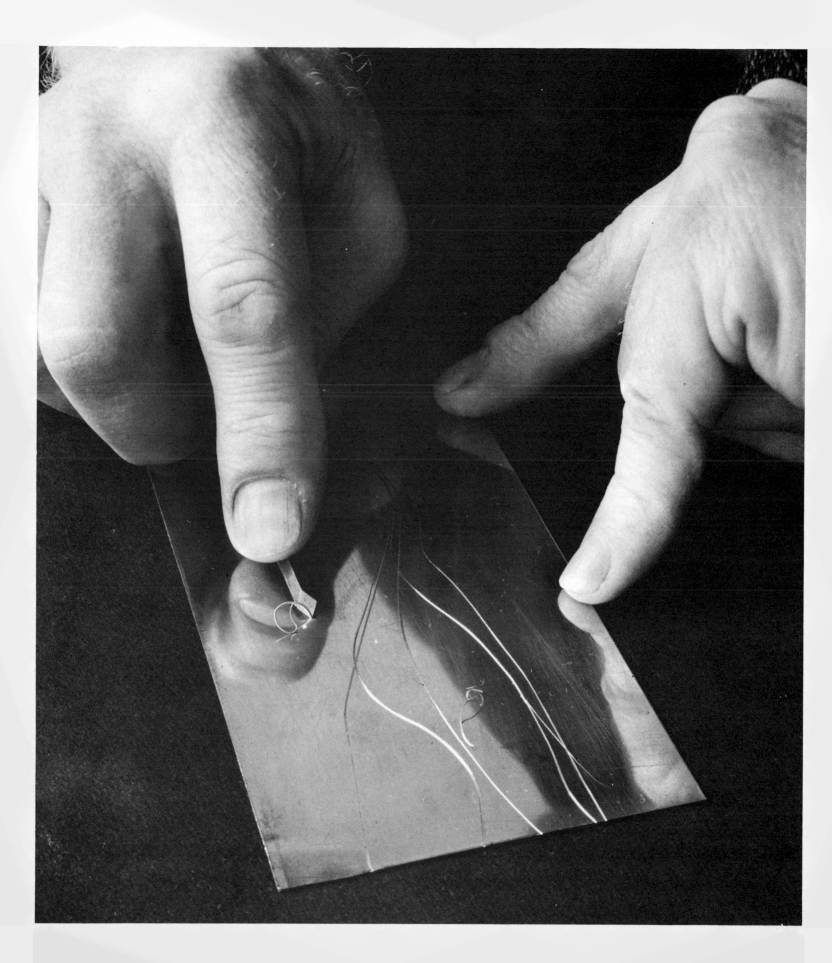

14
Shiko Munakata,
b. 1903, Japanese.
Flower Hunting Scene.
Woodcut in black and dark grey,
1954. 52 × 63 in.
Museum of Modern Art,
New York.

15
Slipper stencilled in brown on
yellow. American, 1800–20.
Brooklyn Museum, Brooklyn,
New York.

16
Trevor Allen,
b. 1939, British.
Couch with Cushions to Sit On.
Colour lino cut, 1969.
Collection the artist.

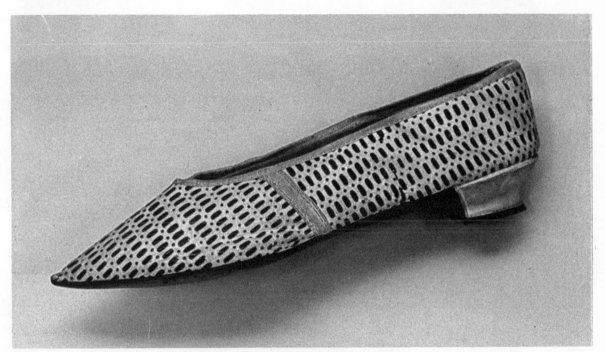

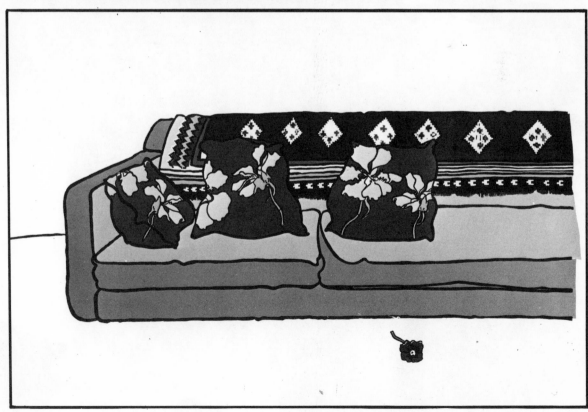

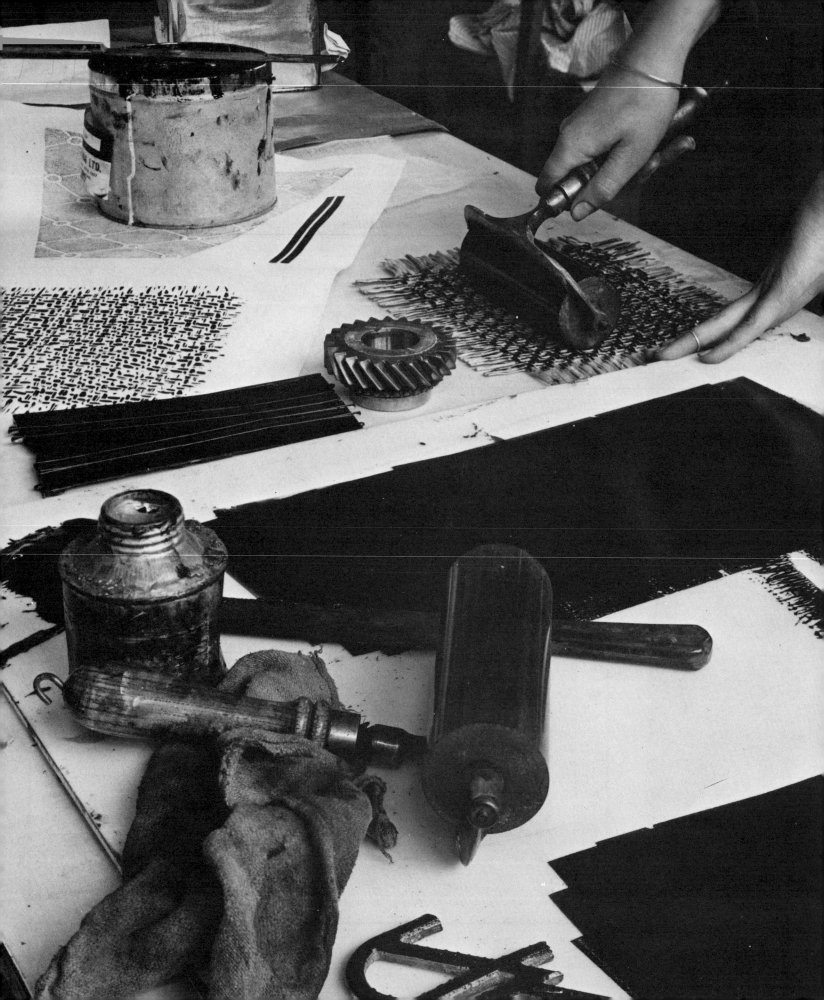

1

Printmaking without a Press

17
Various found objects including a table mat being inked up ready to print. On the left is a proof that has been taken.

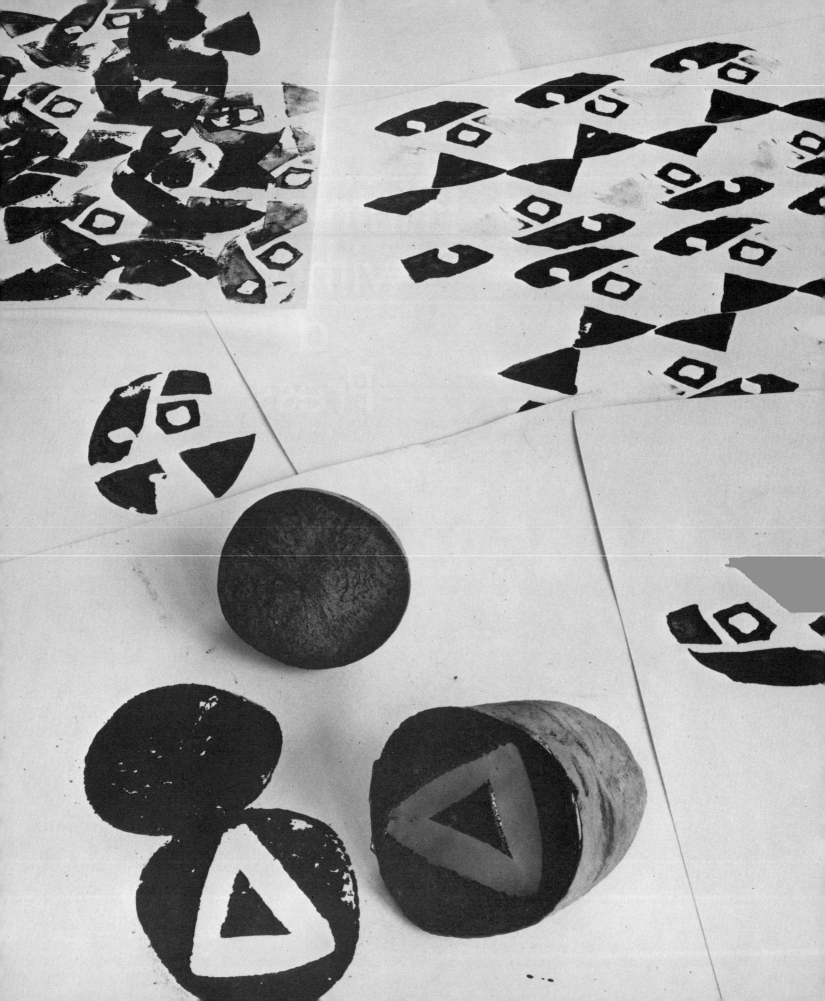

II
Simple Prints

'I gave him my view that anything made by impression was a print; if it had never been seen before in that form, so much the better.'
S.W. Hayter

While some of the techniques discussed in this chapter are among the simplest and most primitive methods of printmaking, this is not to say that they are only to be used by children. On the contrary, often the simplest means produce the best art. This chapter is concerned with showing some of the potential of printmaking with the minimal equipment. All the materials are easily available, and the suggestions made should be of use from an educational point of view, since they are of a kind that can be developed in schools by very young children. I have found that children from about five years old can work with some form of printmaking, and the discipline, the simple research and the resulting print make an exciting contribution to the child's creative development in the visual field.

Printing with found objects

One of the simplest forms of printmaking is the direct inking up of found objects which are then printed by hand. The prints in Ills 20 and 21 were made with easy-to-find objects—metal cogs and flanges, a thin plastic apple carton flattened out. All of these are objects found in some part of the immediate environment. They have only been covered with ink from a roller, as in Ill. 17, and printed by laying a piece of paper on top of the inked subject and rubbing the back of the paper with a wooden spoon. (A wooden spoon is softer than a metal one, and does not become hot through friction during the rubbing.)

Ill. 17 shows various found objects, one of which, a straw table mat, is being inked with a roller ready to print: on the left can be seen a proof that has already been taken.

Although no cutting or work on the object is required, a wide range of images can be created which, until printed, remain unrealised. For any object, for example a glove, has a different visual meaning when printed. Two gloves are illustrated here, both printed in relief: a heavy gardening glove (Ill. 30: notice the textures of the woollen parts) and a lady's leather glove (Ill. 31).

Most objects can be inked with a brayer or roller. Then a sheet of absorbent paper, cartridge, hand-made or Japanese, can be put on top of the object, and by careful rubbing or burnishing with the back of a spoon—preferably wooden—a print can be made.

The work will have a greater personal value when the child has looked for and found the object himself. The environmental search that leads to the discovery of objects suitable for printing can extend any project, relating it beyond the schoolroom to the outside world, during which process the inventiveness and understanding of the child is increased and encouraged.

However, this need not be exclusively a young person's method of printing. The printing of found objects is a pursuit similar to the making of collages. Collage is an arrangement of paper materials and other two-dimensional

18
A cut potato, one half with a triangle cut out and printed. In the background are potato prints by children.

19
A square of lino has been printed in black by a child, then some cuts have been made in the lino square and a new print made next to the first. Subsequent cuts and prints were made until the surface of the lino had all been removed.

20
Relief print taken from metal cogs and flanges.

21
Relief print taken from a thin, flattened plastic apple carton.

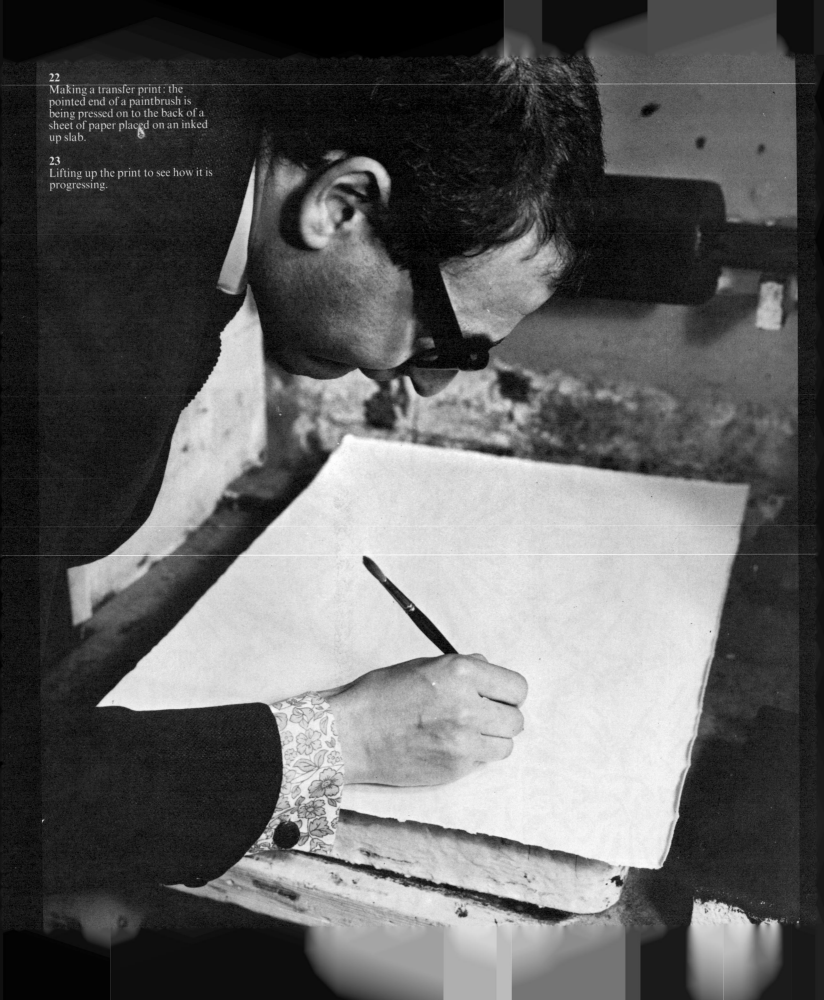

22
Making a transfer print: the
pointed end of a paintbrush is
being pressed on to the back of a
sheet of paper placed on an inked
up slab.

23
Lifting up the print to see how it is
progressing.

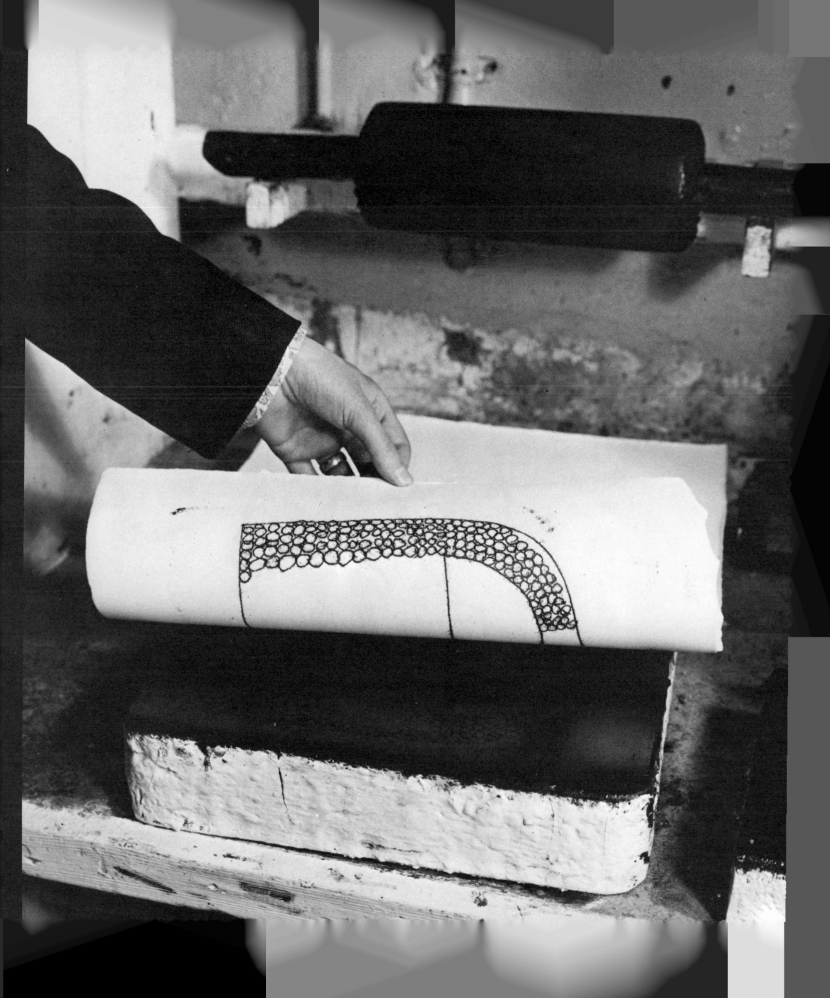

Shoemaking

found surfaces, stuck down on to a paper background or some other flat surface. Picasso and Braque made many collages, especially during their Cubist periods. Another great artist, Kurt Schwitters, used scraps such as bus tickets or torn advertisements to produce collages, and, operating on the same principle, built huge constructions from such things as stickers, stamps, bus transfers, corrugated card, torn paper, cut paper, transparent papers, postmarks, addresses, commercial trademarks, slogans from newspapers, packages, newspapers, numbers, letters, coins, corks, cloths, photographs, buttons, nails, magazine illustrations, litho work, silver foil, wood, perforated tin, sealing wax, matches, wheels, etc. 'The waste of the world becomes my art', he said.

It is surprising that so few artists have used prints of found objects as the basis of their work. However, Michael Rothenstein has conducted interesting experiments in this field (see the chapter on relief printing).

Objects with a specific and obvious use, such as a glove, can be used to convey ideas. Metal can be used, either when rusted and textured or when new and of machine-made precision. These found (or bought) objects can be coloured with a roller, usually a soft gelatine one, which has been inked from a slab. A thin film of ink is applied with the roller; then a sheet of reasonably absorbent paper is placed on the object and, with both held steady, the paper is rubbed or burnished. Every so often it should be carefully lifted in order to see how the print is progressing. When one object has been printed on a sheet of paper, others can be added, one after another, until the desired composite image is achieved. If the object to be printed is flimsy, it can be soaked in P.V.A., which hardens it; and so a shirt may be stiff enough to print in a relief press and be used to produce a number of identical prints.

The potato cut

The simplest and easiest way to make a cut image or mark for use in printing is to make a potato cut. A potato is taken and sliced in half to give a flat surface; then a simple shape or line is gouged out with a knife or any other small tool. Water colour, paint or ink (water soluble, since the potato is mainly water) is applied to the raised surface and the potato is upturned on to the printing paper. This pressing creates an easily reproducible print.

In Ill. 18 a triangle has been cut out and the moisture allowed to evaporate by leaving the potato exposed to the air for a while. A print has been made and can be seen to the left of the potato; and a print has also been made of the half potato without any design cut into it. In the background are some potato cuts by children.

Apart from the footprint or fingerprint, the potato cut is for many their first consciously made, repeatable mark – the artist's mark. It is not very far from this to the more sophisticated mark cut into lino, drawn on a litho plate, or carved in wood. The particular value of the potato cut is that it is very easy to cut and print in one colour. Children of almost any age can cope with and enjoy this method of printing, as can be seen from Ill. 25, of a repeat pattern made with potatoes by a child.

The particular qualities of the potato cut are its softness and, in a design of the repeating type, an often charming irregularity owing to difficulties of registration; the potato seldom prints a colour evenly, so a certain amount of variation in surface texture can be expected. The process is used by children because of its cheapness, the availability of the material, and its extreme simplicity. It is rarely used by professional artists because of the difficulty of producing editions of prints that are the same: the potato tends to shrivel up within a short space of time. Other vegetables, such as parsnips, can also be used.

Rubber stamps can of course be used in printmaking to great effect, especially for designs in which repetition is prominent.

The lino cut

Lino, which will be discussed at length in the chapters on relief printing, requires a few words here. Simple lino cuts can be made by slightly older children who can be given cutting tools if elementary safety rules are explained to them; and it is of course considerably easier to cut than wood. As an exercise in aspects of visual design and research the lino cut can be invaluable. It can easily be used for fabric printing with specially prepared inks, and is often printed without a press.

Of particular interest is Ill. 19, which shows prints made from a square of lino from which parts of the surface area have been progressively removed, until there is hardly any left. As an introduction to the technique of printing and the understanding of cutting it is a valuable

exercise for children. The repetition is interesting. The block could also have been printed in a different colour after each cutting, one image being superimposed on the others. With sympathetic guidance by the teacher, it is evident, children can create strong and intricate work in the classroom.

It is possible to cut away the block to create dark lines or to cut grooves in the block to produce white (that is, unprinted) lines on the paper; but the aim should never be to produce the equivalent of a drawn line in lino. Such an aim is, however, perfectly legitimate in the case of the technique I shall now discuss.

Transfer drawing

The monoprint drawing or transfer drawing is one of the most exciting ways of exploiting a line drawing, and is one of the simplest. First a roller is applied to a sheet of glass or metal, or better still an old litho stone, covering it with a coat of oil-bound ink, preferably black. A sheet of absorbent paper is lightly laid on this slab, and a drawing or diagram made on the back with a pointed instrument (or, for that matter, any tool); a ballpoint pen or a pencil will be found to yield the best results at first. The drawing is thus transferred to the underside of the sheet, giving a sensitive and delightful line against a lighter-toned background in the same colour. If a block is used that is smaller than the sheet of paper, there will be a white border round the print which will make it look more workmanlike or professional.

A similar technique is one that involves painting a sheet of hardboard or masonite with black decorators' paint and letting the surface dry. After this a sheet of paper can be laid on the masonite and drawn upon with a ballpen, which breaks the surface crust, penetrating to the still wet ink underneath and producing a design in a manner similar to that described in the previous paragraph. In this case, however, the whole operation is less delicate.

Transfer drawing gives a particularly exciting line and, if a really pointed tool is used, a sharpness that can be obtained from no other drawing method. This decisive quality is combined with a blurred or soft effect around the drawing (Ill. 24). Tone can be produced by pressing lightly with the hand on the areas that are to be darker.

Paul Klee and Paul Gauguin used this particular technique, but generally speaking it has received insufficient attention from important artists. The American printmakers Hedda Sterne and Carol Summers have both made some direct transfer drawings. It is important to use an oil-bound ink, and any smooth surface will be satisfactory to print from. The ink should be smooth and not too sticky. Possible tools range from a compass point to the fingers: a contrast between the hard mark and the soft is characteristic and should be exploited.

Ills 22 and 23 show two stages in the creation of a transfer print. In Ill. 22 the artist is using the pointed end of a brush to draw on the back of a sheet of paper that has been lightly laid on to a litho stone which has previously been inked with a roller. Ill. 23 shows a print being lifted up in an unfinished state so that it is possible to see how it is progressing. Wherever pressure has been exerted the ink has been lifted from the litho stone on to the paper.

Collage blocks (collographs)

Printing blocks of one's own can be made with found objects. Textiles, string, beans and other suitable materials are glued to a surface, perhaps covered with lacquer, and then printed. In Ill. 27 a plastic hairpin block can be seen which an art student has made as a relief block for printing. This was done by sticking hairpins on to a hardboard (or wood) base. When the surface is inked preparatory to printing, a geometric surface pattern becomes visible. From a few plastic hairpins, a board and some plastic adhesive, a new and exciting image is formed. Notice the print behind the block, with its simple but effective repeat pattern.

Ill. 32 shows an interesting way to make a block. Take a piece of hardboard and paint on a layer of P.V.A. or any plastic agent that will harden; but before it completely hardens draw a comb through it. After it has been left to dry it should harden enough to enable prints of most types to be taken from the block. Under the block in the illustration is a relief print taken from it by inking the surface with a roller and printing by hand (that is, burnishing).

Ill. 42 shows a rubbing taken from the same block. This block, and one I call 'Australia', which is embossed wood, appear in several chapters of this book to illustrate the variety of prints it is possible to make by using different printing techniques with a very simple block.

Stencils, masking, cardboard prints

In Ill. 26 cut stencils are shown, together with masking, paper and rollers. A print is

25
A child's colour pattern made with a potato cut with water-bound inks.

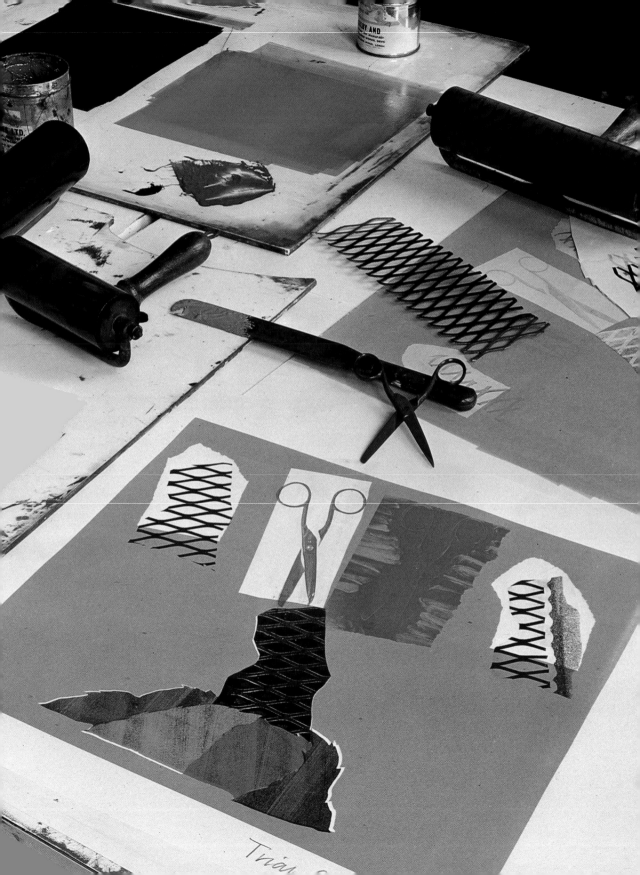

26
A print in progress made by offsetting from rollers and masking with paper masks.

27
A block made with plastic hairpins, a board and a plastic adhesive.
A print from the block is shown in the background.

being made by offsetting from rollers, masking out with paper masks, and running the roller over them, using the first and the second image given by the roller. (The second often prints better than the first.) By masking out small areas with paper and printing a piece of cardboard covered with ochre over the whole print one makes a coloured backgound for white shapes.

Cut paper or card into various shapes, lay them on the inking-up slab, which will keep them still and flat, and roll each piece from its centre to obtain even distribution of colour. Lift the shapes carefully, lay them on to the printing paper, and cover them with a second sheet. Use a wooden spoon to burnish them, peel away the second sheet and the shapes, and there is the finished print. A variation of this method is to paste or stick cardboard pieces to a block and ink these up as if to make a normal relief print.

The string print
String is attached by glueing on to a wood or masonite background and printed as a relief print. Although this is a very simple method indeed, a variation is used by many contemporary printmakers, who roll up wires bent in various ways and print them in an etching press.

Norman Gorbaty's *Print Making with a Spoon* gives an excellent list of original ways for children to make prints, including an ingenious corrugated cardboard print, and explains Mo-Glu, Casein, drip and bean print techniques. Gorbaty remarks that children as young as four can be engrossed by making bean prints for hours at a time.

These are only a few of the very many possibilities that exist in work with simple prints. Clearly, any creative teacher can devise simple printmaking techniques which are suitable for beginners and children of all ages.

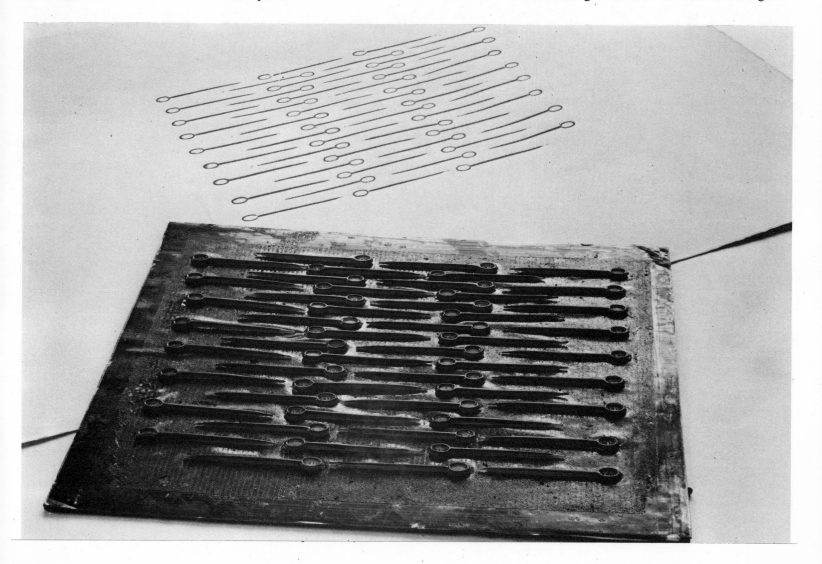

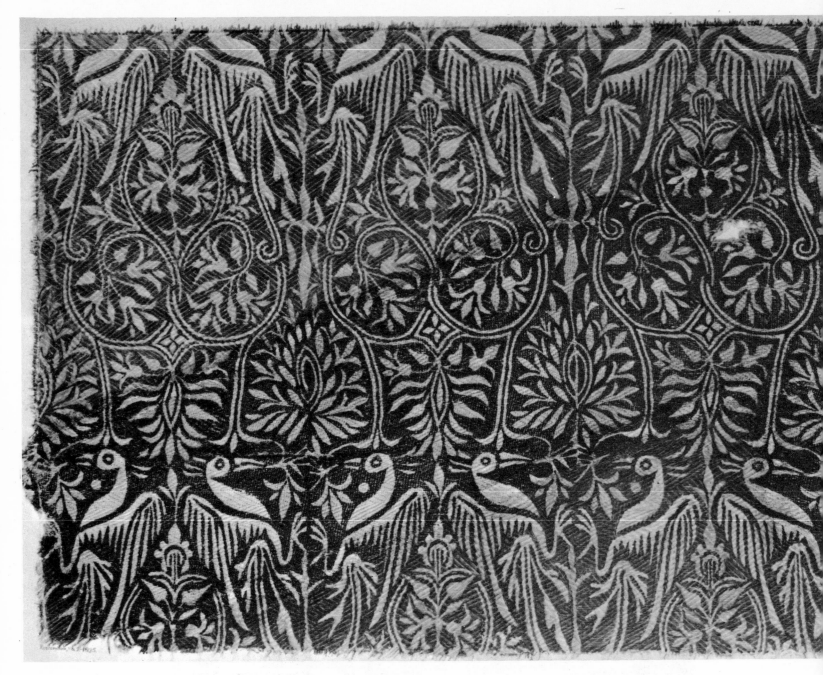

28
Block print on linen:
birds. 14th-century German.
Victoria and Albert Museum,
London.

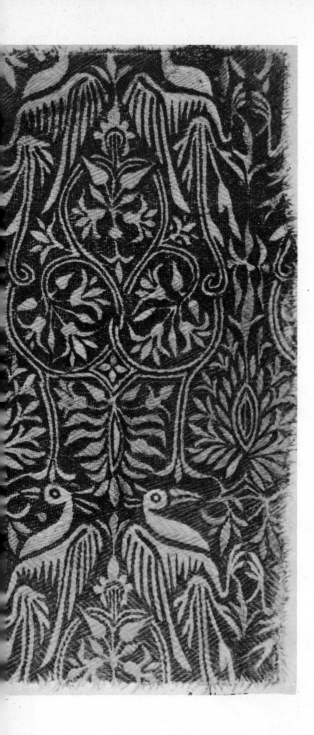

29
Italian school, 15th century.
Woodcut illustration for
*Aeneas Silvius Piccolomini:
storia di due amanti*. Dick Fund,
Metropolitan Museum of Art,
New York.

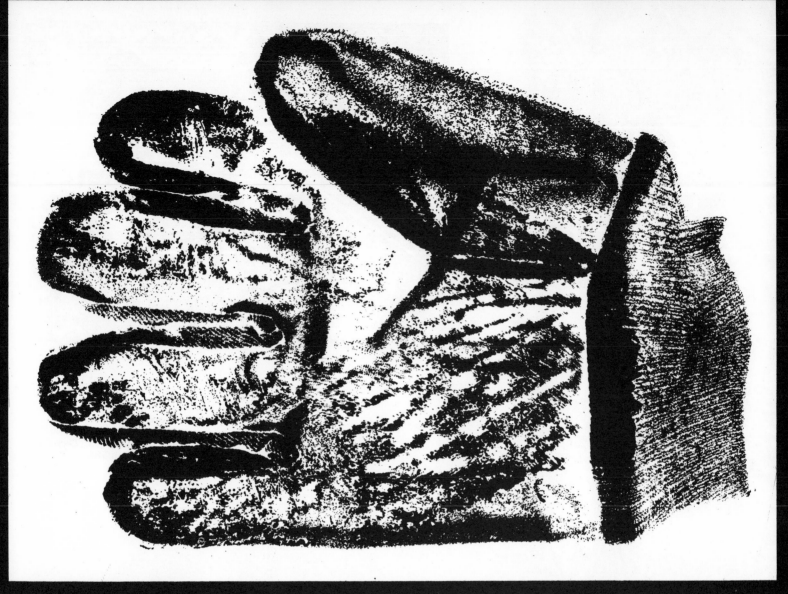

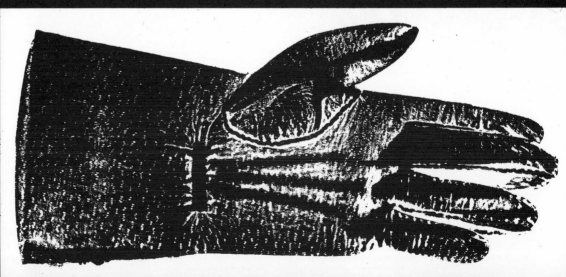

44

31
Relief print made from a lady's
leather glove.

32
A liquid P.V.A. resin has been
poured on to hardboard, drawn
through with a comb, and left to
dry. Under the block thus created
is a relief print taken from it.

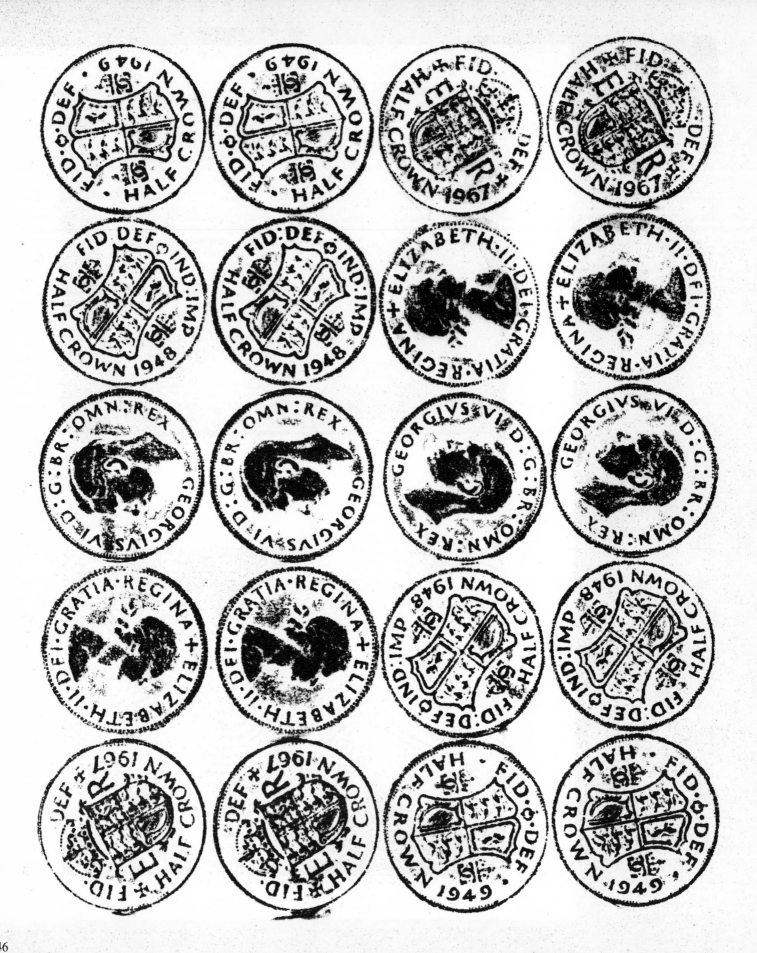

III
Rubbings (Frottage)

'In such a daub one may certainly find bizarre inventions. I mean to say that he who is disposed to gaze attentively at this spot may discern therein some human heads, various animals, a battle, some rocks, the sea, clouds, groves, and a thousand other things – it is like the tinkling of the bell which makes one hear what one imagines.' Leonardo da Vinci, on throwing a sponge soaked with different colours against a wall.

This too is an extremely simple way of making prints. Of course, some will say 'a rubbing is not a print at all', but if a mark can be transferred from a surface on to a sheet of paper and produced in an edition, this seems to me reason enough to include it in a book of this kind. If not a print, it is very closely related to one, and in particular to the relief print taken from found objects.

The basic method of rubbing is to lay a sheet of rather soft, thin paper on to any surface carrying a relief design, and then to rub some type of wax crayon or lead pencil on the paper so that the raised pattern on the surface is picked up (Ill. 33).

This method has mainly been used for the rubbings that are taken from church brasses (Ill. 34), and there are many books about this fascinating hobby. In many European countries there is a continuing tradition of making brass rubbings from churches and from inscriptions on early gravestones. These are collected and sometimes sold (see the Bibliography). Here, however, we are concerned with the more creative side of the medium:

the making of a personal image by rubbing.

We all become familiar, when children, with a simple coin rubbing of a penny. The coin is slipped under a sheet of paper which is then shaded over with a pencil, causing the image of the coin to appear. For one such rubbing (Ill. 33), made with litho chalk, a line of English half crowns was stuck down with double-sided sellotape or scotch tape to prevent them from moving, and then four rubbings were taken to produce the image shown.

The possibilities of rubbings are tremendous, but until recently not many artists have ventured into the field. The sheer number of available textures and surfaces may be compared with those of the relief print, and for artists who are fascinated by textured surfaces of any kind, the rubbing is a most exciting way of making images. It has the advantage of coming out the same way as it is made, rather than in reverse, as in the printing of a lino block; also rubbings can be made of surfaces that for various reasons are too difficult to take a print from, for instance a very uneven surface. A straightforward rubbing of a piece of wood, for example Ill. 37, creates a textured surface that stimulates the imagination at once.

Lettering and designs such as carved inscriptions can be used to take rubbings from, and it is possible to take rubbings of any sort and transfer them to a litho plate – rubbings of string, cloth, embroidery or mechanically made objects. A rubbing taken from wood that has weathered (Ill. 37) conveys a feeling of the life of the wood. Plastics cast or punched

33
Rubbing made with litho chalk of English half crowns. The line of half crowns was stuck with double-sided sellotape to prevent the coins moving.

34
Rubbing of a monumental brass, originally in Dunstable Priory church, Bedfordshire. The brass commemorated Robert Alee (d. 1518) and his first wife Elizabeth. $20\frac{1}{2} \times 4\frac{1}{2}$ in and $21\frac{1}{2} \times 5$ in. Victoria and Albert Museum, London.

35
A rubbing in coloured crayons made by a student from a metal grating.

with holes can also be used with surprising effect. Rubbings can be made with different crayons, colours, textures, all on the one sheet of paper.

Taking rubbings from wood is perhaps the simplest way of beginning printmaking. The duplication of shape and texture without any mess can be done quietly at home. There are innumerable varieties of wood to choose from, and wood is one of the easiest materials to obtain. Even a rubbing taken from a child's desk, with initials carved in it, can be very effective.

Metal gives a rather different effect. In Ill. 38 a metal border with another metal rubbing placed in the centre makes a much simpler, stranger and blacker image than the rubbing from wood (Ill. 37).

The history of rubbings

Rubbings have been made for many centuries, notably by the Chinese, who have specialised in rubbings of inscriptions, tombs, etc. In his book *Fine Prints*, Carl Zigrosser says of the stone rubbing: 'T'a. About the year 175 the six Confucian classics were engraved on stone by Imperial authority, and the slabs set up at the entrance of the Academy in order that scholars might have the benefit of an accurate and enduring text. Copies were struck off for the use of scholars when lampblack ink was perfected during the 4th and 5th centuries, and it was discovered that impressions of inscriptions and designs incised in flat slabs of rock could be obtained.'

The earliest stone rubbing now in existence dates from between 627 and 643. Stone engravings were also made in China to provide a permanent record of famous paintings, and rubbings were taken from the engravings. These were made before the discovery of the woodcut, which was also developed by the Chinese.

In Hong Kong the traditional way of making a rubbing is still carried on by Hsuan Chang in the New Asia College, and he is the third generation of a family working in this way from inscriptions and works of art.

A number of modern artists have used the rubbing. At least one was made by the great Norwegian artist Edvard Munch: in the Munch Museum in Oslo there is a rubbing, made in all probability in litho chalk (since Munch was an enthusiastic lithographer), from one of his own wood blocks and transferred to a litho stone (Ill. 41).

Max Ernst is the most important modern artist who has used the rubbing (Ill. 40); his name for the technique is 'frottage'. Working by himself, he produced several new and impressive ways of making rubbings. His own description of his discovery of the technique conveys his excitement.

'I was struck by the obsession that showed to my excited gaze the floor-boards upon which a thousand scrubbings had deepened the grooves. I made from the boards a series of drawings by placing on them, at random, sheets of paper which I undertook to rub with black lead. I was surprised by the sudden intensification of my visionary capacities... My curiosity awakened and astonished, I began to experiment indifferently and to question, utilising the same means, all sorts of materials to be found in my visual field: leaves and their veins, the ragged edges of a bit of linen, the brushstrokes of a 'modern' painting, the unwound thread from a spool, etc. There my eyes discovered human heads, animals, a battle that ended with a kiss.'

'Under the title *Natural History* I have brought together the first results obtained by the procedure of frottage (rubbing).'

Look again at Ernst's rubbings (Ill. 40). His *Natural History* of 1926 is one of the most important Surrealist works, both original and fascinating. He is almost the only artist who has used rubbings to create a new world of the imagination. As there are so few artists who are working on the same lines, I hope that some readers of this book are inspired to take this fascinating road to self-discovery.

Materials and methods

Printmaking methods, as I have pointed out, cannot be rigidly separated and put into self-contained chapters. Each of the different uses of the P.V.A. liquid plastic block, for example, has characteristic features, but an awareness that media of various kinds can be mixed is essential, and opens up endless possibilities for discovery. (See Ill. 43, and also Ill. 149.) One rubbing, taken from an experimental block made with P.V.A. and reproduced here (Ill. 42), has a soft, blurred look.

To make a rubbing you will need a bar of cobblers' wax, heelball, a large thick crayon or, if the work is to be delicate and light, perhaps a medium soft pencil. In many countries a rubbing stick of black wax is specially manufactured for the purpose. Gold wax is also a

36
Conroy Maddox,
b. 1920, British.
Double Decalcomania,
1968.

51

37
Rubbing from wood.

traditional material. Several sheets of thin, tough but soft paper will be required, and possibly weights (as shown in Ill. 44) to hold the paper still. It is best to rub sharply and not too many times, as this obscures the clarity of the rubbing. It is possible to use the edge of the crayon to help produce greater sharpness of definition. To make a creative attempt at a picture in the way that, say, Max Ernst did, try to become aware of surfaces that may yield interesting images, then start rubbing on a chosen part of the printing paper.

The rubbing being made in Ill. 44 shows how the paper is kept in place by a weight and by the left hand. An actual-size rubbing of an embossed or blind-stamped piece of wood (Ill. 43), from a packing case for Australian cheddar cheese, shows how accurately texture can be reproduced.

Decalcomania

Another form of simple printmaking that could be included in the next chapter is dealt with here; it too is connected with Max Ernst. This is decalcomania: ink or paint is applied to paper, which is then folded so that the two inked halves meet; they are then pulled apart to reveal an image. Examples by the English Surrealist artist Conroy Maddox are shown here (Ill. 36). The folds and the double image are clearly shown in this colourful example. In fact this is a double decalcomania because it has been worked on twice.

Surface rolling

Another way of taking a rubbing is by applying a roller charged with stiff ink on to the surface of the paper, which is placed on top of the wood or block and rolled until the image

appears. The result will usually be rather rough and may lack clarity. A traditional way of making a similar type of print, in this case from Chinese stone rubbings, is explained in Zigrosser's book:

'A dampened sheet of thin but tough paper was laid on the stone and forced into all the incisions, whereupon black ink (occasionally red or green or blue) was applied with a flat pad to the surface of the paper (that side which we would call the back). Because the ink could not reach into the incisions, the design appeared in white against a background of black.' This, like other rubbings, has the advantage of producing an image that is the right way round.

The writer of an important book on graphic processes has said that 'self-impressions (inked and printed surfaces) can be made of materials, wall-papers, plants, fish skins, coins, etc.

It is hardly possible, however, to produce art in this way.' I strongly disagree: in my view, deliberately chosen rules and disciplines are of positive benefit in canalising creativity, and the works of such artists as Max Ernst (Ill. 40), Enrico Baj in Italy and Dubuffet in France (Ill. 58) clearly demonstrate that any means that are relevant to the artist's intention can be used to produce prints that are works of art.

'When I adjust materials of different kinds to one another, I have taken a step in advance of mere oil painting, for in addition to playing off colour against colour, line against line, form against form, etc., I play off material against material, for example wood against sackcloth.' (Kurt Schwitters, artist).

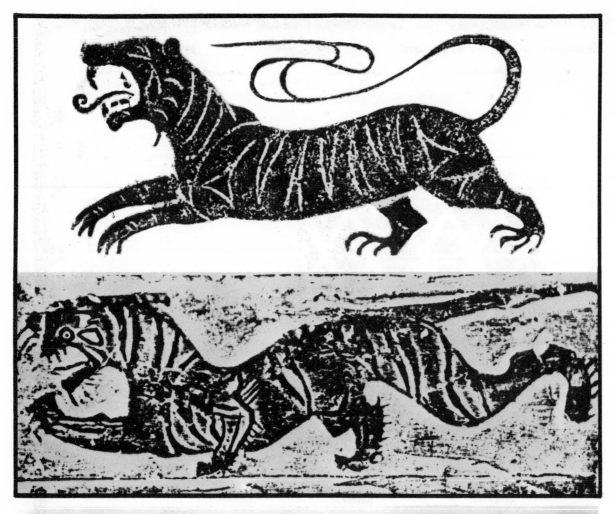

39
Chinese stone rubbings. Detail from Han relief.

40
Max Ernst,
b. 1890, Cologne.
In the Stable of the Sphinx.
Frottage from *Histoire Naturelle*,
1926. Bibliothèque Nationale,
Paris.

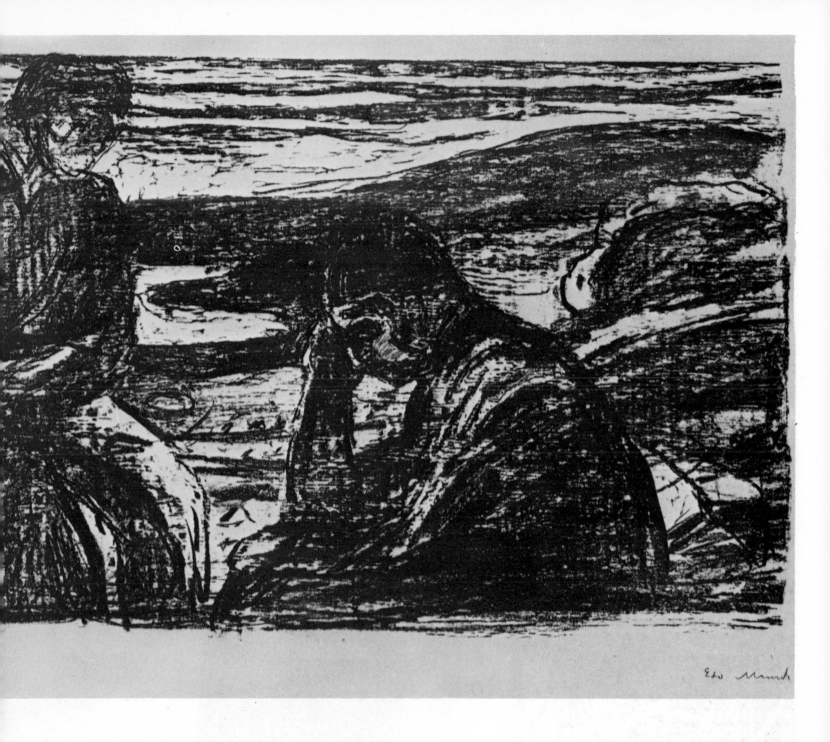

41
Edvard Munch,
1863–1944, Norwegian.
Melancholy. A rubbing taken from
one of his wood blocks and
transferred to a litho stone.
Munch Museum, Oslo.

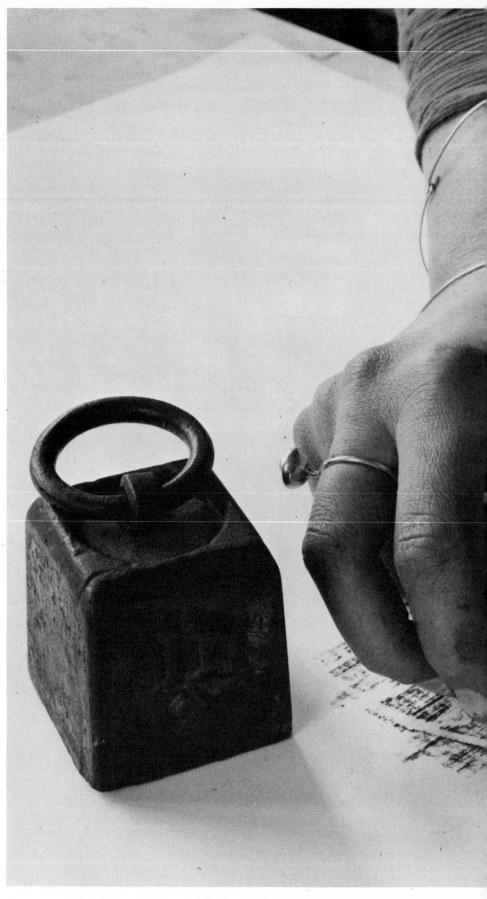

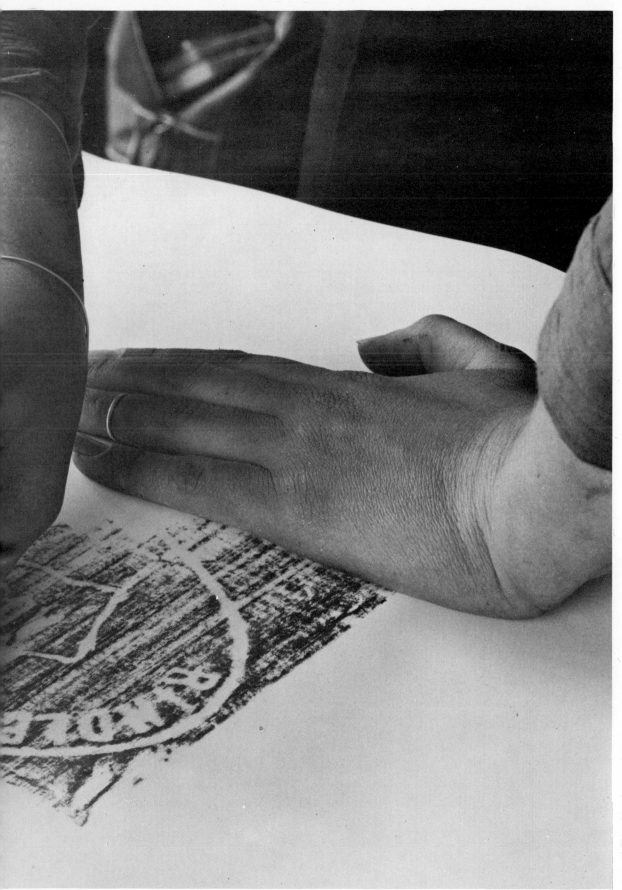

42
Rubbing from block made from
liquid P.V.A. on hardboard.

43
Rubbing from embossed or
stamped wooden packing case.

44
Rubbing in progress showing paper
held in place by a weight and the
hand.

IV
The Monoprint (Monotype)

'Even if I could pull only one print from each of my plates, I would still make them.'
Peterdi, author, printmaker

A monoprint is a single impression, produced by covering a sheet of glass or metal with thin ink, working upon it in some way, and then covering it with a sheet of paper. The image is usually transferred from block to paper by hand pressure (Ill. 45).

There is an unreasonable prejudice against the monoprint, probably because it is impossible to produce duplicates. Many gallery directors regard the monoprint as a drawing, and keep their collections separate from other prints; and most international exhibitions of prints exclude the monoprint. However, every good monoprint is the logical result of the process employed; it looks like a print and could be made only by a printmaking process. The great monoprints of Degas (Ill. 46) and Matisse (Ill. 57) are clearly more characteristic of prints than drawings. And, incidentally, many modern etchers and relief printmakers take only a single print from a plate which is capable of producing more, or limit themselves to a very small edition.

Making monoprints is a very simple form of printmaking. The swiftness, directness and autographic quality of the medium is always in evidence. Its particular characteristic is an individual surface quality, visible for example in Ills 45 and 51, which is created in the process of lifting the paper from the glass. It resembles direct oil painting or watercolour, and has a natural, painterly feeling; but it also has its own characteristic look, and what has been described as an 'organic rightness'. The monoprint can be used to work out ideas, to make sketches for larger works, or in combination with other works. It needs no special equipment. The end result can vary in style from the atmospheric qualities of Prendergast's *Orange Market* (Ill. 55) to the controlled clarity of a Matisse nude; the nude reproduced here (Ill. 57) is from a series he made in 1914.

A monoprint that will repay study is *Mescal* (Ill. 48), an illustration for Malcolm Lowry's book *Under the Volcano*, made by Rod Harmon when he was a student at Brighton College of Art. It was worked on by being continually added to and built up, almost as one does with a painting. At times when working on the series of which this is part, Rod Harmon almost obliterated his design with white ink, which was also printed, and continued working on it when it was dry. The final product admirably complements Lowry's novel.

A print with a completely organic look can be obtained by splattering the surface of an inked plate (or slab or glass) with white spirit and placing a sheet of absorbent paper on top (Ill. 51). This type of mark can be used for inspiration in the same way as an artist in the past, such as Leonardo, could discover fantastic landscapes and strange people and designs in a textured wall or surface. (See the epigraph of the chapter on simple prints.) The accidental marks that can appear on a monoprint can be developed into a new print: the plate is cleaned and colours are painted in to pick out the design suggested by the marks.

45
Paper being lifted from a stone, showing an example of monoprint texture.

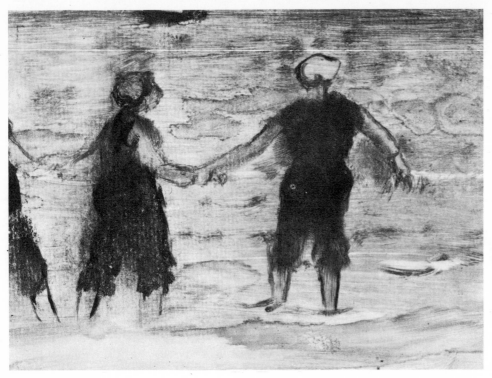

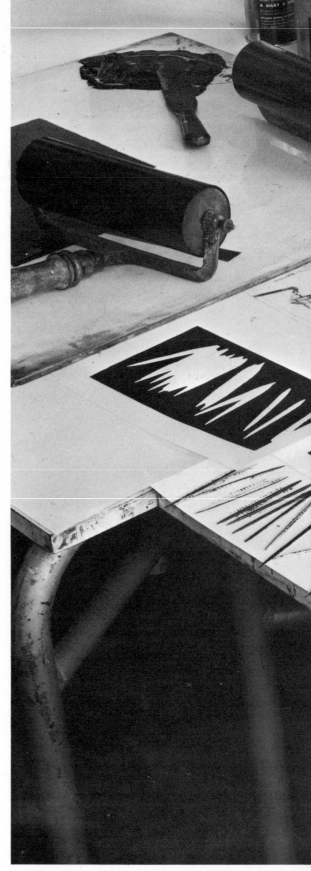

The monoprint can be used by itself or in combination with any other media; this is dealt with in the chapter on mixed media. The image painted on the plate or glass is transformed by being printed on to a sheet of paper. With experience, however, chance effects can be controlled, and the skilful artist can produce monoprints ranging at will from the absolute chance effect to the completely controlled drawing, as seen in Ills 56 or 57.

As a medium, the monoprint can be full of creative surprises for the student and the artist. By varying the consistency of the ink one can get as thick a surface as in *Mescal* (Ill. 48); this particular print was painted on copper and printed in an etching press. Or the surface can be as thin and delicate as parts of *The Album* (Ill. 56). It is in fact one of the particular virtues of the monoprint that the artist can produce a colour so delicate that it looks as if it has just settled on the paper.

For an amateur monoprinting is one of the cheapest and easiest ways to start working in printmaking. It is also one of the best ways for the teacher to introduce a class of students to the print, since they can be given a slab of glass or litho stone or plastic laminate, and can produce literally dozens of prints in the course of a morning.

Objects can also be placed on the stone or plate, showing up in white relief on the print.

46
Edgar Degas,
1834–1917, French.
The Bathers.
Monoprint, $4\frac{3}{4} \times 6\frac{1}{4}$ in.

47
Various materials used for the making of monoprints or monographics: mesh, P.V.C. strips, chicken wire. Two monoprints made with P.V.C. tape can be seen in the background.

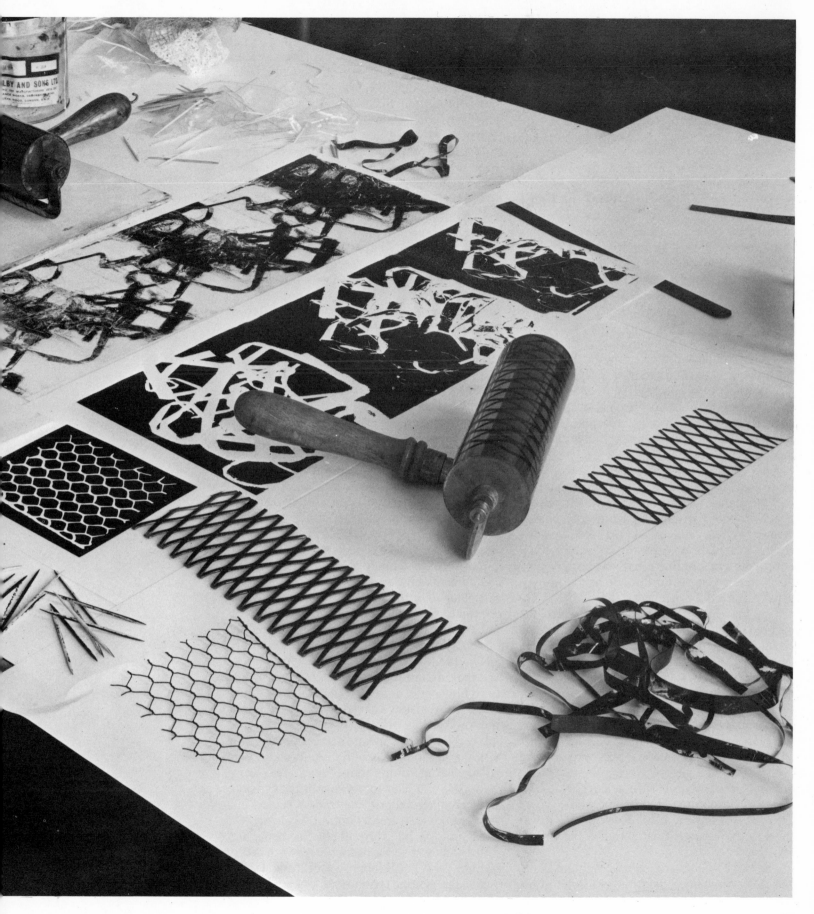

Torn paper can be used in the same way, and if after using them the artist turns the torn pieces over, they will have a residue of ink on the back which will give graduated tones on a new print. Similarly, if string is used, some of the ink will come away with it after printing, leaving the mark of the string's shape and texture on the plate; and this too can be printed.

Monoprints may be made in quite another way – white on black. The print by Matisse (Ill. 57) was made by rolling black ink over a plate and then drawing on it with a sharp point. This gives a print with a white line on a black background. The resulting work, as you can see, has a characteristic sharpness; the economy of Matisse's line makes it very impressive. It is also possible to produce prints of this type with a press.

The history of the monoprint

Not much has been written about the monoprint yet, and so far as I know, only one book has been entirely devoted to it, Rasmusen's *Printmaking with Monotype*. Yet despite this, and despite the fact that not many artists specialise in the monoprint, it has an illustrious history.

Any etching plate not wiped completely clean will have some residue of ink that will tint the paper when printed; and the monoprint probably originated from this phenomenon. When the artist realised that by wiping the plate in a particular way a tonal effect could be obtained that was not given by the bitten or engraved line alone, the monoprint came into existence.

The first artist of importance to use the monoprint method in a pure form was Castiglione (Ill. 49), who seems to have developed the technique single-handed in Rome from about 1635. There are certainly very many works by him completely in monoprint. As an etcher he was influenced by Rembrandt, who also used wiping effects on his plates. Castiglione made monoprints by painting a picture on a metal plate and printing it directly, and also by covering the plate with ink and drawing on it with a sharp tool; and at times he combined both methods. There are many examples of his work in the Royal Library at Windsor Castle and in the British Museum.

The English poet and painter William Blake was a very inventive printmaker; some of his innovations are described in the chapter on relief printing. He used the monoprint (Ill. 55), though not always in its purest form; often it was in combination with his etched relief prints. Blake delighted in working out new and complicated techniques in printmaking. This is an early description of his technique: 'When he wanted to make his prints in oil, he took a piece of millboard and drew his design upon it with some strong dark ink or colour, which he let dry. He then painted on it with oil colour in such a fusion that it would blur well, painting roughly and quickly so that the pigment would not have time to dry. After taking a print on paper he finished up the impression with watercolour.'

Mary Cassatt also worked with both etching and monoprint (Ill. 56). The monoprint suits her light Impressionist style very well. It was her master, Degas, who was the great explorer of the monoprint. He made hundreds, ranging in size from about 1×1 inch to the approximately 17×24 inches of *The Foyer*. *The Bathers* (Ill. 46) shows where the highlights have been made by wiping areas from a coloured plate with a piece of rag. Degas is probably the greatest of the modern printmakers to exploit the monoprint, and a study of his work will convince anyone that this medium need not be considered a poor relation of such better established media as etching and lithography.

Many of Degas' contemporaries and successors also worked successfully with the monoprint. In France, Corot, Pissarro and Gauguin all made monoprints; Gauguin in particular continually experimented with printmaking, creating many wonderful works and often using the monoprint. In America J.S. Sargent and Frank Duveneck both used this method. In 1880 James McNeil Whistler was making monoprints in Venice by tinting an etching plate, a method that was very much suited to Whistler's suggestive, atmospheric and low-keyed work (Ill. 148).

It was an American landscape artist working with the monoprint, Charles A. Walker, who called the medium 'monotype'. The word monotype can lead to confusion today, since in the commercial printing trade it is used in a different context. In this book I have used the word 'monoprint' throughout, as being unambiguous and verbally consistent with 'lithographic print', 'silkscreen print', etc. I have used it as a generic term for all 'one off' prints.

48
Rod Harmon,
b. 1942, British.
Mescal, 1966. Monoprint illustration to Malcolm Lowry's novel *Under the Volcano*.

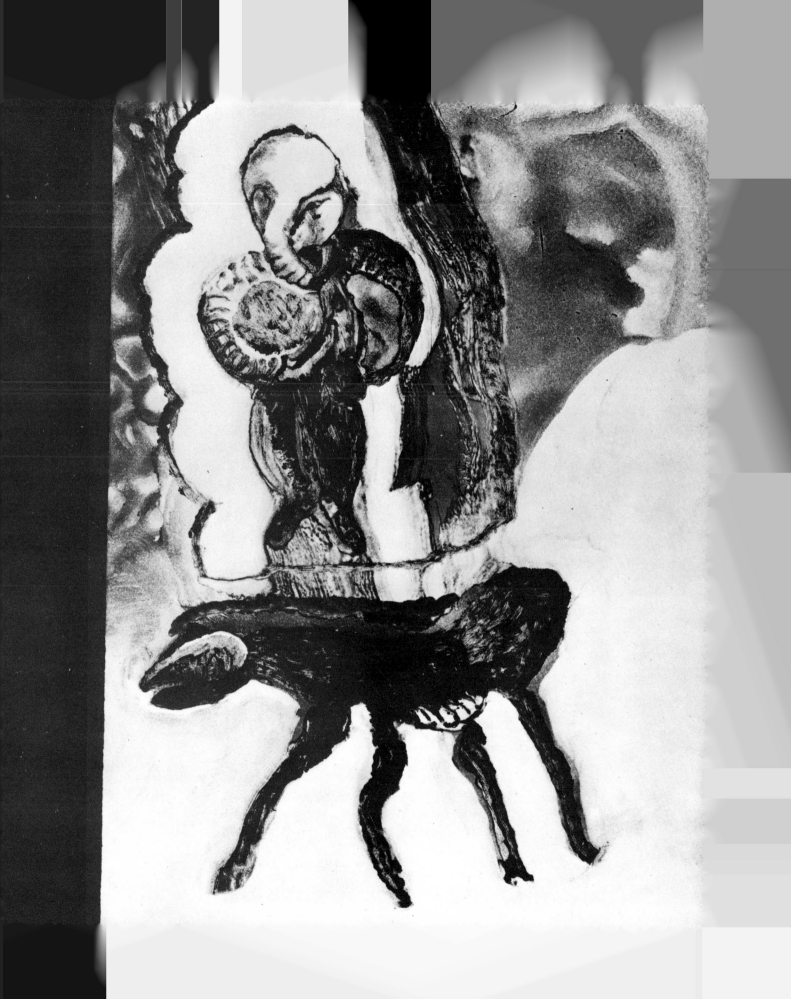

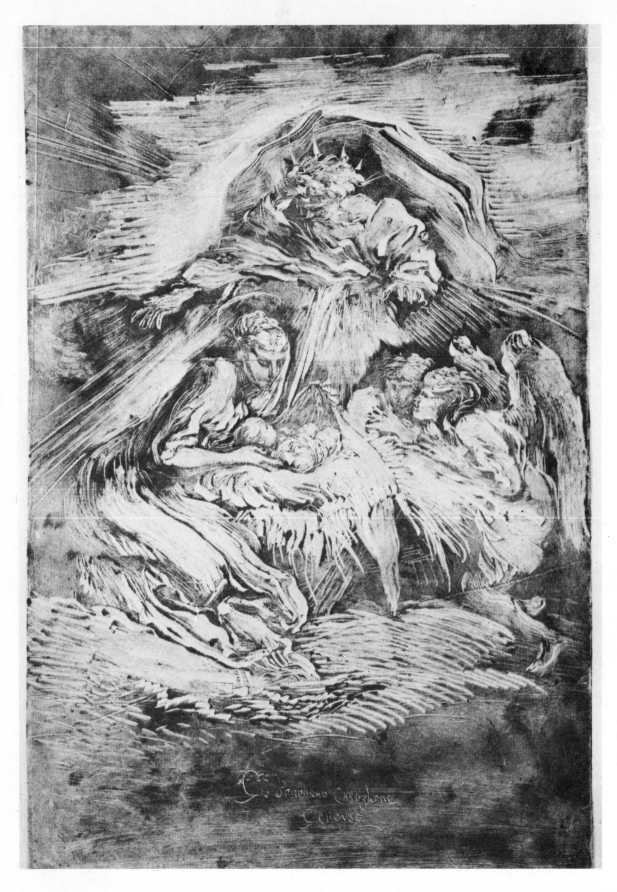

49
Giovanni Benedetto Castiglione,
1600–1670, Italian.
The Nativity. Monoprint.
Royal Library, Windsor Castle.

The word 'monographic' is used to describe those prints which could possibly be printed in editions, but of which only one copy is taken.

Around the turn of the century Maurice Prendergast, an American Impressionist artist of great skill and charm, was the most important artist working with monoprints. *Orange Market* (Ill. 55) is a beautiful and accomplished work which demonstrates the possibilities of the medium, in this case through a realistic depiction of a fruit market. Prendergast seems to have taken the medium as seriously as Degas did, and some of his prints are rather similar to the French artist's in subject and technique. Prendergast's prints, however, are usually a flood of colour, whereas Degas worked mainly in black and white. (Degas often worked from a monoprint on to a litho stone, the printer being responsible for the transference from paper to stone.) Abraham Walkowitz in America also used the monoprint to a considerable extent.

Modern times

In the 20th century such diverse masters as Klee, Picasso, Matisse and Rouault have found monoprinting well suited to their different styles. Jean Dubuffet has made many monoprints in conjunction with related techniques, for example cutting up prints and sticking them on canvas as material for collage (Ill. 58). He is one of the modern artists who have exploited not just monoprinting, but many other printmaking techniques.

Max Ernst, a restless experimenter, used many of the techniques of the monoprint, especially on canvas, which he would then paint over in part, leaving certain areas with pure monoprint textures representing landscapes, rocks and skies.

Materials

The simplest materials can be used. All that is needed are:
1. A small thick sheet of glass, a metal plate or a flat lithographic stone
2. Oil-based inks or paint
3. Brushes
4. Turpentine substitute, white spirit or paraffin as a solvent and for cleaning
5. Paper which is absorbent and tough
6. A rag for cleaning
7. Palette knives
8. A roller or brayer

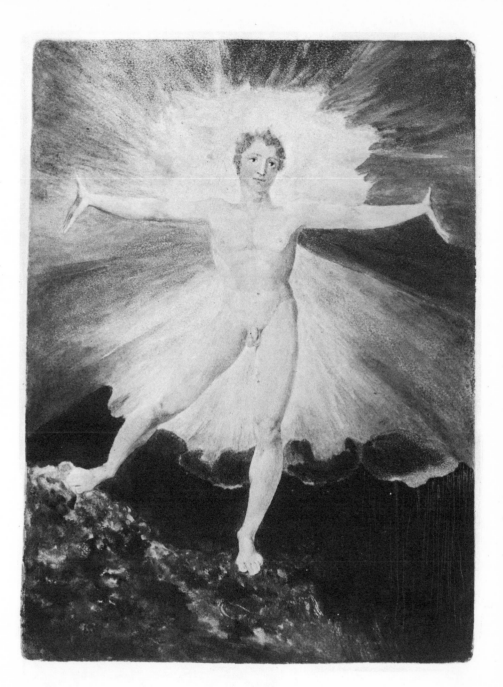

To start making the simplest kind of monoprint, spread a little ink on to a sheet of glass and sprinkle some white spirit on it. Then draw on the glass with a rag, perhaps adding some small pieces of torn paper. Place a sheet of paper on the surface of the glass and rub gently with the back of the hand. Lift up the paper, and you have your first monoprint (Ill. 45).

Prendergast described his method of making a monoprint in a letter: 'Paint on copper in oils, wiping parts to be white. When picture suits you, place on it Japanese paper and

50
William Blake, 1757–1817, British. *Glad Day*. Monoprint. British Museum, London.

65

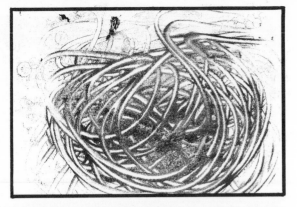

51
Four prints showing typical
textures of the monoprint.

52
Hugh Davies,
b. 1946, British.
Monoprint, printed from lino,
1968.

either press in a press or rub with a spoon till
it pleases you. Sometimes the second or third
plate is the best.'

Registration

If you are printing from a sheet of glass, you
can slip a drawing underneath the glass and
use it as a key drawing. When using a key
drawing in this way, attach one edge of the
printing paper to the bench with thumb tacks
so that the paper can be placed or 'registered'
in the same position for each addition to the
final print. Ill. 51 shows four different mono-
print textures all taken from the surface of a
litho stone. The ways in which the four textures
were made are as follows: by putting turpsy
ink on to the stone and drawing with the
fingers; by wiping a piece of rag over the stone;
by splattering ink and turps on to the stone;
and by printing from a dryish ink residue that
had been left on the stone.

Drying

It is necessary to hang some prints to dry, and
this can be done with the ball pattern rack
(Ill. 132), especially if they are supported by
two corners. Otherwise a stout length of string
with plastic clothes pegs can be used.

Other printing materials

It is not always necessary to print from
smooth, hard surfaces. The colour print done
by Hugh Davies when he was a student (Ill. 52)
was printed from lino blocks. Gauguin, it is
said, used sun-baked mud tiles.

The transfer print

Another type of monoprint is the transfer
print, described in the previous chapter. It is
not at all surprising that such inventive and
personal artists as Degas and Klee should have
used this transfer method and combined it
with many other techniques. At the present
day, American artists such as Hedda Sterne
and Carol Summers and English artist/ illus-
trators such as John Lord and Barry Fantoni
make transfer prints.

In the monographic print, more complex
methods of transfer printing are possible. This
can be done with rollers, an example of which
can be seen in Ill. 26 showing Peter Hawes'
experimental sheet, offset rollers and a print
(notice the offset print of the scissors). A
variation of this technique is described in
S.W. Hayter's book *About Prints*: a wood

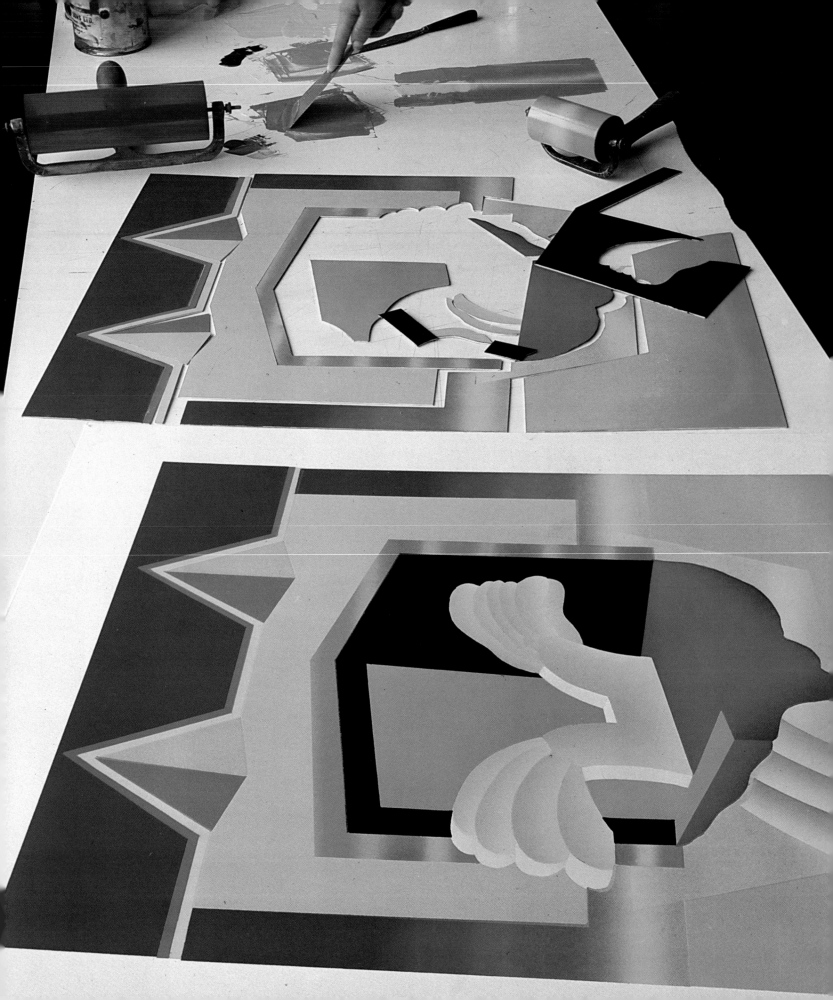

53
A cardboard relief print with
blocks showing the merging of
colour, by Lynne Moore, British.

54
Rollers and sellotape with etching
plate and unfinished print.

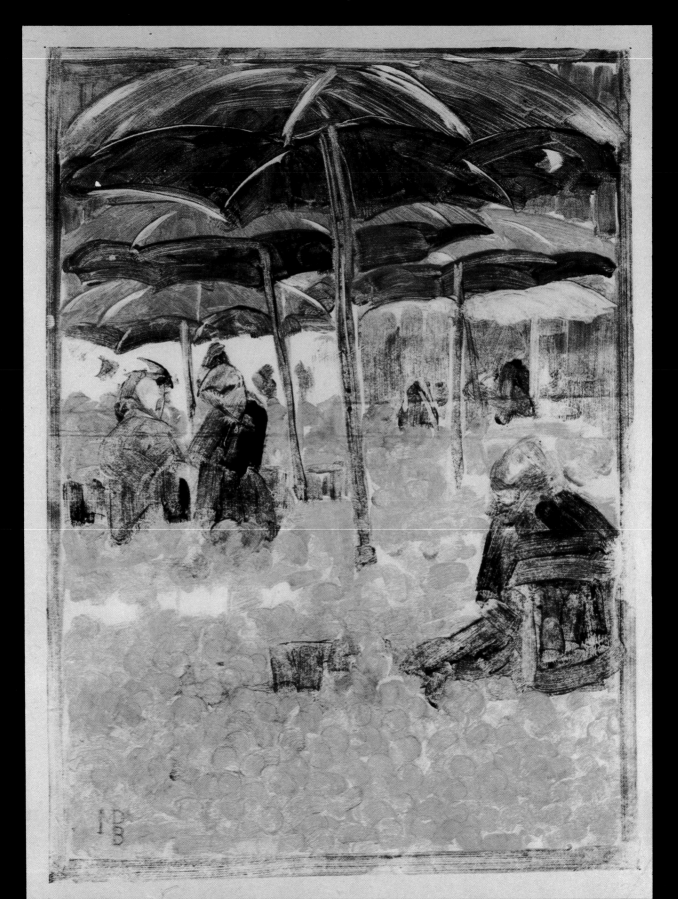

block, or indeed any object, is inked with a roller, and then a perfectly clean gelatine roller is rolled over the object very slowly, picking up the impression. This is then transferred to a sheet of paper which is pinned or weighted down. A little practice with this method of printing will show that considerable control is possible; for example, it is easy to develop the ability to print the roller down on to the paper in the right position every time.

A technique closely allied to the monoprint is shown in Ill. 54. Sellotape is stuck on to an etching plate and the small green roller is rolled over it. The sellotape is then lifted off the surface, leaving green and white. After this, the large red roller is rolled over the whole surface, filling in the white areas with red (the same procedure as in Ill. 10), and the image is printed in an etching press. This type of 'one off' improvisation can be continued indefinitely, as in Ill. 26. Offsets from rollers eventually become so complex that it is difficult, and perhaps even impossible, to arrive at the same result twice. This, of course, influences the printmaker's approach, so that he tends to produce series of related ideas rather than to print editions of a single work.

The print by Lynne Moore (Ill. 53) is not strictly a monoprint, but is closely related. It is a cardboard relief print, as can be seen from the background of pieces of coloured card. The complexity of the design and the blending of the colours (the technique can easily be understood by looking at the rollers) make it improbable that a complicated print of this kind could be produced in a large edition; hence this particular print is one of an edition of only three. When this technique is used, each individual piece of card has to be coloured with a roller and printed separately, usually twice. To achieve the required smoothness and register, it is printed by putting the card blocks face down on to the paper with only one or two sheets of packing on top, and printing in a press on absorbent filter paper.

The textured paper print
The dipped paper technique is an interesting way of printing random textured marks. Creased or crumpled paper is dipped quickly into water-based or thin oil-bound ink. Having absorbed some colour, it is then pressed on to a sheet of paper to make a print. Sometimes a double image is wanted, and this can be achieved by pressing a second sheet of printing paper on top of the original print. A dipping technique is also often used for transferring on to paper the texture of a found object such as lace, fabric or string.

Marbling
The traditional method of marbling used for book endpapers can produce unexpected results. Oil colour is floated on top of a water-filled bowl, sink or photographer's developing tray, and printing paper is laid lightly on top of it. When the paper is lifted off, the colour will have left a fascinating organic image.

Also organic – and very definitely a monoprint – is the image of a piece of a fur coat which has been inked with a roller and printed in a cylinder press (Ill. 59). If inked and printed again, it would look quite different, as the hairs would turn in other directions, resulting in different textures and tones. It may be technically possible to soak the fur in some plastic medium to stiffen it, but the resulting print would lack the characteristic softness of fur so well seen in the illustration.

Presses
The traditional method is the etching press; but a press is not essential.

The plaster print
The plaster print, which is not strictly a monoprint, is taken from an etching plate when the etcher has no press and wishes to examine the work in progress. I have included it here because certain artists take a single plaster print and then carve it and work on it in various ways. I know of no artist who has made an edition of plaster prints, although it is technically possible.

The print is made as follows. Ink the plate and wipe it as for an etching; then place the plate face up on a flat surface, possibly with plasticine or some frame round the edges, and pour plaster on to it. When set, the plaster comes away easily. Scrim or some other material can be put on to the still wet plaster.

With the exception of artists like Dubuffet (Ill. 58) there seems to be little interest in monoprinting among printmakers. It would therefore be a good deed to try and revive the medium, especially in view of the opportunities it offers for personal expression. Also, although some of the big exhibition committees will not accept the monoprint, one can always have one's own 'one-man exhibition'.

55
Maurice Prendergast,
1859–1924, American.
Orange Market.
Monotype. $12\frac{1}{2} \times 9\frac{1}{8}$ in.
Gift of Abby Aldrich Rockefeller,
Museum of Modern Art,
New York.

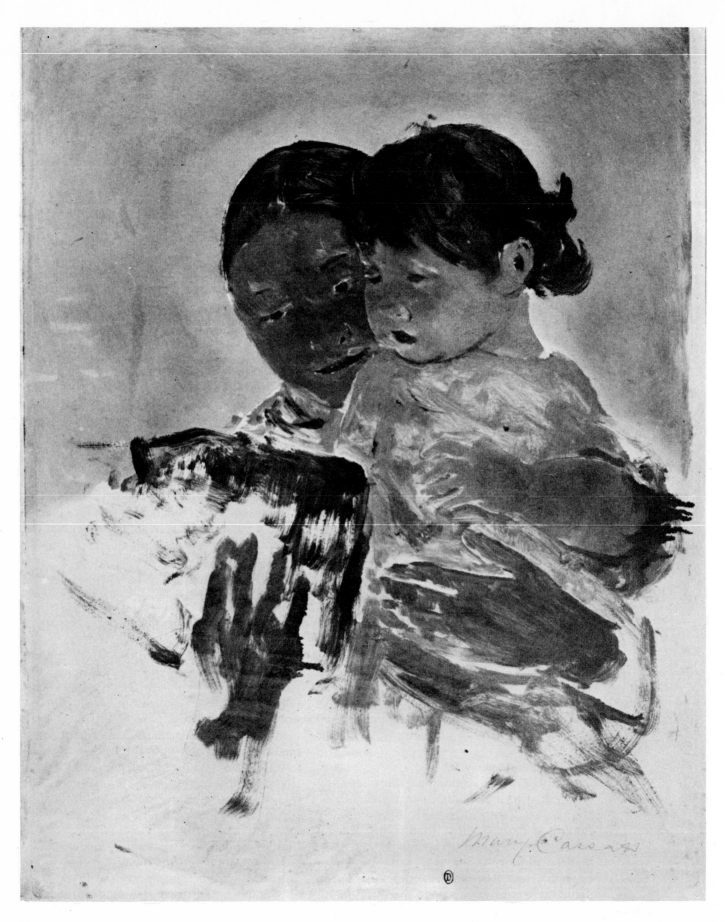

56
Mary Cassatt,
1845–1926, American.
The Album. Monoprint.
Bibliothèque d'Art et
d'Archéologie, Paris.

57
Henri Matisse,
1869–1954, French.
Torso with Arms Folded.
Monoprint, 1914. 7 × 5 in. Frank
Crowinshield Fund, Museum of
Modern Art, New York.

58
Jean Dubuffet,
b. 1901, French.
Rencontre. 'Assemblage
lithographique' using monoprint
techniques, 1958. 23 × 16 in.

59
A 'one off' impression of a fur coat
printed in relief by a student.

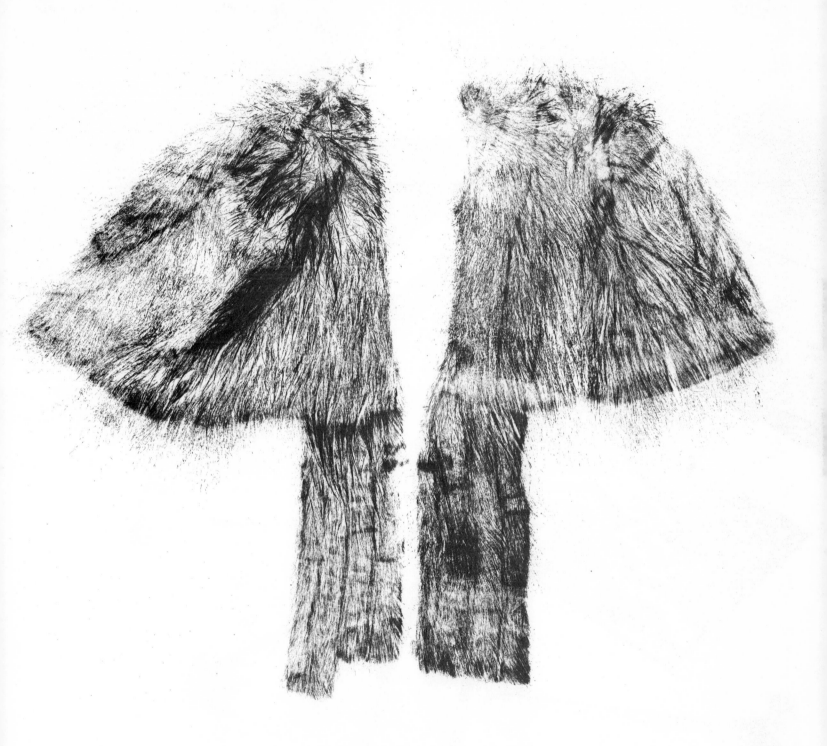

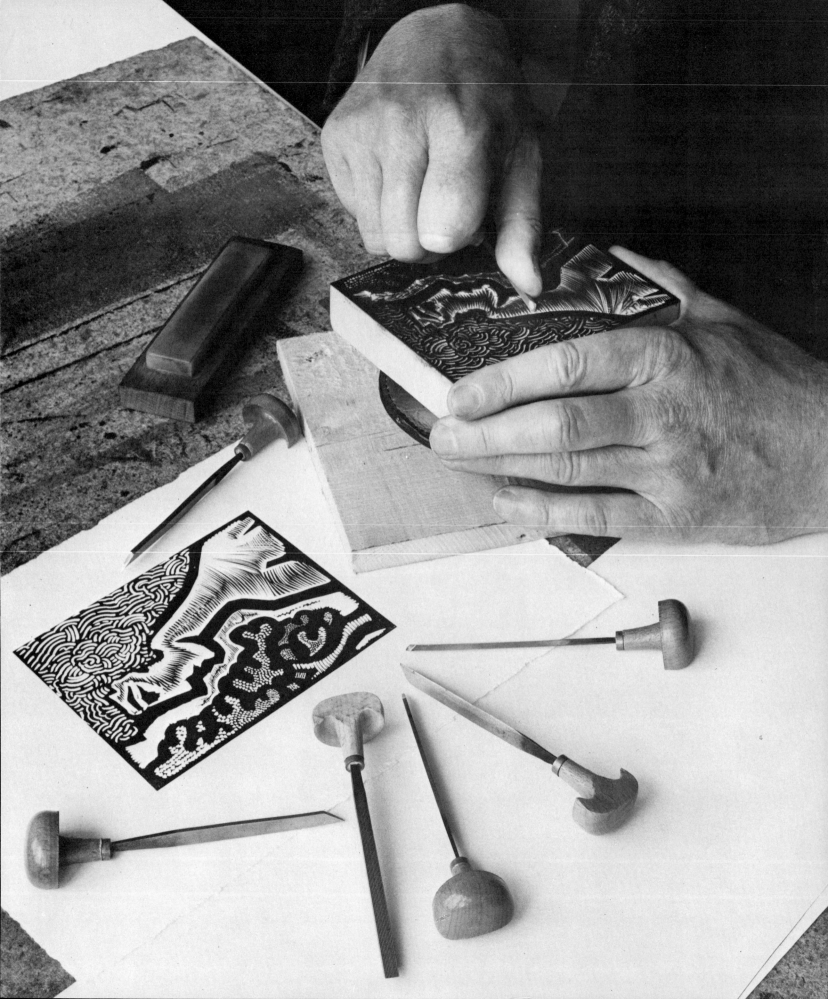

V

Relief Printing without a Press

'I want to go beyond virtuosity. I want to strip my work of "effects" until it stands monolithic, based on reality and yet transcending it. It must flow naturally from my materials, from the way of the chisel and the way of the block. This is very difficult but it is the only right way. It is the ultimate ideal.' Shiko Munakata, printmaker

The relief print, sometimes called the surface or block print, is an image taken from any surface that has been inked by a roller or brayer. It may be printed either in a press or by hand; in the latter case a wooden spoon can be used to rub or burnish the back of the print, as in Ill. 61.

In relief printing it is the uppermost surface of the block or plate that is of prime importance, since it receives the ink. The parts below the surface (that is, those that have been cut or gouged away) do not pick up ink and therefore do not print. (Since the unprinted areas are an integral part of the design, the gouged-out parts of the block might be said to 'print white', or whatever the colour of the printing paper.) Ill. 60 shows a wood engraver cutting away parts of his relief block.

The easiest way to experience relief printing is to ink your own hand and press it firmly on to a sheet of paper, so making a hand-print. The raised parts of the hand, to which the ink sticks, will print black; the concave and therefore uninked surfaces will leave no mark.

The three traditional ways of making relief prints are:

60
Hands of a wood engraver at work with tools, block upon sand bag, and print.

1. The woodcut (Ill. 3)
2. The wood engraving; Ill. 60 of a wood engraver shows both the tools and a print taken from a wood engraving in progress
3. The lino cut (Ill. 117)

The importance of the lino cut and woodcut lies in the energy, directness and authority that can be given to the cut image. Michael Rothenstein, the English relief printmaker, says in his book on this subject that the wood or lino cut 'suggests the character of permanence; a connection with the incised legend on the hard material of wall or monument'.

The texture of strongly pronounced wood grain has been exploited by many artists; the variety of organic textures that can be printed from it is inexhaustible. And relief prints can also be made with woodblocks that have been weathered or damaged, lengths of wood that have blistered paint on them, and charred wood that has nails driven into it.

On the other hand, a lino block, for example, can be cut so as to produce a simple, direct, untextured graphic image, as in the accomplished and disturbing prints of the Amsterdam artist Oey Tjeng Sit. His lino print *Counter Mirror* (Ill. 77) has a smooth, sharp and contrasted line, a quality typical of the lino cut. The Swiss-born artist Félix Vallotton can also be cited: he made 145 delightful and dramatic woodcuts in a straightforward, clear manner (Ill. 64).

Today relief prints include etched lino, prints made from found objects, and cardboard prints (Ill. 53), besides the more con-

ventional lino cut (Ill. 115), wood engravings such as Luther Roberts's illustrations to poems (Ills 78-80), and the strong, powerful woodcuts of Tadek Beutlich (Ill. 76).

Most objects can be printed in relief, as can be seen in Ill. 66, made from three everyday objects: a paper collar, part of a model railway line, and a gramophone record. Relief is possible with virtually any mateirla, traditional or modern, hard or soft, plastic or metal. By printing found objects the artist is continually presented with images that could not have been calculated or designed: the possibilities are endless, and I know of no artist who has fully explored this field (see the chapter on simple prints).

Much work has been done with the three-dimensional relief print, mainly by printing a flat sheet of paper with a motif that is designed to be cut out and folded or otherwise manipulated. Initial experiments could be made by constructing a box or cube.

Sensitive printing lends itself to diverse effects and when done by artists such as Munch, Gauguin (Ill. 5) and Kirchner (Ill. 74), often gives better results than professional printers can achieve. Gauguin, in order to produce tone in his prints, often filed down the woodblock surface.

Only a few artists seem to be investigating the possibilities of the photographic relief print. One method in use is to have photographic blocks made, which are then printed in letterpress. (Letterpress is surface printing of the kind usually concerned with commercial printing of half-tone blocks and type.) Printing plates have been made photographically by screening photographic images in varnish on to metal plates which are then etched and printed in relief.

The history of relief printing

The very first examples of relief printing are the hand-prints made by prehistoric men who painted their hands with pigment or colour and pressed them against cave walls.

The technique of cutting a woodblock had been discovered by the 6th century AD, as is apparent from surviving fragments of Coptic textiles, stamped with woodblocks.

Woodcuts were made in the 9th century (and probably earlier) by the Chinese, who were great innovators in this medium. Chinese influence was exerted upon Japan via Korea, leading to the development of the Japanese

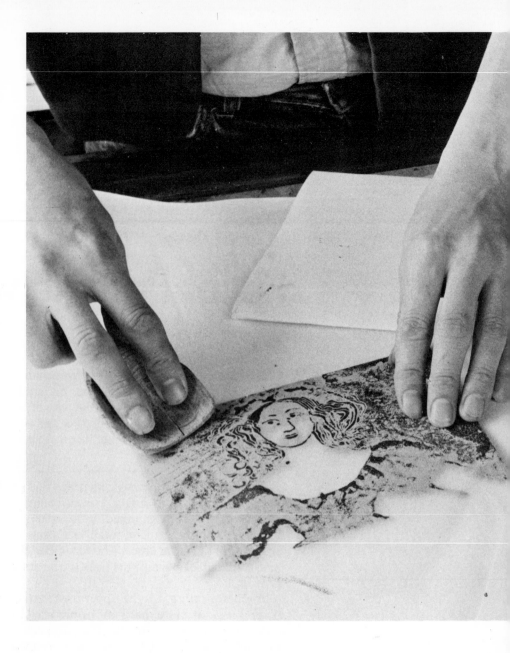

woodcut. The woodcuts of the Ukiyo-ye School, in which everyday life was depicted, are regarded as the glory of Japanese print-making.

Textiles printed from a wooden block, common in the Middle Ages, became traditional products and can still be found in certain parts of Europe. Religious images and playing cards printed from woodblocks were also popular in Europe about 1450.

When the manuscript book, illustrated with miniature paintings, was replaced by the printed book in the late 15th century, the woodcut came into its own. The new editions and translations of the Bible provided partic-

61
A small etched and cut lino block being burnished with a wooden spoon. The illustration shows a print in the right foreground.

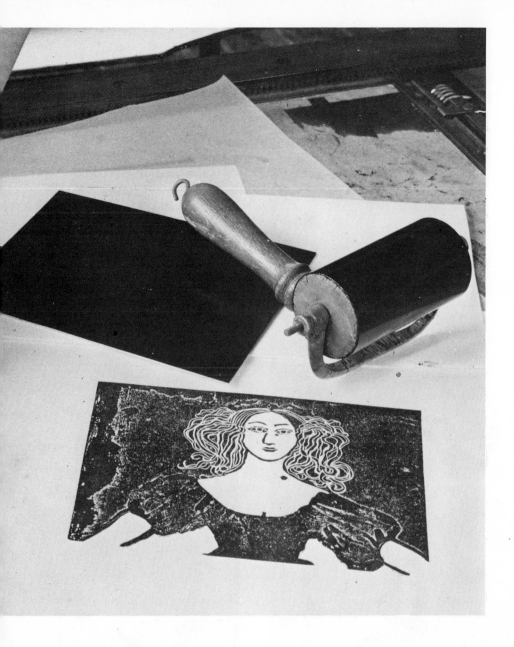

century. Chiaroscuro wood cutting, an imitation of a drawing on toned paper heightened with white, often after such artists as Raphael and Titian, became very popular. The discovery of intaglio in copperplate engraving led, however, to a decline in the use of the woodcut, although one notable artist, Hendrik Goltzius (1558-1617), continued to work in the medium.

Printing with wood was revived by the English artist Thomas Bewick (1753-1823), who perfected white line engraving on the end-grain of boxwood. His illustrations for *A General History of British Quadrupeds* (1790) and *A History of British Birds* (1797, 1840), part of which he himself wrote, had a great influence on the development of wood engraving. Also influential were the inventiveness and draughtsmanship of the engravings in the books of Jean Granville in France.

William Blake discovered a new form of relief print, made by drawing on the surface of a metal plate with acid resist and etching the metal away; Posada, the Mexican popular artist, used a similar method in his broadsheets. Blake also made magnificent small wood engravings to illustrate the *Eclogues* of Virgil, published by Dr Thornton in 1821.

The development of photography in the 19th century ended the production of prints as copies of paintings. On the other hand, the use of the woodcut for book illustration in its decorative and creative form was revived in England by Charles Ricketts and William Morris.

Modern times

Gauguin (1848-1903), painter, sculptor and potter, was also one of the great modern innovators in printmaking. His work was a constant search for ever more effective self-expression. The Norwegian Munch (Ill. 67) was probably influenced by Gauguin's work. After cutting the design, Munch often cut his block into pieces, as in a jigsaw, coloured them separately, put them together and printed them (Ill. 68). These two artists were the most important precursors of modern printmakers and their techniques.

The German Expressionists, and especially those of the *Die Brücke* group, such as Ernst Kirchner (Ill. 74), were strongly attracted to woodcutting. And it was in fact well suited to the Expressionist approach, being direct, intense, stark and almost crude.

62/*pages 80–81*
Utagawa Kunisada (signed Toyakuni), 1785–1864, Japanese. The various stages of making a colour print. Woodcut. Victoria and Albert Museum, London.

ularly good opportunities. The Cologne Bible, printed about 1479, influenced the woodcuts of Dürer and Holbein, and Lucas Cranach designed woodcuts for the first edition of Luther's Bible in 1522. Not only Bibles but many other books, secular and religious, included woodcuts, and the numbers of books and prints alike continued to grow. Strongly contrasted styles appeared–Dürer, master of the early woodcut and copper engraving, delighted in minutely detailed, sophisticated prints, while Hans Baldung produced strange yet vigorous work in the woodcut.

Woodcuts were very frequently made as reproductions of well-known works in the 16th

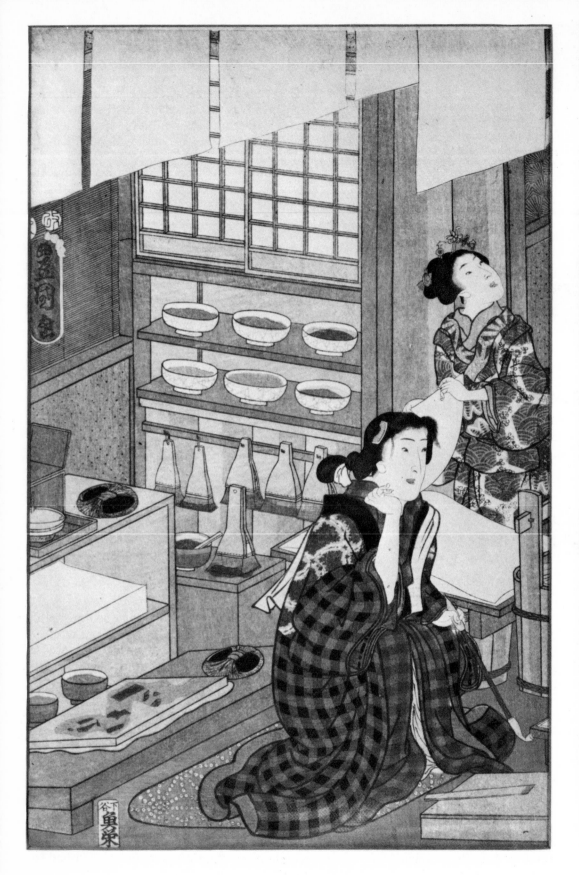

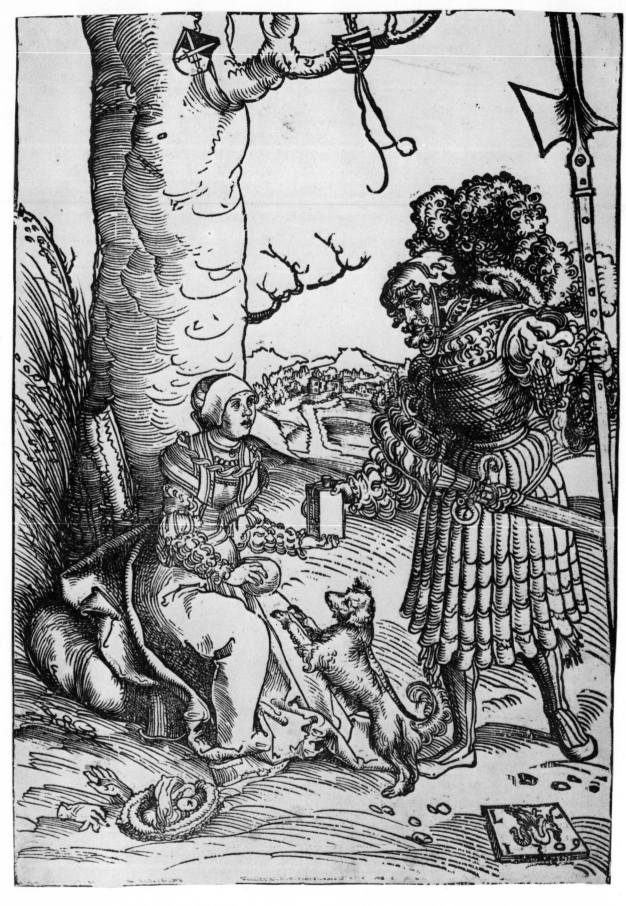

Other artists continued to use the traditional woodcut or lino cut methods, though in very different contexts. Ill. 29, a simple woodcut done in 1500, is not so very different in technique from the print by Félix Vallotton (Ill. 64). As we have seen, Oey Tjeng Sit uses a traditional technique to make his lino cuts. In recent times, a modern Japanese artist, Shiko Munakata, who started as an Impressionist painter, decided that this style was not 'Japanese' and has since concentrated on woodcuts of great power and originality which nevertheless convey a strong sense of continuity with tradition (Ill. 14).

Both Matisse and Picasso, masters of the 20th century, have used the medium of the lino cut to produce great art. This demonstrates yet again that a good artist can create in any medium. Picasso has done amazing work in printmaking in nearly all its aspects, and in particular has produced some of the most original and lively works that have ever been made with the colour lino cut (Ill. 75).

In recent years, an exciting development in relief printing has been the etching of lino (Ill. 61), which has been explored in England by Trevor Allen (Ill. 16) and Michael Rothenstein (Ill. 186), who has shown himself to be an impressive and dedicated artist. Something has already been said of the variety of other methods by which relief prints are made nowadays.

Materials
The simplest form of lino cut or woodcut can be made with these tools and materials:

1. A block of wood, possibly plank wood, or a piece of lino; the size will depend on the size of the print required
2. A Stanley knife and/or a Japanese cutting knife
3. Chisels
4. Gouges
5. A gelatine, rubber or plastic roller or brayer
6. Printing inks
7. Paper for printing on
8. Possibly a G-clamp to fasten the lino to the table, as in Ill. 117
9. White spirit or turpentine substitute
10. Pencils or brushes and ink
11. A wooden spoon or baren for burnishing
12. Rag for cleaning
13. A sheet of glass or marble, or a formica table top or old litho stone

Simple printing methods
Many artists prefer to work directly on to the block without any preliminary drawing. Detailed parts of the block can be cut out with a knife, or large areas with gouges or chisels. Do not hesitate to use any tools that might prove useful.

It is advisable to take an early proof on newsprint or inexpensive paper. This will show how the print is progressing. Examine the proof carefully and then continue cutting. When the block is finished, a final print may be taken, preferably on hand-made paper. This is done by rolling a thin film of ink over the block, placing the paper on top and carefully rubbing on the back of the print with a wooden spoon. Weights on the block and print will help to hold the paper in position (Ill. 44). The burnishing will force the paper into the cavities of the block; the softer the paper the more effective the process.

Sharpening wood engraving tools
Keeping tools sharp is very important. Use hard Arkansas stone and thin oil. To sharpen gravers, spitstickers and round scorpers (all pointed and round-nosed tools: see Ills 157-166), place the face of the tool absolutely flat on the oilstone and rub with a circular motion. If the end of the tool is not kept flat on the stone, the tool will be sharpened unevenly or blunted, and the angle at which it is ground will be destroyed. Square scorpers and multiple tools should be sharpened with an up and down motion.

Rollers
Use rollers that are either rubber composition, gelatine or plastic. Gelatine rollers are most sensitive but need more care in cleaning and storing. They must be cleaned carefully each time and dusted with white powder before being put away. If a screw eye is fixed in the handle, the roller can be hung upside down on a hook, which seems the best method of storing it.

Inks
Letterpress inks are best. Oil or varnish should be added to obtain perfect consistency when printing, so that a thin, smooth layer of ink can be rolled on to the block. It is usual in colour printing to let the ink of the first colour dry completely before the next colour is printed.

A hard skin tends to form over ink that has

63
Lucas Cranach,
1472–1553, German.
David and Abigail. Woodcut.
Harris Brisbane Dick Fund, 1926,
Metropolitan Museum of Art,
New York.

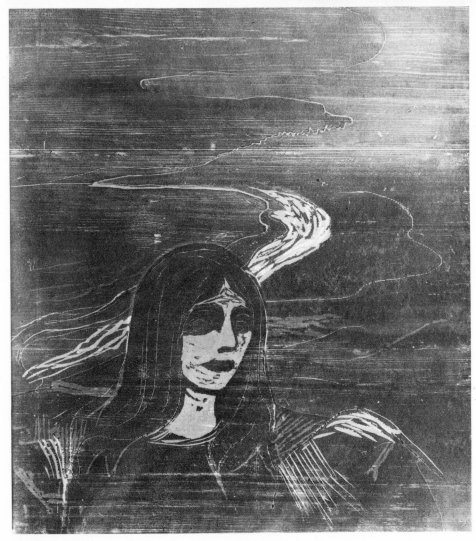

64/*above left*
Félix Edouard Vallotton,
1865–1925, Swiss/French School.
Necrophores. Woodcut.
Victoria and Albert Museum,
London.

65/*above*
Objects printed or about to be
printed in relief, including a wire
coat-hanger, torn button card and
record.

66/*right*
A relief print taken from found
objects, a record, a paper collar and
toy railway line.

67/*far left*
Edvard Munch,
1863–1944, Norwegian.
Girl's Head against the Shore.
Woodcut on green, red, yellow
and black. 1899.
Munch Museum, Oslo.

68/*left*
Block for the previous print, cut in
two pieces with jig-saw. Munch
Museum, Oslo.

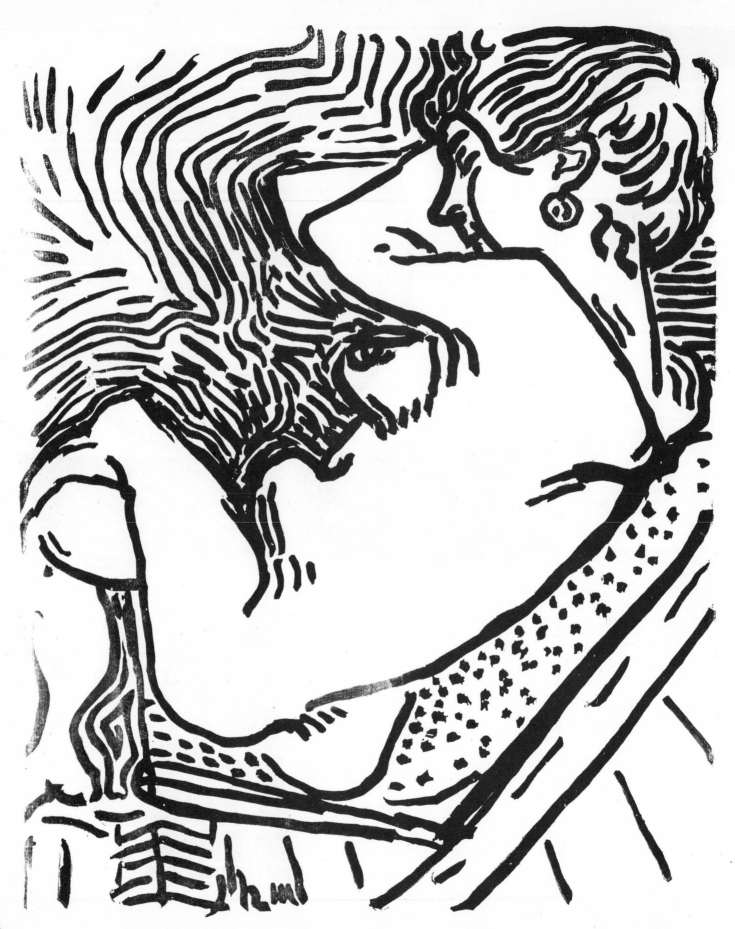

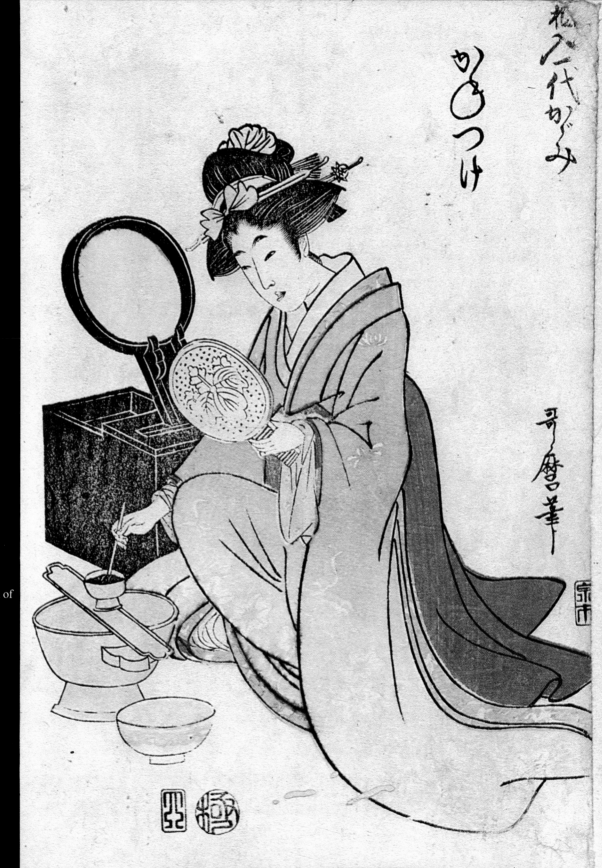

69
Henri Matisse,
1869–1954, French.
Nude Study. Lino cut, 1906.
18¾ × 15 in. Gift of Mr and
Mrs R. Kirk Askew Jr, Museum of
Modern Art, New York.

70
Kitagawa Utamaro,
1753–1806, Japanese.
Woman at her Toilet.
Victoria and Albert Museum,
London.

71/*page 88*
Carol Summers, American.
Fontelimon. Relief print.

72/*page 89*
Philip Sutton, British.
Heather Cook.
London Graphic Arts Inc.

Made by the same jig-saw
method that Munch used
(Ills 67, 68). The irregular
edges are caused by the wood
splintering while being cut,

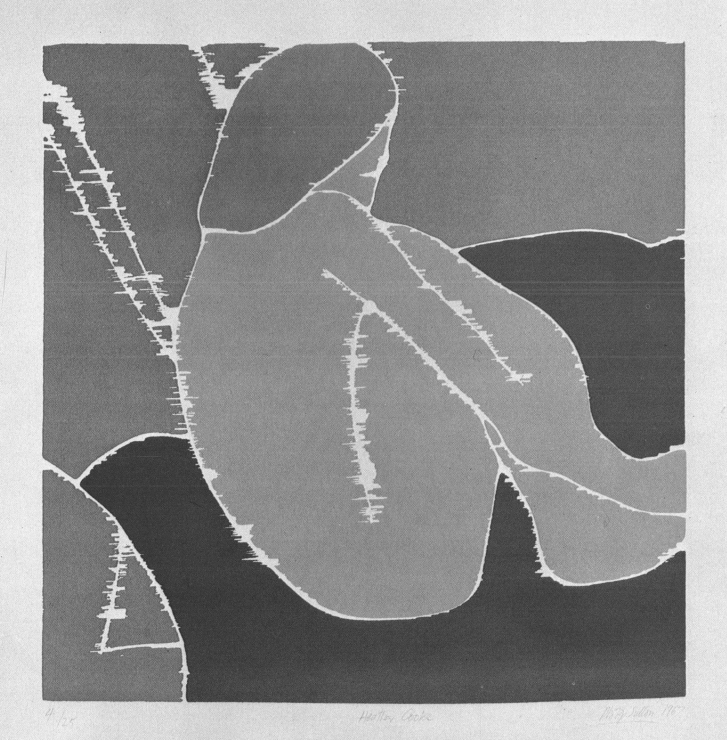

4/25 Heather Cooke [signature] 1967

been left for a long period, and this skin should be removed completely before the ink is rolled out. Always use a clean palette knife for each separate colour. Tubes of ink are useful but expensive. Water colour inks are quick-drying and clean but tend not to have the body or brightness of oil-bound inks. Hence although the Japanese printmakers used water colours to print with, the modern artist generally uses an oil-bound ink.

Ask the manufacturer for the most lightfast inks; others may fade or change quickly.

Cleaning

As always in printmaking operations, clean up immediately, use plenty of solvent and make sure that the rollers do not have any ink left on them.

Driers

I have never found that paste driers, if mixed in the ink in small quantities, affect its colour or consistency, while they do ensure a print will be ready to be worked on the next day.

A reducing or thinning agent can also be used. A shiny oil-bound ink usually has an unpleasant appearance, but a soft heavy paper will take up much of it, and at other times the shine can be utilised to obtain specific effects.

The paper

Unlike silkscreen printing, which can be done on most materials, relief printing is usually done with a softish absorbent paper. Many relief artists prefer Japanese hand-made papers; although the thinner sheets are liable to be fragile, they have a quality of their own. A soft, hand-made, hot press paper of about 140 lb is suitable. Filter paper is absorbent and prints well, but handles badly. The smooth side of any paper is usually the best for printing relief surfaces. Unsized papers from certain suppliers are called 'waterleaf'.

Registration

In Ill. 109 various metal pieces—crushed tins, metal flanges, tin lids—are being assembled on a sheet of paper for placing or registration. 'Stops' or pieces of shaped cardboard can be seen stuck down to mark the place on to which the paper will be fitted. When the prints of the smaller objects have been taken, they will be removed from the sheet of paper on which they are registered and the large piece of wood to one side will be inked and placed over the

area marked 'log'.

Blocks can usually be kept for as long as they are needed. Sometimes the printing capacity of the woodblock may be improved if it is left under a very thin film of dry ink, making it less absorbent.

Wood

The wood, possibly plank wood, can be of any type so long as it is not too hard to cut, or so soft that its cut edges break down during printing. The beginner at least should not attempt to use wood with knots or really uneven grain. The grain of the wood directs the cutting to a certain extent, and to begin with any plank wood will do.

Plywood is very suitable as a block for cutting, especially if it is of a reasonable thickness so that it does not warp. Particularly interesting is the characteristic slightly jagged grain that appears when it is cut.

Wood engraving, xylography

The traditional difference between the woodcut and the wood engraving is that the print made from cut and gouged plank wood is called a woodcut, and the end-grain print, which is smooth, delicate and smaller, is called an engraving. (The cutting processes should be compared in Ills 3 and 60.) Peterdi, however, defines the difference as follows: 'A wood engraving is any print wherein the majority of the work was done by gravers; therefore, such a print has a predominantly linear conception, while any work done with knives and gouges, and conceived in broad, openly cut areas, I shall call a woodcut.'

Boxwood (which is expensive), cherry and maple are all good engraving woods, and these are bought ready made and type high.

Colour woodcuts

In relief prints each colour is usually printed from a separate block. The Japanese used a key block for this, but it is possible to take a tracing on to the first block, which could be cut, and then a print from it printed on to the next block, which would then be cut, and the operation repeated. These blocks can then be proofed or tried out until the artist is satisfied, and then the editioning can start. This is the method used by Trevor Allen (Ill. 16).

Lino

Lino, scored with a Stanley knife, can be

73
Artist painting on lino with candle wax, which will act as a resist to caustic. White powder has been mixed to enable the drawing to be seen clearly.

cut into any manageable size if bought in bulk. It has no grain and can be cut in any direction. Heat will soften it, making it more malleable.

A ballpen, pencil or brush with ink or paint can be used to draw the design on to lino (Ill. 73). Some artists put carbon paper under a tracing of the design, place the two on the block, and go over the design again with a stylus or ballpen, pressing it on to the lino in carbon. If the tracing paper carries a design that you want to print as drawn, not in reverse, turn over the tracing paper and transfer your drawing on to the block in reverse; thus it will appear the right way round when printed.

Etched lino
A grained and tonal effect, rather like a half tone or aquatint, is achieved by the simple method of etching lino.

After cleaning the lino with a fine wire brush to get rid of grease, paint the design upon it with a resist. The most efficient seems to be melted candlewax, which will stay liquid with only a small amount of heat, in a large metal ladle or saucepan. For the painting (Ill. 73) an ordinary soft paintbrush will do. Extremely detailed work can be done with this method, as can be seen in the sharp, complex design of John Urban's block (Ill. 118).

Apply a strong mixture of caustic soda flakes and water with a plastic brush directly on to the lino. If it is left overnight a deep bite will be made in the ungreased areas. Then hot water and concentrated scrubbing will remove the resist, the soda and the residue of lino, leaving the block ready for printing. It is also possible to apply the caustic solution directly on to the lino.

Metal: zinc etching
Any metal plate bitten or etched or dented in any way can be printed as a relief (see the chapter on etching and engraving). After many years of woodcutting, the Mexican Posada devised a way of painting on zinc with a resist. When the surrounding surface is etched away and a print is made in relief, as a woodcut is printed, it becomes very difficult to tell whether wood or metal has been used.

Posada's method is similar to one employed by William Blake. A book by a contemporary, John Thomas Smith, states that Blake made plates 'by writing his poetry, and drawing his marginal subjects of embellishments in outline upon the copper plate with an im-

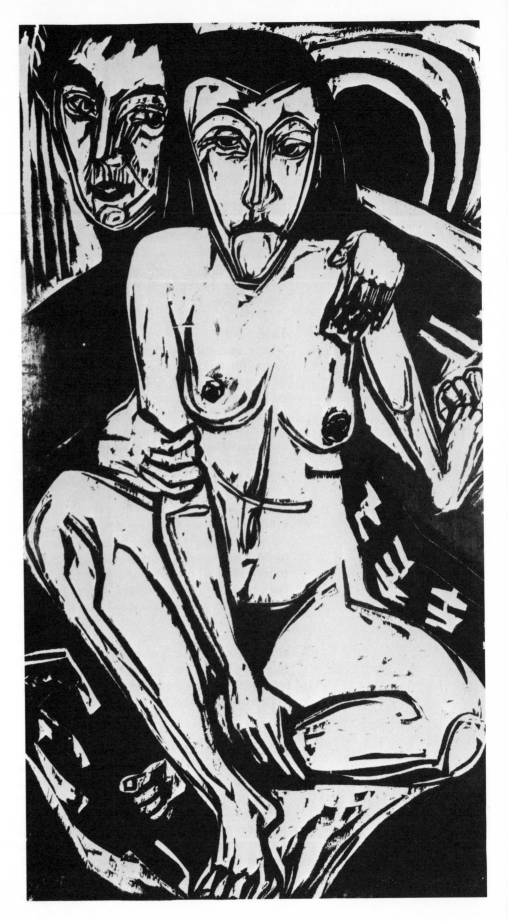

74
Ernst Ludwig Kirchner,
1880–1938, German.
Self-Portrait with Wife.
Colour woodcut.
Victoria and Albert Museum,
London.

75
Pablo Picasso,
b. 1881, Spanish.
La Dame à la Collerette.
Colour lino cut, 1963.
London Graphic Arts Inc.

76
Tadek Beutlich,
b. 1922, British.
Girl with Insect. Colour woodcut.

77
Oey Tjeng Sit,
b. 1917, Indonesia/Dutch School.
Counter Mirror. Lino cut, 1968.
Collection H. and J. Daniels.

pervious liquid, and then eating the plain parts or lights away with aquafortis considerably below them, so that the cut lines were left as stereotype. The plates in this state were then printed in any tint that he wished, to enable him or Mrs Blake to colour the marginal figures in imitation of drawings.'

Zinc etching can be done as follows. A design is painted on to cleaned and polished zinc with varnish resist. The plate is then immersed in a bath of diluted nitric acid and the non-varnished parts are etched away. It may be necessary to revarnish the edges at times as nitric acid has a tendency to undercut. It is possible to put an aquatint similar in appearance to half tone on to a plate which is etched with a view to printing in relief.

The name given to this method is 'zincography' (a name that has also been applied to lithographs made from zinc plates).

Hardboard

Cuts made in hardboard are generally rather difficult to control because the material is rather thin. But of course it is quite possible to cut a design right through the hardboard, creating a free form shape that can be mounted

(for firmness, and to register it) on to another sheet of hardboard. The cutting in this case could be done with a jigsaw or a fretsaw as well as with the traditional cutting tools.

Printing large prints

The American Leonard Baskin has made some very large prints, including some extremely detailed work; reproduced here the British artist Edward Bawden has done the same in England.

One way to produce such large prints is to place a thick layer of newspaper on the floor, lay the printing paper face up on the newspaper, and put the block face down on to the paper. Stand on the block, so that the weight of the body acts as a press. Not everybody uses this method: I have seen an eight foot print made from wood burnished by hand.

The elimination method

The elimination method is only one of many ways of making colour prints, but it does have the advantage that the same block is used for the whole process. The lino block is first printed uncut on, say, twenty sheets of paper. The first cuts are made and the blocks are cleaned and then printed in a different colour on top of the first colour on the sheets of paper already used. More cuts are added, a new colour printed, and so on until the print is finished. Picasso has produced magnificent prints using this technique.

The cardboard print

In cardboard relief printing (Ills 53, 116), a sheet of cardboard, perhaps an eighth of an inch thick, is cut up according to a predetermined design, usually in large pieces reminiscent of a child's jigsaw. Each piece is then inked in a given colour and printed on to a sheet of paper by rubbing or by using a press (see the chapter 'Relief Printing with a Press').

Plastics

Various plastics such as perspex and celluloid can be used to print from. The tools that one can carve with may be flexible drive toolmakers' drills or the standard power drills on to which a number of heads can be fitted. Picasso has made drypoints on celluloid which could have been printed in relief. And of course it is possible to soften and mould plastics before printing from them.

Picasso has experimented widely and with

great ingenuity with reliefs, producing much fresh new work that bears the stamp of his forceful and vital personality. However, it is the inherent qualities of the medium that have made such achievements possible and have compelled us to re-examine the relief print.

78
Luther Roberts,
b. 1923, British.
The Grandmother. Wood
engraving, 1966.
An illustration to a poem.

79
Luther Roberts,
b. 1923, British.
Nude. Wood engraving, 1966.
An illustration to a poem.

80
Luther Roberts,
b. 1923, British. *Parting*.
Wood engraving, 1966.
An illustration to a poem.

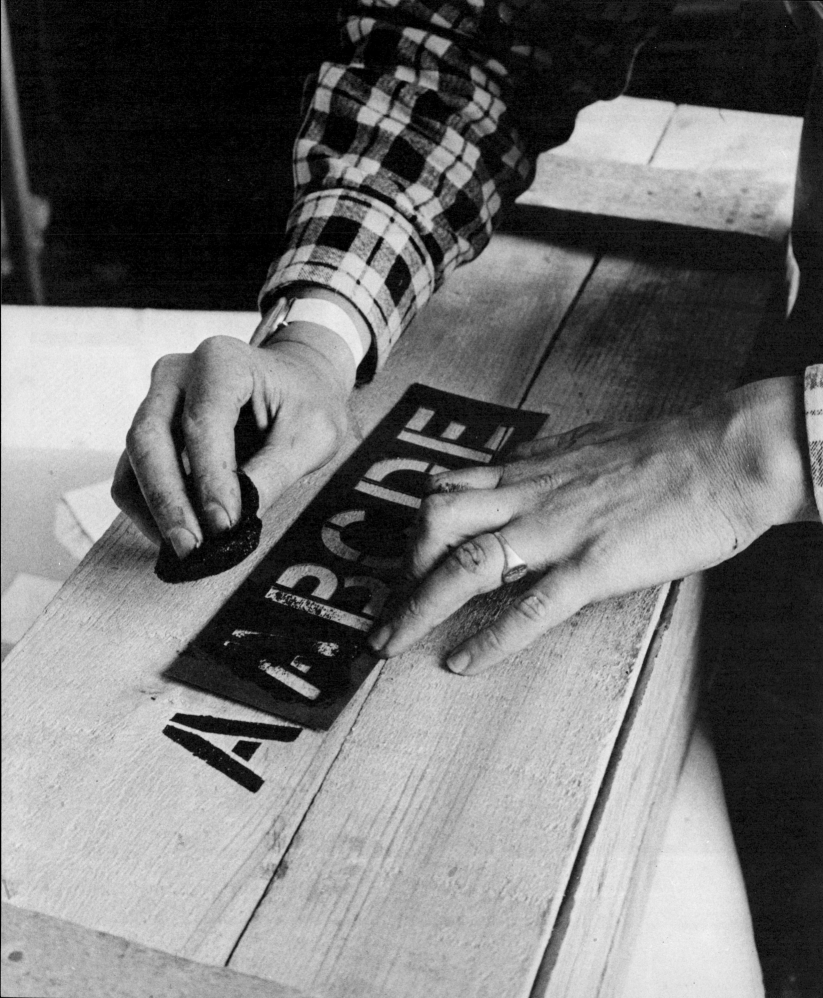

VI
Serigraphy

'The instruction shows the way and the method. The vision is the work of one who has wished to see.' Japanese proverb

The silkscreen or serigraph has developed from the simple stencil (Ill. 81). Essentially it is made by stretching silk mesh over a wooden frame, blocking out chosen areas by various methods, and making a print by forcing ink through the unblocked areas (Ills 87, 88). The use of the term 'serigraphy' for artists' silkscreen prints originated in 1930 with Carl Zigrosser (see the Bibliography).

Serigraphs are easily printed without much expense and with a minimum of equipment, as a press is not needed. Direct results are achieved simply and quickly, and this form of printing is probably faster than any other hand process. And as well as being simple to practise, serigraphy has the advantage of versatility. An artist can create works which are autographic, using the directly made brush stroke in much the same way as he does to create a brush drawing or painting. He draws directly on to the screen, which can then be printed. A magnified detail of a screen print (Ill. 89) displays the rather rough quality of work done by hand and also the texture of the screen, in this case made of organdie, which is often a feature of the serigraph.

It is also possible to work in serigraphy with hard edges and completely geometric shapes, as Victor Vasarely, the distinguished Hungarian artist working in Paris, did in his colour print called *Planetarische Folklore/No. 3* (Ill. 97), in which many graduations of colour produce a rich optical effect within a subtle and complex design.

Many contemporary artists are developing fresh ideas about colour with serigraphy. In *Flasher* (Ill. 98), by the British artist Brian Rice, a very simple semi-geometric design, with large areas of flat simple colour, appears to great advantage.

Great variations in consistency are obtainable with silkscreen inks. Colours can be printed opaque (in order to blot out everything underneath) or thinned until they become transparent. Serigraphy must be the only printmaking medium in which one can print white on black and still obtain a white that is pure white. The British artist Dennis Hawkins uses the overprint (see the chapter on lithography), as for example in *Ikon-Inside-Outside* (Ill. 105). He uses large areas of colour, and by printing his own serigraphs is able to exploit the brightness and richness obtainable through the silkscreen process.

Metallic inks such as gold and silver can be printed easily in serigraphy, and it is probably the best medium for producing luminous and fluorescent colours, especially in large areas. Both matt and gloss colours are easy to use and can be combined in the same print. I have even seen a gloss black printed on a matt black very successfully.

Some serigraphers do not print their own work; instead they design the print, employ a craftsman to do the printing, and then sign and approve the finished work. Many other artists of course prefer to do all the work of making a print for themselves.

81
Packing case being stencilled with the letter A.

The history of stencil and silkscreen

The first examples of the stencil, like the first relief prints, were made by prehistoric man. He would place his hand on to the wall of the cave and blow colour or ground pigment on and around the hand, possibly on to grease. When the hand was taken away, a 'negative' of its shape remained. These stencilled hand-prints can still be seen in caves in France and Spain. The Abbé Breuil's book *Four Hundred Centuries of Cave Art* covers the subject fully.

The Romans in the 1st century evidently had lettering stencils, in the form of perforated tablets which they used to teach children how to form letters. In China and Japan, stencilling was used in the 4th and 6th centuries for decorations and designs on fabrics. And Francis

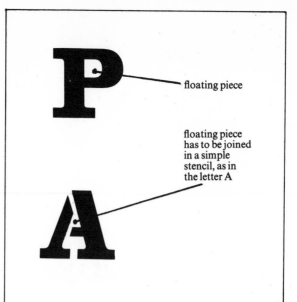

floating piece

floating piece has to be joined in a simple stencil, as in the letter A

82/*left*
Stencil with floating pieces.

83/*right*
Frame and silk.

84/*far right*
Halving joints.

85/*below left*
Masking shellac: ink reservoir.

86/*below right*
Hinged frame. The hinge is so arranged that there is a small space between the screen and the baseboard. This makes the screen lift off the print after the squeegee has passed–an action known as 'snap-off' –thus preventing mesh marks.

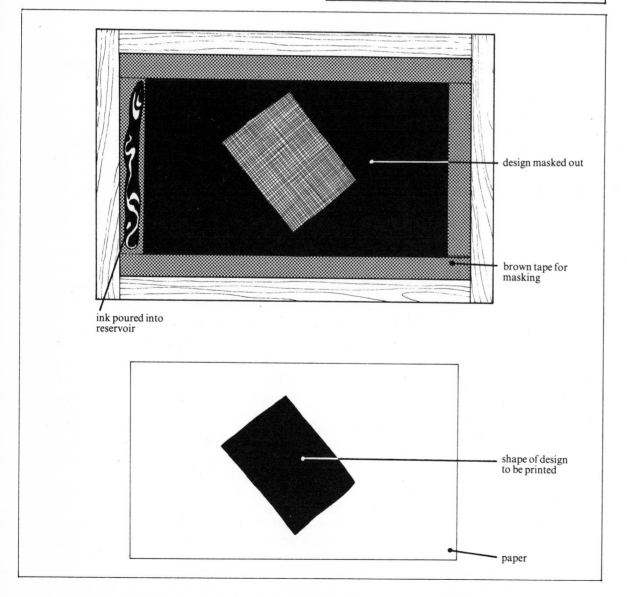

design masked out

brown tape for masking

ink poured into reservoir

shape of design to be printed

paper

staples

card for paper registration marks

baseboard

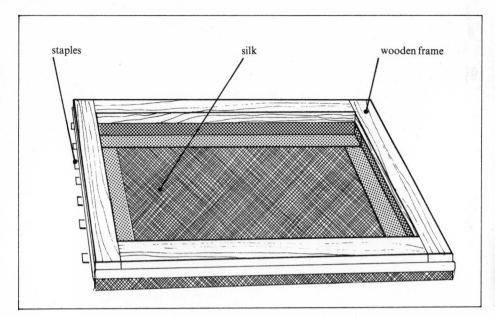

staples silk wooden frame

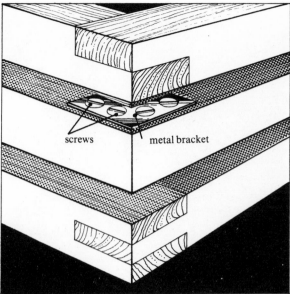

screws metal bracket

hinges

99

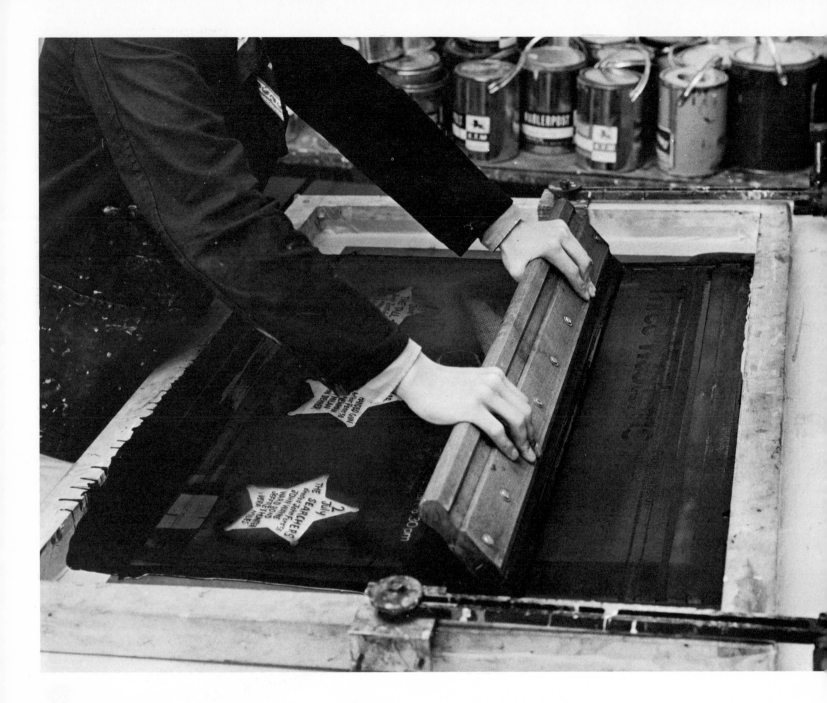

Carr's *Guide to Screen Process Printing* shows the stencilled signature of Charlemagne, which dates from the 8th century.

The stencil has been used to decorate and colour designs and woodcuts since that time – for example, to colour the playing cards and woodcuts of the 14th and 15th centuries. In the Gutenberg Bible, decorative colour was added to initial letters by stencil. In the 15th century stencils were used decoratively on walls in England and in France; and the first stencilled wallpapers were made in 16th-century Holland. In 19th-century England William Morris designed some magnificent stencilled wallpaper. (A stencil technique is still used in the theatre for transferring a wallpaper pattern on to 'flats' and backcloths.) Stencilling became a common way of decorating interiors and even furniture in the early 19th century; the Brooklyn Museum has a stencilled slipper dating from 1800–20 (Ill. 15).

The vital change from the simple stencil to the stretched silkscreen was developed by the Japanese in the 17th century. The discovery is credited to a dyer, Some-Ya-Yu-Zen, whose prints can be seen in the British Museum.

87
A poster being printed in silkscreen. The photograph shows the correct angle and position to hold the squeegee.

88
The poster printed and the screen lifted.

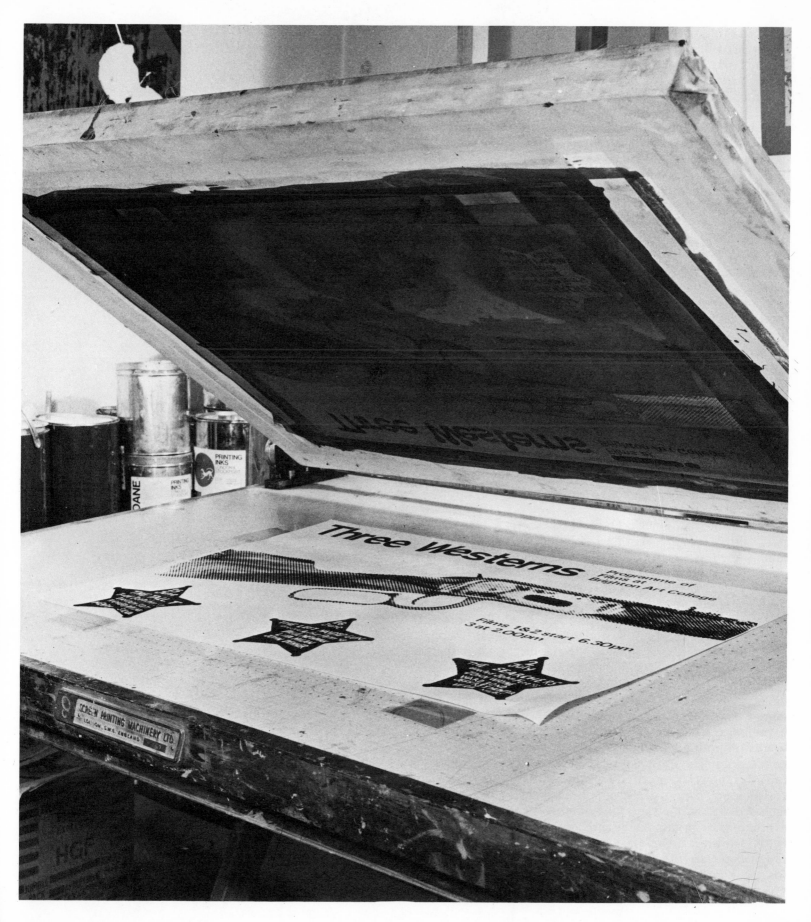

When printing stencils of unusual complexity, he used human hair to hold in place the 'floating' parts of the design that were not attached to any other part; the small triangle in the letter 'A' is just such a floating piece (Ill. 81). Thus it became possible to make much more intricate prints with a stencil.

Once the hairs holding the floating pieces had been connected to a frame for support, the idea of using a porous material, silk, stretched on a frame, soon followed. A diagram (Ill. 83) shows the silk and the frame. The silk most often used is bolting cloth, the traditional material of the miller's sieve. This is stretched round a wooden frame. The stencil is attached to this screen, blocking out chosen areas, and the ink is then forced through the silk mesh on to the material to be printed upon. It is from this that the modern silkscreen has evolved.

Modern times

Even in the early decades of the 20th century, however, silkscreen did not become established as an important printmaking medium for *artists* in the same way as etching and lithography had. The only exceptions were in the United States – such artists as Anthony Volonis, who has worked on projects concerned with serigraphy since 1932, and Sylvia Wald, another pioneer printmaker, who exploited accidental effects.

The reason for this neglect is that in the early part of the century silkscreen printing was mainly used as a commercial form of reproduction for showcards, posters and notices, which were often printed in a crude and slapdash manner with inks which were too thick and vulgar colours with bad registration. This tended to deter artists from using silkscreen, and even today when commercial reproduction in silkscreen has become as good, if not better, than most other forms of printing, an eminent printmaker such as Peterdi, the American painter and etcher, admits to having a prejudice against silkscreen prints. Many books on printmaking refer to the technique condescendingly or leave it out completely.

Today, however, more and more artists are realising its potential. Serigraphs are now included in most important international exhibitions of printmaking, and some of the better known contemporary artists are using the medium, having discovered its suitability for the kind of image they want to create; examples are Eduardo Paolozzi and Joe

Tilson in England, and Andy Warhol and Jim Dine in America. Paolozzi's *Assembling Reminders* (Ill. 102) shows how much complexity and detail can be rendered in silkscreen. In *Ziggurat* (Ill. 103), Joe Tilson has combined a linear drawing with solid areas of colour. The Andy Warhol print called *Flowers* (Ill. 104) is screened directly on to a canvas. Jim Dine has used repeatable collage–cut-out magazine illustrations glued on to the print–as part of the final work (Ill. 107).

Materials

Art has been produced with quite ordinary materials. Given many of the simple items listed below, it is possible to make a serigraphic print.

1. A printing frame or a length of 2 × 2 inch wood (Ill. 86)
2. A squeegee, or materials to make one (Ill. 93)
3. A baseboard: an old table will do, or a piece of chipboard or blockboard. This should be larger than the screen size, and has to be flat and smooth, with no tendency to warp (Ill. 90)
4. Two metal hinges and screws (Ill. 91)
5. A length of bolting cloth or nylon
6. Printing inks
7. Paper or card for printing on; this should be slightly absorbent
8. A staplegun or trigger tacker (Ill. 92)
9. White spirit
10. Scissors
11. Gum strip
12. Knives
13. Brushes
14. Litho ink (tusche)
15. A sponge
16. Sellotape
17. Water
18. Newspapers
19. Gouache paint
20. Rag for cleaning

The frame

An important item is the frame, usually made of wood, though some commercial printers favour metal. 2 × 2 inch seasoned wood should be used, jointed together at the corners. It must not warp but must remain rigid (Ill. 86).

For a first attempt at making a serigraph I would recommend a frame of modest size, perhaps 22 × 30 inches for the complete

89
The texture that can be gained from a design on an organdie silkscreen; magnified.

frame. The design itself will be smaller than the area within the frame; the area between the design and the frame is masked out and becomes a well or reservoir for the ink. Smaller prints can be made by masking out (Ill. 85).

The baseboard

This is the flat surface to which the frame is hinged. The printing paper is laid upon it and will eventually be covered by the screen. The base must be of a material that does not warp, and blockboard or chipboard are recommended. It must be larger than the frame, and the frame will be hinged to it so that it can be lifted up from one side (Ill. 86). It should be easy to undo the hinges by taking out the pins, as this helps with both the making of the stencil and the cleaning (Ill. 91).

The silk or mesh

The three main types of material used in serigraphy are organdie, bolting silk and nylon. Nylon is the most expensive and lasts, with care, for a considerable length of time;

it can be cleaned again and again after printing and then re-used. Bolting silk can also be used many times, and is cheaper than nylon. Organdie is used mainly for its cheapness, and although it will do for the beginner, it is rather coarse and does not wear too well; it is therefore really an economy to start with bolting silk or nylon, which give a sharper image and do not sag. Both silk and nylon come in various weaves or gauges, so that it is possible to choose the weave most suitable for the work in hand. It is worth remembering that too small a gauge becomes difficult to print, as the ink clogs up the weave; while too coarse a weave could cause loss of definition. Gauges vary, but any reputable firm of screen suppliers will be pleased to recommend material of average gauge, and will also give technical information about inks and so on.

Stretching or tacking the silk

When the silk has been bought, it must be stretched over the wooden frame. The piece of silk used should overlap the frame by about

90
Stretching sequence.

91
Hinges.

92
Staple gun.

93
Squeegee.

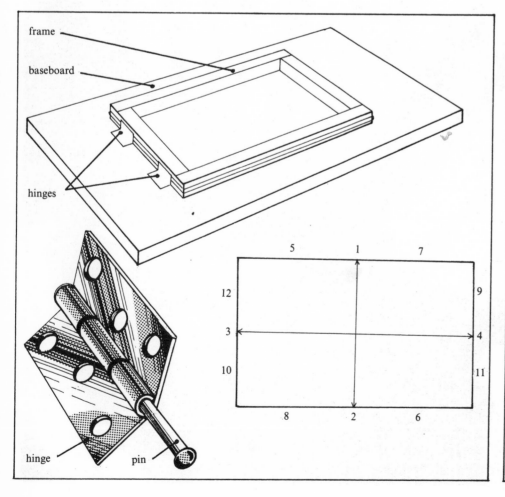

four inches on each side, and the edges should be folded to give a double thickness (Ill. 83). The silk must be drawn tight, with all the threads of the warp and the weft running straight and parallel, with no ripples or creases. The best method of fixing the silk on to the frame is with a staple gun or trigger tacker, which will fire the staples directly into the wood. The diagram (Ill. 90) shows the best order in which to do it. Start stapling at the centre of the top edge of the screen, go on to the centre of the bottom edge, and then staple the centre of the left and right edges, gradually working outwards from each point in strict sequence. Tack along the edges by stapling at intervals of a few inches at first. As you gradually make the screen tighter, fix the staples closer together so that there is only a half-inch gap between any two. If a canvas stretcher or pliers are used, it is a good idea to glue two thin pieces of card to the gripping part of the tool so that it is less likely to tear the silk.

If thin strips of card are placed on top of the silk before stapling through to the frame, it will be very much easier to remove the staples. This also reduces the risk of damage to the silk.

Finally, when the silk is stretched and the corners are folded so that the screen is taut, a strip of card can be inserted between the silk and the frame, thus raising the level of the screen and further increasing the surface tension. The silk can then be damped with a sponge; when it has dried, any creases or slack still in the material will have disappeared.

The squeegee
Next, one needs a squeegee with which to force the ink through the mesh of the silk. This usually consists of a strip of heavy rubber, called the blade, which is fitted, screwed or glued into a wooden handle (Ills 93, 96).

Today many artists and printers favour a polyurethene blade, which is harder-wearing than rubber and rarely needs sharpening; for to keep the printed image sharp, one must keep the blade sharp. (This can be done by

94
A method of silkscreen registration.

95
Stacking prints at home.

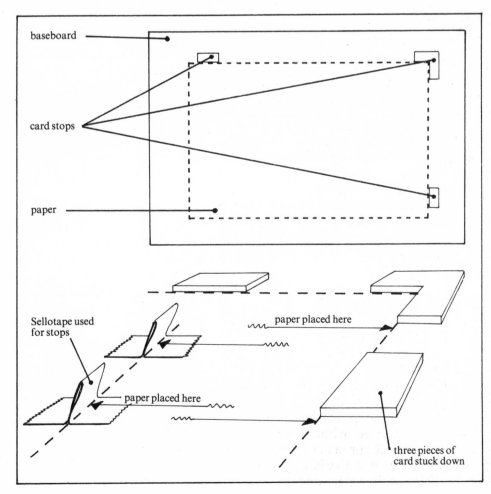

baseboard

card stops

paper

Sellotape used for stops

paper placed here

paper placed here

three pieces of card stuck down

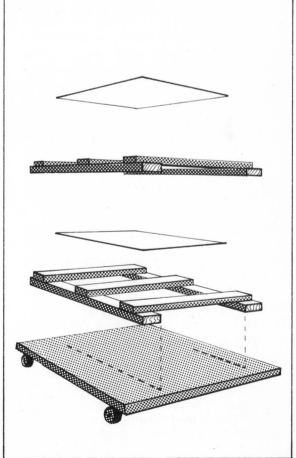

rubbing the blade along a piece of sandpaper that is attached to a flat surface.) The polyurethene or rubber should project about one and a half inches below the handle, but ready-made-up squeegees can be purchased that are sold in units of an inch. The length of the blade should be about five inches less than the inside measurement of the frame. The blade must be level, smooth and sharp.

Sealing

The screen must be masked around the edges, and the most suitable material for this is gum strip or tape, available in many widths, which will seal the mesh so that the ink does not seep underneath the frame. Gum strip is also used to mark out the printing area so that there is plenty of margin all round the frame (Ill. 85).

The main advantages of gum strip (brown paper tape) are that it comes away easily with warm water and is quicker and cheaper to use than many screen fillers. The four-inch width is the most useful.

Registration

Methods of registration vary, and the conscientious printmaker will doubtless himself devise appropriate and personally satisfactory methods. The simplest form of registration is done by sticking small stops (pieces of thin cardboard, 1×1 inch) in three key positions on the baseboard under the printing frame (Ill. 94). Each time a print is to be taken, the sheet of paper is fitted against these stops, so that the image will fall in the same place on each sheet of paper.

To register a second colour, print it on to a transparent sheet of acetate which has been taped on to the baseboard, carefully place the paper with the first colour in the required position under the transparent sheet, mark the place by attaching stops to the base, and then remove the transparent sheet. An accurate second printing can now be carried out.

Making a stencil: torn or cut paper

The simplest stencil is made with thin torn or cut paper, such as newsprint or dressmakers' pattern paper. Cut with a knife or scissors, or tear away parts of the paper to make a design. The holes made in the paper will be the shape of the image to be printed, and must of course not exceed the size of the unmasked area of the screen. Turn the screen upside down and lightly fix the paper stencil to it with very small pieces of gum strip, just at the corners, taking care that the stencil is lying *absolutely* flat on the screen; after the first print has been taken the stencil will stick to the silk because of the adhesive quality of the printing ink on the screen.

To take the first print, having previously ensured that the ink is loose but not too runny (white spirit mixed with the ink will thin it), pour some in a line into the reservoir at the top of the frame (Ill. 85). Hold the squeegee with both hands at an angle of forty-five degrees and, having positioned the paper under the screen, draw the ink across the screen towards your body, maintaining a steady, even pressure on the squeegee. Each different colour printed necessitates a new stencil. A yellow screen can be printed over blue to give green (see the chapter on lithography). It is often best to take as many prints of one colour as are needed before changing the stencil and using another colour. One of the first set of prints can aid in the positioning of the second colour.

Simple stencils

A simple way of blocking the screen is to use a candle or beeswax. The screen is placed on a smooth bench with the silk touching the bench top. A candle is used to draw the design; the wax blocks the mesh, making it impossible for the ink to print in those areas. To remove it, use methylated spirits, or a hot iron pressed on top of the mesh on to brown paper. The surface of the wax has a rough, interesting texture. A similar method is explained later.

Shellac knotting is available at most hardware stores. It can be painted on with a brush to produce an excellent intricate design, but it is impossible to remove from the silk, which must be replaced before a new print can be made.

Gouache or poster colour paint

One of the most direct methods of making a stencil, if oil-bound printing inks are being used, is to block out with gouache or poster paint applied directly on to the screen with a brush. This will give a very free and autographic mark (though it is of course the unmarked areas that print). When dry, the screen can be printed without any further preparation. After the print has been made, the ink can be washed out with white spirit and the gouache paint with water, and the process

96
A corner of a silkscreen studio. On the left is a stacking rack, in the foreground a screen with a squeegee resting on it.

97/*page 108*
Victor Vasarely. Hungarian/School of Paris. *Planetarische/Folklore/No. 3.* Galerie der Spiegel, Cologne.

98/*page 109*
Brian Rice,
b. 1938, British. *Flasher.*
Colour serigraph. 1967.
London Graphic Arts Inc.

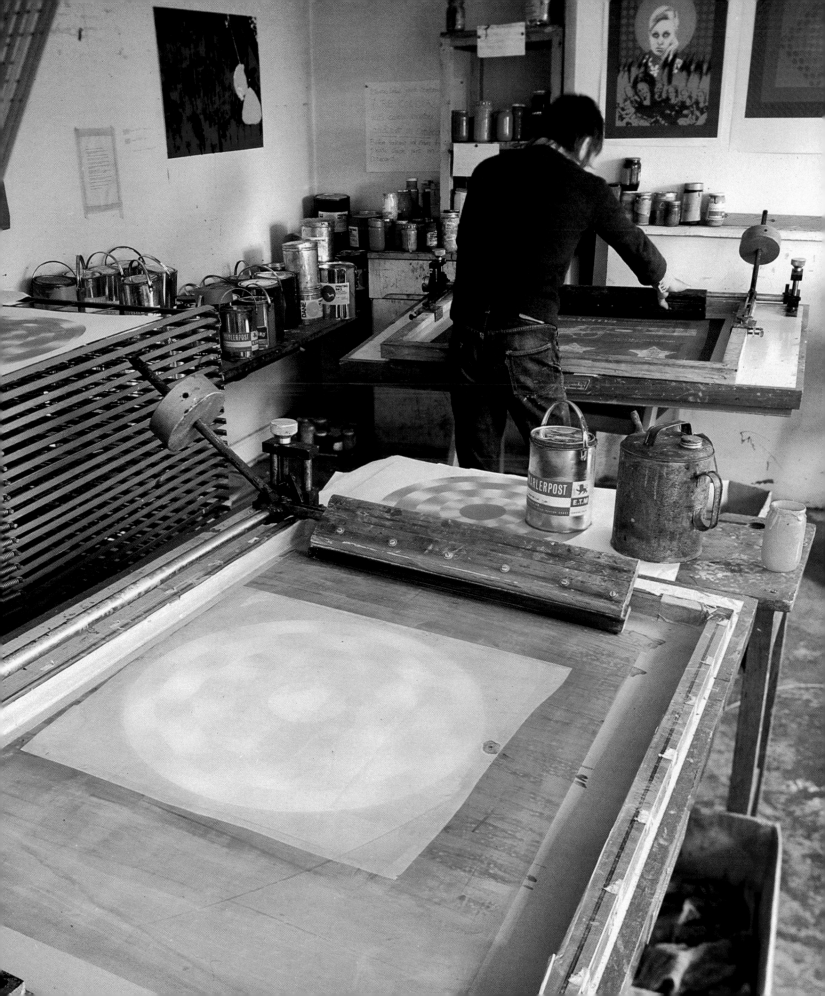

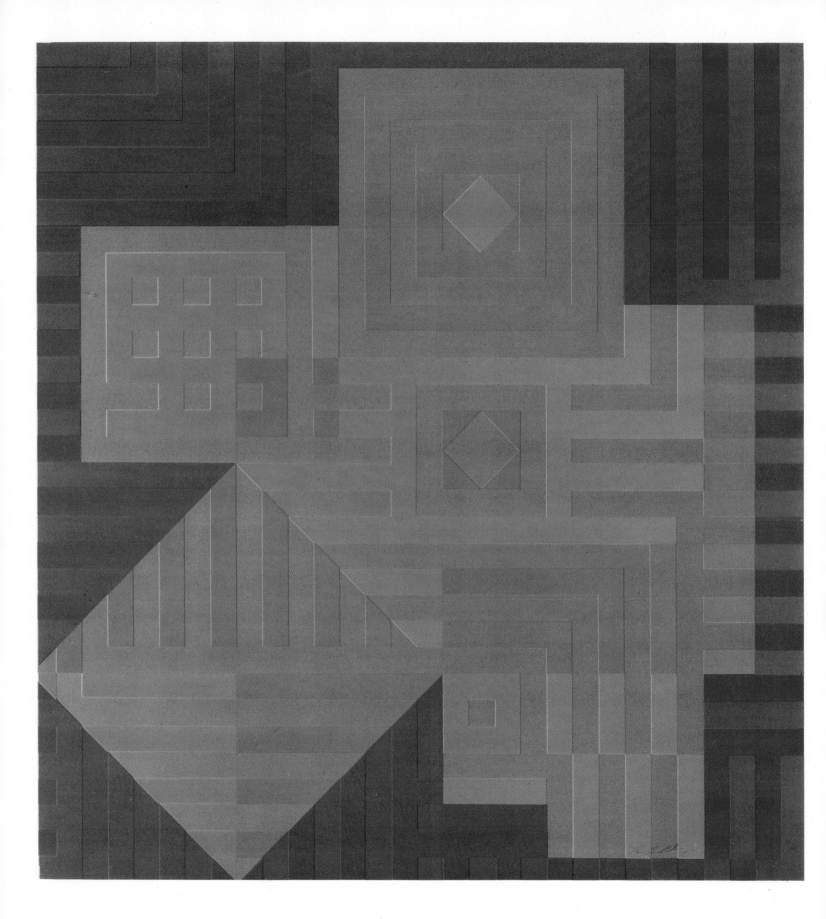

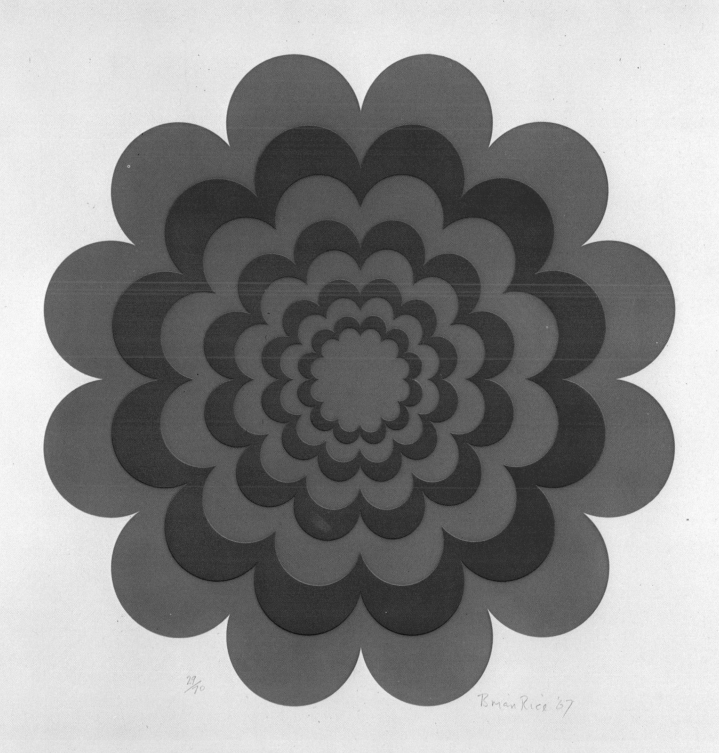

29/40 Brian Rice '67

99
Richard Anuszkiewicz,
American. *Screenprint No. 1281.*
Colour serigraph.
Galerie der Spiegel, Cologne.

repeated for further colours. The artist who wants immediate results will find this method useful.

Lacquer stencil film (profilm, etc.)

If an intricate, hard-edge geometric print is needed that has small isolated areas, one of the best solutions is to use a prepared stencil paper such as is manufactured for the purpose, for example profilm, or the equivalent screen stencil, which consists of two surfaces laminated together. One is the backing sheet and one a shellacked surface which can be ironed on to the screen. With a sharp scalpel it is possible to cut into the shellacked surface only and then lift off the parts that are to be printed; the non-printing areas of the design will still adhere to the screen.

There are special stencil-cutting knives of various types, but a sharp, thin blade of the Stanley knife (matting knife) type, or a surgeon's scalpel, is useful (Ill. 164). When all 'floating' pieces have been removed, the stencil is placed, shellacked side uppermost, under the screen on clean paper. A medium hot iron is run over the screen, causing the shellack coating to melt slightly and stick to the screen. A sheet of thin paper or tissue paper will protect the silk from the iron. Certain prepared stencil papers are attached to the screen by a solvent, thus dispensing with an iron. When the stencil has been fixed to the screen, the backing can be peeled off, and after gum tape has been stuck round the image, the screen is ready to print.

Litho chalk and ink (tusche)

This is a popular method of making a stencil, and is particularly suitable for prints with delicately drawn lines. The design is drawn in litho ink or soft litho crayon. The screen should be raised slightly while this is being done, by putting a thin piece of wood or pencil between the baseboard and the screen, so that the ink does not go through the screen on to the baseboard. When the ink or crayon is dry a layer of gum (photo-engraving glue can be used) or cellulose ink is squeegeed across the whole screen with a piece of cardboard. When the gum or cellulose is dry, the tusche design is dissolved with white spirit or turpentine. This leaves the drawn design unblocked so that the drawn areas are the parts that print (the reverse of the gouache method). Very considerable variations in texture are possible, and the effect is the closest among serigraphs to the brush drawing or painting.

Cleaning

Clean up immediately after printing. Put newspapers under the screen and scrape off the surplus ink with card, not with a palette knife (which might damage the silk). Flood the screen with white spirit or turpentine substitute: do not be niggardly. Wipe the screen down with rags, replacing the newspapers as they get too wet. By holding the screen up to the light it is possible to check whether or not the mesh is blocked. Do not be misled by the stain left by the ink, which will not affect subsequent printing; indeed it could be a help in placing other colours on the screen.

When the ink is removed completely, wipe the screen with a clean rag and store it. It is usually convenient to have a number available for use in the studio.

Inks

The most convenient and most useful types of ink for the artist working at home are the water-based and oil-bound inks made specifically for silkscreen (see the list of suppliers on page 220). It is possible to improvise and use cold-water paste with dyes or poster paint, or to use students' oil colours diluted with turps for the oil-bound inks.

Cellulose inks can be used, but they need special thinners and have a very strong smell, and so are not suitable for printing at home or in a small studio. They are also rather more expensive than oil-bound inks.

When mixing ink, use glass jars, preferably the kind with a screw cap so that the ink can be stored and used again if necessary. When storing oil-bound inks it is a good idea to pour a layer of white spirit on top of the ink in the jar, to prevent it skinning; inks can be stored in this way for months. The larger type of palette knife should be used for mixing. Water colour printing inks seem to work quite well when mixed with a water colour base. If they do not have quite as much body as oil-bound inks, they take less cleaning up.

Other serigraphic methods

In serigraphy there are as many ways of making an image as there are artists. One way is to put wire or string on top of the baseboard, or to sprinkle it with something such

Dark Wings 3/13 *Sylvia Wald '53-'54*

as Fuller's Earth, and then place over it the
paper to be printed upon. The resulting
prints are of course related to rubbings (see
Chapter III).

It is also possible to use a typewriter stencil,
which can be drawn or typed upon and
attached to the screen in the same way as a
paper stencil. Colours can be blended by (for
example) pouring both red and yellow into the
reservoir of the screen, and by using the
squeegee in the normal way to make the
colours merge. After a couple of prints have
been taken they will be found to be merging
perfectly, giving a colour that changes from

red through orange to yellow by a subtle and
smooth gradation.

Three-dimensional prints

The use of serigraphy to make three-dimen-
sional images or prints has recently increased.
The English artist Richard Smith has made
three-dimensional serigraphs (Ill. 106), as
has the optical painter and printmaker (or
'Op artist') Victor Vasarely in France.

Sometimes three-dimensional prints are
made by screening on to existing forms; at
other times they are printed, and then made up
and fixed together, from a two-dimensional

102
Eduardo Paolozzi,
b. 1924, British.
Assembling Reminders. Colour
serigraph.

103
Joe Tilson,
b. 1928, British.
Ziggurat. Serigraph, 1964.
Marlborough Fine Art, London.

104
Andy Warhol,
b. 1930, American.
Flowers. Serigraph on canvas, 1965.
Robert Fraser Gallery, London.

105
Dennis Hawkins,
b. 1925, British.
Ikon-Inside-Outside. Serigraph,
1968. Collection the artist.

117

sheet. One reason why much of the three-dimensional work in printmaking is done by the serigraphic process is that one can screen on to virtually any surface, including perspex, metal, leather and wood. In his print *Teabag* (Ill. 188) the American Claes Oldenberg has printed in colour on felt, plexiglass and white plastic, with felt bag, plastic disc and rayon cord encased in plexiglass.

Photographic stencils

Modern artists often make use of photographic stencils, creating images which can be incorporated in the print or can even *be* the print, as in Rauschenberg's *Persimmon* (Ill. 100) and Andy Warhol's *Flowers* (Ill. 104).

Some artists are using photographic methods of producing silkscreens themselves; others are making designs that will be photographed and then produced by a silkscreen printer in various colours as planned by the artist.

A photographic stencil may be made either from an opaque image drawn on translucent material or from a specially prepared photographic positive. Tone gradations can be produced by use of the 'half-tone' technique, which consists of breaking up a continuous tone picture into lines or dots.

Photographic stencils are based on the fact that substances such as polyvinyl acetate or polyvinyl alcohol can be sensitised with salts such as potassium or ammonium bichromate, and will then harden when exposed to light; while areas which are protected from light by opaque parts of the positive (the original or drawn design) will remain soft and can be washed away.

Basically there are two ways of preparing photographic stencils: the direct method and the indirect or transfer method. The direct method is to coat the screen fabric with the light-sensitive emulsion and, when it is dry, expose it to light through the positive or drawn design. The screen is then washed in water so that the image areas remain open to allow the ink to pass through.

The indirect method entails the use of a light-sensitive gelatine film commercially prepared on a translucent paper or plastic support. A special piece of equipment known as a vacuum frame can be used to ensure close contact between the film and the positive during exposure. After processing, the film is transferred to the screen. When the support is

106
Richard Smith,
b. 1931, British.
Sphinx No. 1. Three-dimensional
serigraph. Editions Alecto Ltd.

107
Jim Dine,
b. 1935, American.
Toolbox No. 6. Serigraph and
collage. Editions Alecto Ltd.

dry it is peeled away and the remainder of the screen masked out and prepared for printing in the usual way.

The advantages of the transfer method are that it is easier to carry out than the direct method, and that in addition there is no tendency for the image to lose line detail or acquire saw edges.

Photographic stencils make possible the printing of exact detail, half-tone work and colour separations, as well as reproducing such techniques as air brush, charcoal and pen and ink drawings.

These technical advances have added greatly to the attraction of serigraphy for the 20th-century artist.

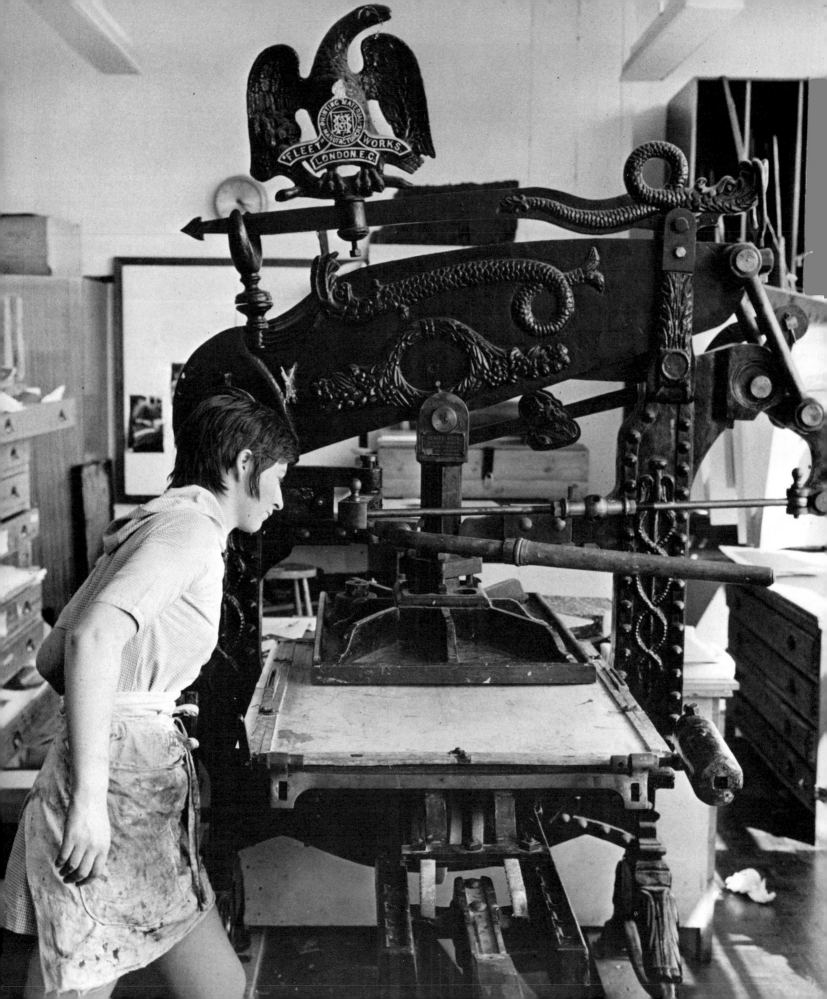

2
Printmaking with a Press

108
Rolling the bed under the main
body of the press. The splendid
Columbian press can be seen in
detail.

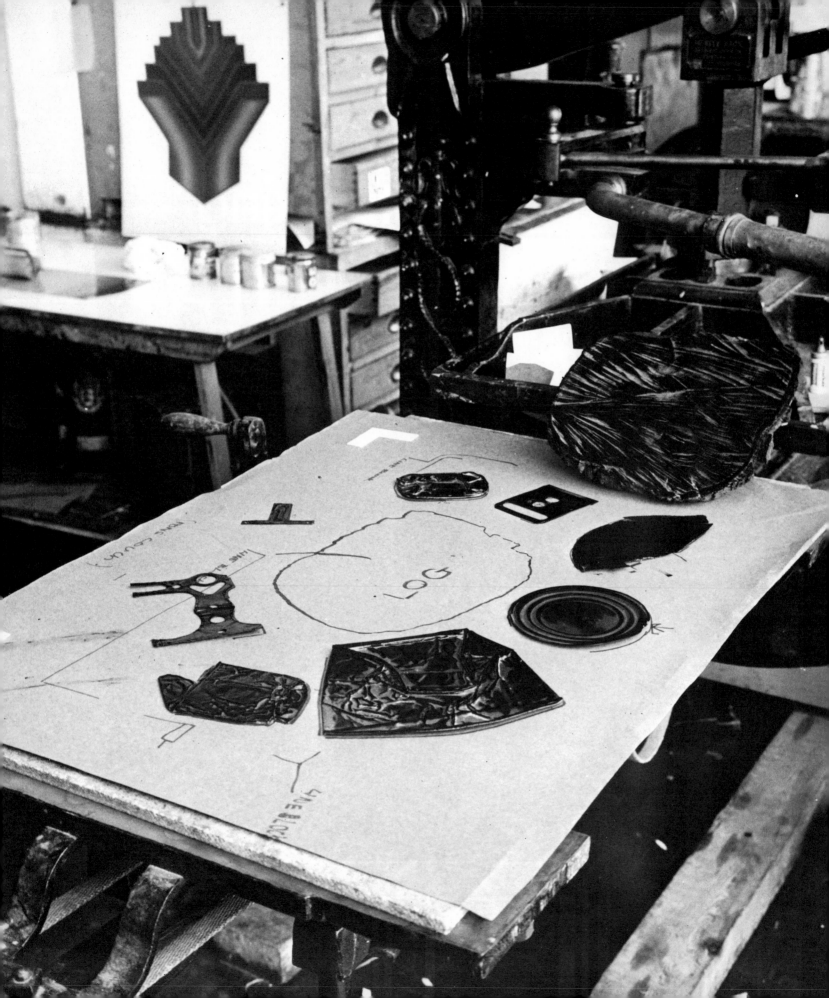

VII

Relief Printing with a Press

'The larger the press the less the effort that is needed to print, for your strength is many times multiplied by the leverage of its movement.' Michael Rothenstein

Printing with a press

All the previous chapters have described printmaking without a press. Relief is one of the few printmaking media in which it is possible either to burnish by hand (Ill. 61), as described in Chapter V, or to print using a press. The main advantage of printing relief blocks in a press is that it makes possible a speed and evenness of pressure in printing that are important factors, combined with the size of work, in the production of editions. There is also the point that many more types of paper can be used in printing with a press (Ill. 108).

Wood engraving blocks are made type high (about 0·9 inch) and can be printed combined with type in modern letterpress printing machinery. Bewick, the wood engraver and naturalist, had many thousands printed from some of his blocks and was satisfied with the quality of all the prints. Lino, already mounted type high, can also be bought (see the list of suppliers) and may be printed either with or without a press.

The mangle press

It is possible to improvise a simple press at home. For example, Oey Tjeng Sit prints his work (Ill. 77) in an ordinary household mangle, used originally for wringing out clothes. In the large studio in Amsterdam in which he cuts his many charming lino cuts, he has a mangle which he uses in the following way. Having inked the lino block (Ill. 118), he places it face up on a large piece of card. He puts a sheet of printing paper face down on to the block, lightly touching it with the hand so that it comes into contact with the ink, whose stickiness prevents it from moving around. A thinner piece of card, perhaps on top of a second sheet of paper, completes the 'sandwich', and the whole is wound through the press; sometimes a final burnishing may be necessary. Oey Tjeng Sit's work is printed on very thin Japanese paper, which makes the printing easier. Mangles used as presses are versatile enough to print many different types of thin block: even a lithograph (see the chapter on lithography).

The pinch or screw press

Another very simple hand press, though rather too heavy to move about easily, is a small screw press (Ill. 110) formerly used for various processes in bookbinding and in commercial artists' studios. These can usually be bought second-hand at relatively little cost, and are excellent for printing small lino cuts. (The paper must of course be small enough to fit on to the bed of the press, and the block must be correspondingly smaller. On the subject of presses in general, it is well to remember that packing can vary in thickness from sheets of newspaper to cut-up felt etching blankets.)

The lino can be inked up and then placed on a sheet of card which is slightly smaller in area than the metal base or bed; the card should be

109
Inked up objects—metal flanges, crushed tins, etc.—placed in register on the press.

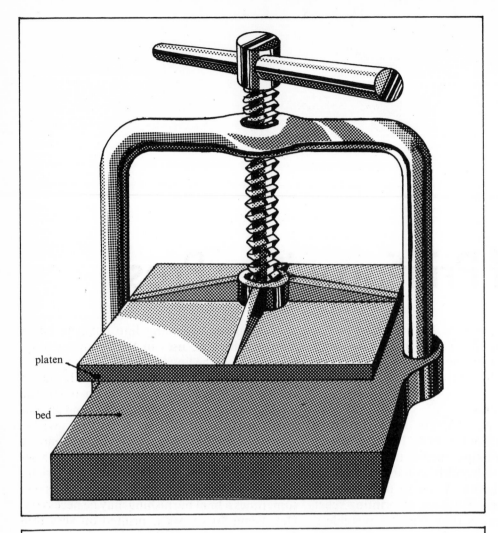

platen

bed

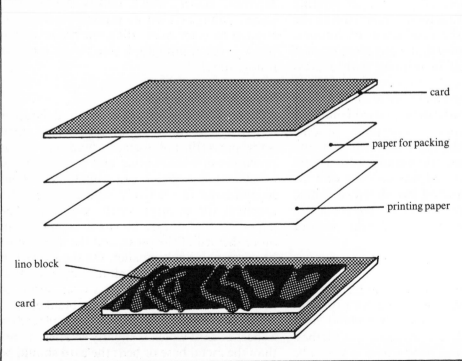

card

paper for packing

printing paper

lino block

card

kept specifically for this purpose. The printing paper is laid face down upon the inked block and the whole put in the press. A few sheets of cartridge paper or newsprint and a full sheet of straw board or cardboard are placed on top for packing. Downward pressure is exerted from the central screw. It is important not to turn the handle round too vigorously or else the platen will come down too tightly, the ink will spread and a 'squashed' lino cut will result.

Cylinder presses
Although most large relief presses are of the platen variety (Ill. 108), it is possible to print from a cylinder press. As the cylinder revolves, the pressure moves across the block. The 'Australia' prints in intaglio and relief (Ill. 149) were both done on a press of this kind, with pressure carefully regulated by blankets and papers. The cylinder press works in a way similar to an offset litho press, but a hard roller is used for pressure, the paper being placed directly on the block.

Columbian, Albion, Washington
However, most relief printing in established studios is done on the presses named above. It is still possible to buy the magnificent old Columbian and Albion presses, originally used for commercial letterpress printing and proofing, but no longer manufactured. Ill. 108 shows a Columbian press being worked in a relief printing studio, and one can see the massive frame.

From the point of view of the commercial printing trade Columbian presses are obsolete; their only function in present-day printing works seems to be decorative. So it is still possible, in England especially, to buy them comparatively cheaply. They are, however, becoming scarce, and the buyer usually has to find transportation and pay for them to be overhauled.

Working the press
When the press has been covered with the tympan or packing, the handle is turned so that the bed moves under the platen. The handle or lever has to be pulled to give the downward pressure which does the actual printing; this may take a lot of leverage, and sometimes the operator puts his foot up against the press so as to obtain additional leverage. (As can be imagined, presses in art colleges are subject to a considerable amount of rough treatment;

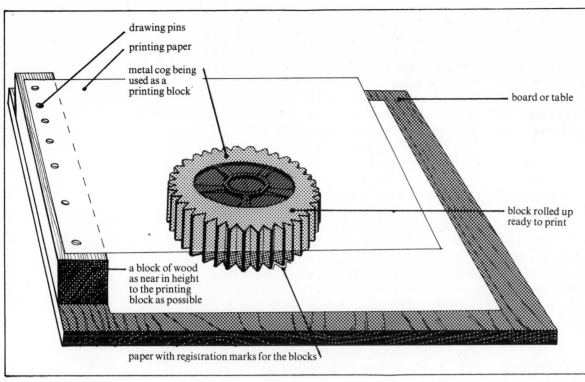

drawing pins

printing paper

metal cog being
used as a
printing block

board or table

block rolled up
ready to print

a block of wood
as near in height
to the printing
block as possible

paper with registration marks for the blocks

printing paper

printing paper

register for
squared-up blocks

card or metal
flanges

backing paper
with registration
marks for
irregular blocks

teachers should make sure that the ones they acquire are large enough to withstand it.)

The press is usually adjusted to take blocks that are type high. Objects lower than this are easily printed by putting a layer of chipboard or blockboard on the bed of the press to heighten it; several layers of such boards can be used, thus making a variety of adjustments possible.

Sheets of paper and cardboard are usually most suitable for packing on top of the print. Some artists who make cardboard prints (Ill. 116) find that they need only one sheet of paper on top for packing.

The tympan (the cover of the bed of the press) is removable, since it is not always needed. It usually folds down on top of the block when it has been placed in position with paper and packing. All presses should be kept as clean as possible, greased and oiled.

Printing

Always check that the printing has been successful before removing the print from the block. First weight the printing paper, as in Ill. 44, then lift a corner to check the printing. Many methods of printmaking make the hands dirty, so, as in etching, use the small pieces of folded card or paper called 'fingers' to handle prints.

The reason for lifting the corner of the print is that, although these presses usually give an evenly distributed downward pressure, it is sometimes necessary to remove the packing (but not the printing paper), turn the block and paper round on the bed of the press, and reprint in order to obtain more even pressure over the printed surface. This is common practice on direct litho presses too. If the print is too faint in parts, it is also possible to carefully add extra ink and print or burnish again.

In Ill. 115, of a colour print in progress, the design is becoming richer with each piece of lino or cardboard. This student is printing the block face down on to the paper, which is an easy way to register the print, especially since lino is flat. This is a mixed media print (see the chapter on this subject).

In Ill. 116 the artist is using cardboard and is printing on filter paper. When using cardboard there is no need to treat the cut card in any way, and one can produce lines and shapes of extreme delicacy (Ill. 53); but, as mentioned before, each colour may have to be printed twice to get the flat, even tone required.

Colour and registration

To make a colour print in relief it is usual to have a different block for each colour and to register on the bed of the press, as in Ill. 109. In the illustration, a number of inked up objects have been carefully placed in position on the bed of the press: tin cans that have been flattened, metal flanges, the circular top of a tin can. This collection is to be printed as assembled, and then the log, being too thick to be put in the press, will be laid in the centre and printed by hand burnishing. Notice the registration stops, which indicate where the printing paper should be placed, and the separate sheet of paper carrying the metal objects, which is marked for registration. The registering of the paper can be seen again, in Ill. 4, in which an artist is putting a sheet of paper carefully down on to a lino block that is in position on the register base sheet.

One way to get colours positioned correctly is to have stops for both paper and blocks (Ill. 113). An alternative, if the blocks are the same size, is to use a simple square mitre of two lengths of wood which can be placed on the bed of the press. If the blocks are cut at right angles then they can be fitted into the corner, and the paper registered on the mitre in one corner (Ill. 113).

In traditional Japanese prints, register marks were cut on the block, as the blocks were larger than the paper.

In printing with colour on the press, there are two main methods. One is to print all the edition sheets with the first colour (say twenty prints in yellow), then to print the next block (perhaps red), adjusting the registration, and so on. When this method is employed, prints are often discarded, and each mistake in colour means one copy less in the uniform edition of the print.

The other method is to proceed by continual comparison and change, by trial and error, until one has a single perfect proof, which is then printed as an edition. An edition produced in this way could then be printed as needed – perhaps five or ten copies at a time.

At one time there was a tradition that the lighter colours, such as yellow, should be printed first; however, nowadays it is often necessary to print a light colour on top of a dark one. It goes without saying that the use of colour must be an integral part of the artist's conception, or the artist working in relief might just as well stick to black and white.

114
Pablo Picasso, b. 1881, Spanish. *Pique*. Relief print. London Graphic Arts Inc.

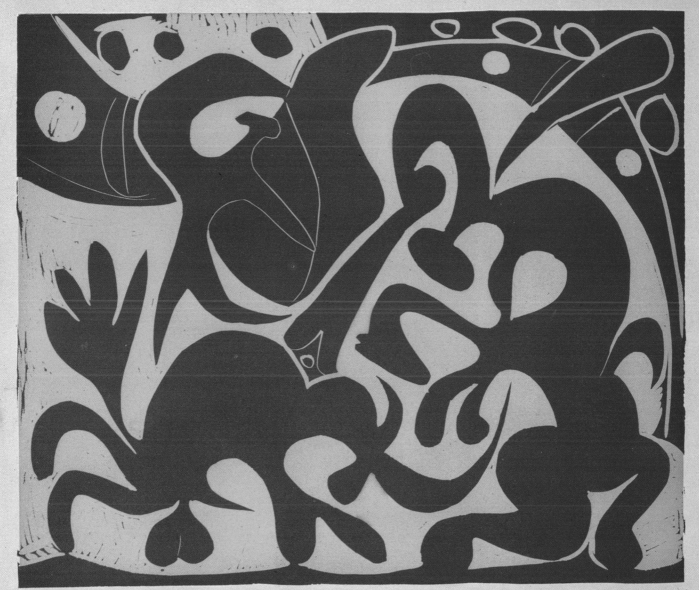

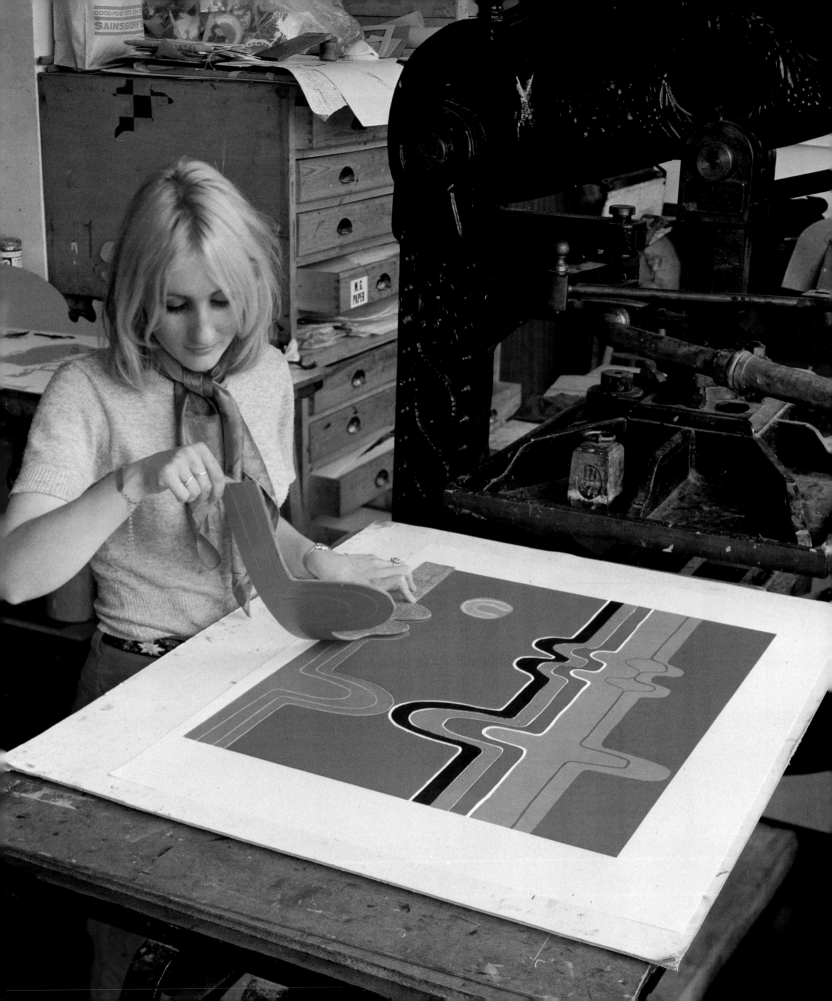

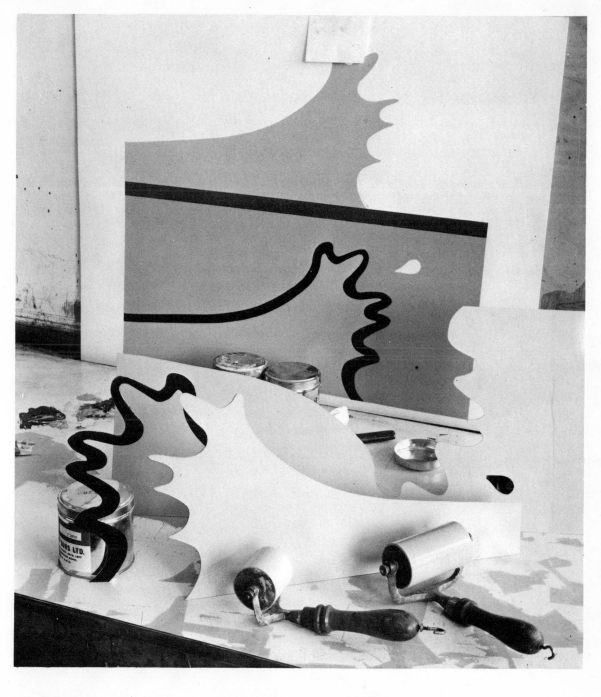

Blocks for printing

It is possible to build up printing blocks on hardboard or wooden grounds in many ways, and all can be printed in a press. In his book *Printmaking*, Peterdi refers to blocks made by dissolving lucite, shaping it and, after it has dried, carving and engraving it.

Many wood blocks can be repaired or built up. In the engraving or woodcut it may be possible to cut out mistakes and insert a piece of new wood, the cracks of which can then be filled in with plastic wood. Lino may straighten out with printing, or by being left overnight in a press. The same is true of warped wood.

Large areas of pure or merged colour may be printed in an etching press in which the pressure is regulated carefully. Embossed or blind printing can be best done on an Albion or etching press with soft papers capable of being dampened, soft blankets and a lot of pressure. The blind, raised surface in pattern or design, to be seen in certain Japanese prints (Ill. 70), is being developed in the contemporary prints of Rolf Nesch and Etienne Hajdu.

115
A student lifting the lino after having printed it face down.

116
A cardboard relief print in progress. Some of the blocks made in cut cardboard are propped up in the foreground.

129

117
A large sheet of lino, clamped to the bench, being cut by a gouge. There is a felt tool holder in the foreground. Notice that the artist's hands are behind the tool.

118
Inking up a sheet of etched lino. The detail that can be obtained with this method is apparent.

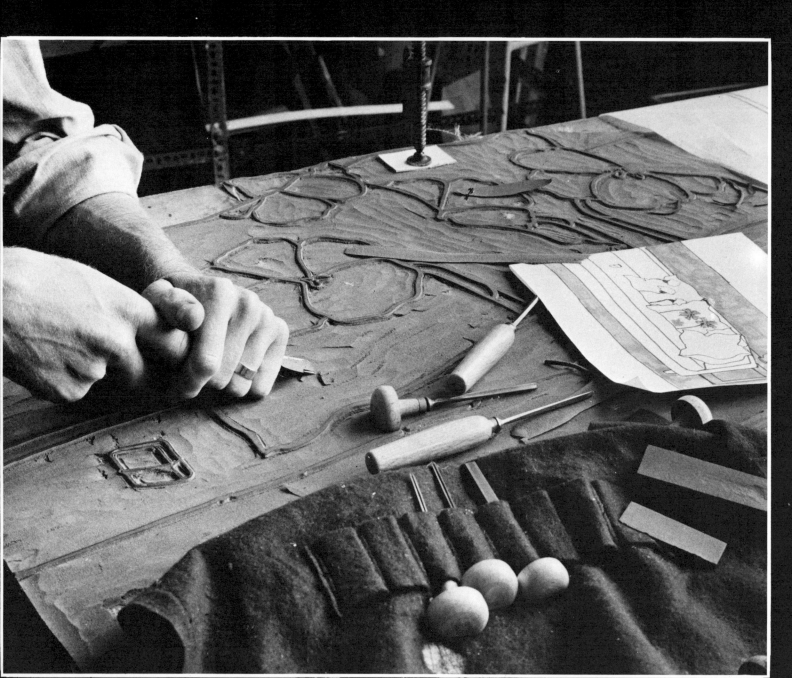

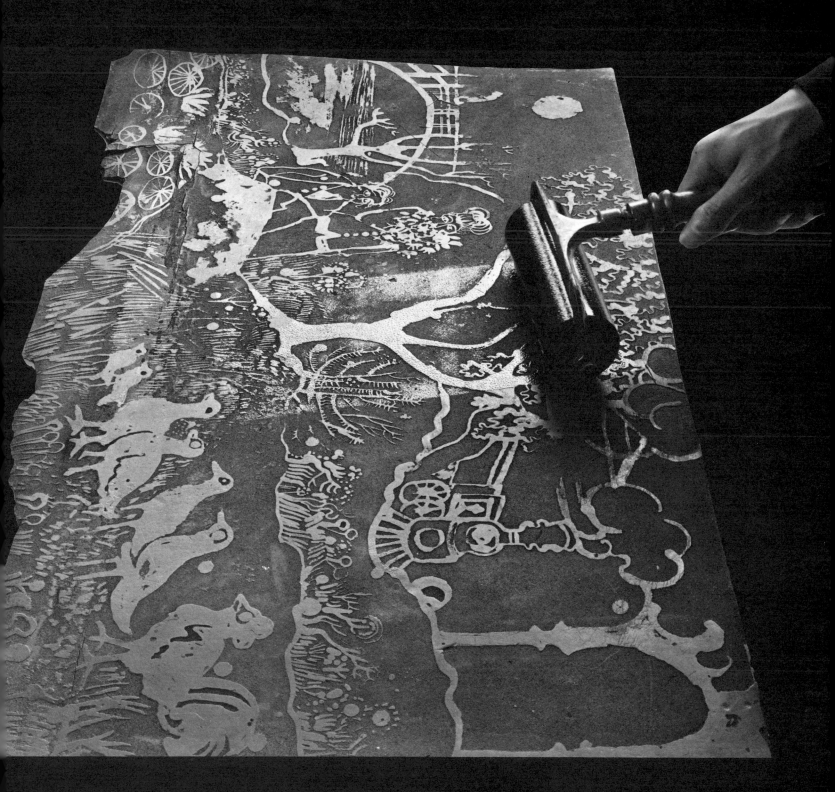

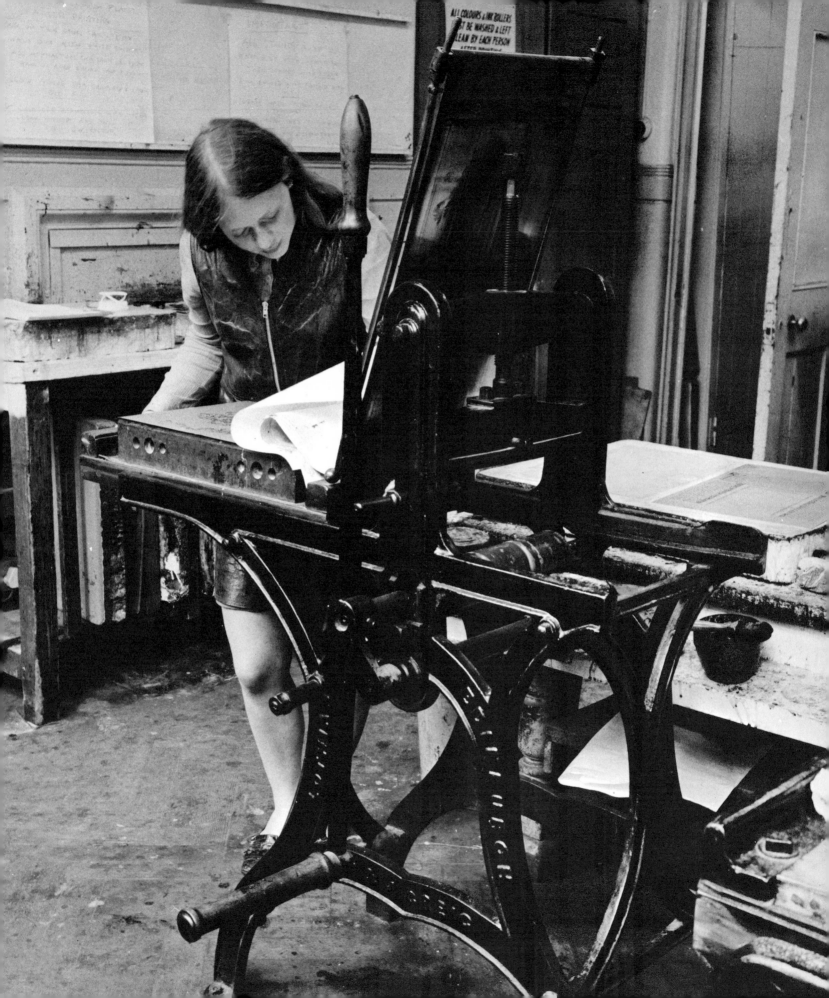

VIII
Lithography

'In the hands of a master no lithograph will ever be a mere multiplication of a drawing, as lithography, like all graphic arts, will always have its own characteristics.' Felix Man, *150 Years of Lithography*.

The lithographic print is taken from a planographic (flat) surface, traditionally Bavarian limestone but nowadays often a zinc or aluminium plate. The image is drawn on to the plate with grease, for example crayon 'chalks' or greasy ink (tusche). It is then processed, and the stone or plate is dampened with a sponge. When a roller, charged with a sticky ink, is applied to the plate or stone (see the frontispiece), the greasy nature of the ink makes it adhere to the image, while it is repelled by the moisture of the dampened areas. A print is then made in a press (Ills 119, 120).

After printing, the image remains and the process of moistening, inking and printing is repeated for each successive print. In Ill. 125 a lithograph is being pulled from a plate; the image has been transferred from the litho plate to the paper, which is slowly being peeled off.

The name lithography comes from *lithos*, 'stone', and *-graphia*, 'drawing', and was first used in France. Lithography is an almost completely autographic medium. A drawing on a plate, however free or delicate, will print as it is drawn: witness the speed and directness visible in the Manet (Ill. 129), and the direct drawing with a litho crayon in the work of a young English artist, Ann d'Arcy Hughes (Ill. 144).

This directness and delicacy has always encouraged a particular type of artist – one who is primarily a draughtsman – to use lithography. But in fact the medium is ideal for any artist who wishes his work to print more or less as drawn, and work on the plate by hand makes possible a spontaneous and original approach. The pure colour print seems easier to produce in lithography than in most of the other media. Turn to Ill. 121, showing colour overprints and separations. In the lower print the colours above and below combine in the centre to make a third colour, which is called an overprint. This example of the way colour overprinting works holds good for other printmaking media in which transparent or almost transparent colour can be used (see the chapter on serigraphy).

In lithography each colour to be printed needs a separate plate or stone, and overprinting is a delightful feature which is clearly visible in the magnificent prints of Georges Braque (Ill. 141) and in the prints of Ceri Richards (Ill. 142), who is one of the most consistent English lithographers. Richards manages with each print to exploit new possibilities in the medium. In *The Golden Fish* the red of the fish itself seems to be the only area not overprinted. In Whistler's lithographs, the image seems to have been breathed on to the stone in true butterfly fashion (Whistler often 'signed' his work with a butterfly symbol). Extreme delicacy of colour is also an attribute of the lithograph, as in the Pierre Bonnard (Ill. 7), and a wash effect almost like water colour may be achieved (see Ill. 138 by Joan Miró).

The printmaking medium closest to the lithograph is perhaps etched lino. However,

119
A direct lithographic hand press.

the lithograph, unlike the typical lino cut (Ill. 77), is so varied that the medium can produce very rough splattered drawing, thin accurate lines, or marks made geometrically with ruling pens and compasses; and, if the artist so desires, it can all be done on the same plate.

Textures on stone or plate can be produced in various ways. The stippled effect made with a hard brush or toothbrush, the ink being flicked on to the plate, is brilliantly evident in many of Lautrec's lithographs, in which little flecks or dots create a hazy and atmospheric effect (Ills 8, 140).

The medium is especially exciting because of the direct and gestural quality it enables the artist to achieve. This directness is exploited by Picasso, who often makes strong but simple brush drawings in litho ink.

The specially prepared surface of the plate or stone makes subtle shading with a crayon possible, from the lightest touch in a smooth gradation to the most intense black, as in Bonnard's *Le Tub* (Ill. 130).

If printing is done on an offset press rather than a direct transfer press (Ill. 120), the image will appear as drawn, not in reverse. There is no deterioration in the printing quality of a lithograph, and it is possible in theory to make thousands of prints from one plate. By contrast, in drypoint engraving (Ill. 155) the first prints are considered the best, and only a very limited edition is normally printed. In practice, however, most lithographers too prefer to limit their editions.

Lithography is a good medium for simulating reality so convincingly that the spectator is deceived ('*trompe l'œil*'), and in David Hockney's witty lithograph *Still Life in an Elaborate Silver Frame* (Ill. 124), the frame around the outside is drawn as part of the print. In contrast, Allen Jones's lithograph *Red and Green Baby* (Ill. 139) has large flat printed areas which set off the rough drawing of the word 'Love'.

Photographic possibilities
One simple way to combine the photographic image with the autographic mark is to take a freshly printed newspaper, select a photograph, place it on a plate, soak the back with white spirit, and run it through the press many times, after which the printing ink sometimes 'takes'. The image can then be printed in the normal way. Any photographic image can be put on a plate. If the image is tonal, it needs to be modified, as with a photographic plate. As in serigraphy, it is not possible to print directly in tonal gradations: the image must be broken down into a mass of half-tone dots which merge optically to give the impression of tonal gradations, as in a newspaper photograph.

Basically a photo-lithographic image can be produced with:
1. A specially manufactured, pre-sensitised plate that is sensitive to light in much the same way as is film in a camera
2. A full-sized opaque image on a transparent sheet—usually a piece of photographic film
3. A strong source of light

The pre-sensitised plate and the negative are arranged face to face, and light is shone through the back of the negative. The opaque areas of the negative prevent light from reaching the sensitive surface of the plate, but on all the transparent areas the light acts on the sensitive emulsion, leaving a latent positive image. The latent image becomes visible as the plate is carefully wiped over with a special developing fluid. In *Smile Please* (Ill. 122) the photographic elements were made in this way.

Booster (Ill. 131), by the American artist Robert Rauschenberg, shows a full length self-portrait (the x-rays are his own) combined with drawing and other photographs. This was printed at Gemini G.E.L., a workshop in America which has two stones fixed together which are capable of producing a print as large as 7×3 feet.

Three-dimensional prints
It is difficult to print lithographs on materials other than paper, although some fabrics, thin sheets of metal foil and perspex have been used. The possibilities of three-dimensional work have not been fully exploited as yet. A number of artists have designed prints which are meant to be cut out and made up by folding or sticking; others have printed images on to sheets of perspex which, when sandwiched together and framed, look like empty space in which unsupported images are suspended. Translucency of colour is possible if light is shone through a print made in this way.

The history of the lithograph
Lithography is a comparatively new print-making process. It was discovered by one man, Aloys Senefelder, who also did research in

120
A hand-operated offset press. The image of a shoe can be seen on plate, paper and roller.

most aspects of the new art. He thus helped to give the world not only a cheap technical method of reproduction but also the magnificent black and white prints of Daumier (Ill. 128) and the great lithographic prints of Toulouse-Lautrec (Ill. 8).

Senefelder was born in Prague in 1771 and experimented with printing in order to print sheet music. He was at first concerned with etching a relief in limestone, and discovered the new chemical process more or less by accident in 1798-99. When he was asked to write out a laundry list, Senefelder happened to have local limestone at hand and so scribbled on the stone with his prepared stone ink of wax, soap and lamp black. He eventually found that the wax, or greasy image, could be transferred on to paper. This was to be the start of the development of lithography, or 'chemical printing' as Senefelder called it.

Some of the first lithographs made by artists were published in England in 1803 in a volume called *Specimens of Poly-autography*, with contributions from Fuseli, Stothard and Benjamin West. These were all in pen and ink line; the first chalk or shaded drawing was made by H.B. Chalon in 1804 in France. Lithography was also developed as a new reproduction process for the printing trade, as it was able to produce more quickly and more cheaply than other printing methods. This parallel development of the fine artist's lithograph and industrial printing has continued to the present day.

The German artist Wilhelm Reuter was one of the first artist lithographers, and in 1804 he published some of his own prints and those of other artists. Another important figure was Herr von Mannlich, who owned a litho printing shop, was a director of galleries in Munich and Schleissheim, and was a patron of lithography. All the same, in Germany lithography developed mainly as a commercial process.

In 1819, when he was over 70, the great Spanish artist Goya lithographed his first prints on a press that had been taken to Spain and set up by José Maria Cardano; at the end of 1825 Goya produced four lithographs of bulls, all masterpieces, of which a hundred prints were made. The German artist Adolph von Menzel made 436 pen lithographs for one work and later in 1851 did his 'Experiments on Stone with Brush and Scraper'.

It was in Paris that Honoré Daumier, in the 'Parisian Types' series (Ill. 128) and his many other prints, immortalised the lithograph.

Here was a supreme artist of the 19th century, who worked all his life in lithography, producing some 4,000 lithographs from 1831. Quite apart from the social and visionary aspects of his work, Daumier's technique, his knowledge of everything that could conceivably be done with the stone and tools, put him in a class by himself as a lithographer/draughtsman. His lithographs were printed in the newspapers, not as collectors' items.

The autographic prints made by Manet in black and white (Ill. 129) are extraordinarily free and exciting. They were done directly with a brush on transfer paper, and were influenced by Japanese prints, which came to Europe as packing for porcelain in the 19th century. (Whistler, Pissarro and others were also profoundly influenced by the Japanese print.) Degas was influenced by Manet and was interested in working with the scraper and various chalks.

Colour lithography was gradually improved, so that by the 1860s Jules Chéret, the French poster artist, was able to do some of the first lithographic posters in colour. Chéret had worked in London, where he had learned lithography from a printer and publisher called Engelmann. In 1866 he set up a print shop in Paris, and produced more than a thousand posters, varying in quality, but gay, lively, decorative and reasonably well drawn. His work was one of the main influences on Lautrec.

Chromolithography (colour lithography) had to be developed as a commercially viable proposition before artists working in the modern idiom, such as Bonnard and Toulouse-Lautrec, could use colour in their prints. Lautrec was one of the first great artists to work on lithographic posters. In 1890 he was commissioned by the proprietor of the Moulin Rouge to draw a poster showing the can-can. The poster was a great success, and Lautrec went on to produce masterpiece after masterpiece in the medium; by the time he died in 1901 he had produced 375 lithographs.

The 'Nabis' were a group of French artists, influenced by Oriental, Egyptian and early Renaissance art, who came together in 1888. All of them made some lithographs, but the most important members were Pierre Bonnard, Edouard Vuillard and Maurice Denis, all of whom were influenced by Gauguin. Bonnard designed many of the covers for the Nabis' magazine *Revue Blanche*, founded in 1891, and his first poster, *France-*

121
An example of overprinting. In the
upper print the red and blue over-
lap in the centre of the left-hand
strip to produce a third colour, in
this case black. In the lower print,
yellow has been added to the red on
the right, making an orange square
where they overlap, while in the
centre strip the yellow has
combined with the blue to produce
green.

122
Harvey Daniels,
b. 1936, British.
Smile Please. Colour lithograph
with photographic elements,
1967. 30 × 22 in.
Collection University of Sussex.

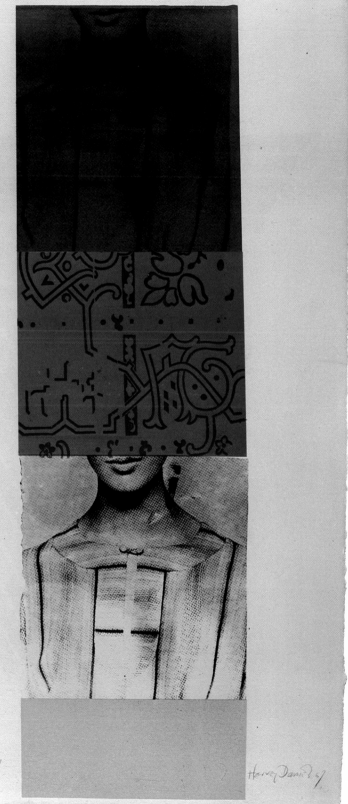

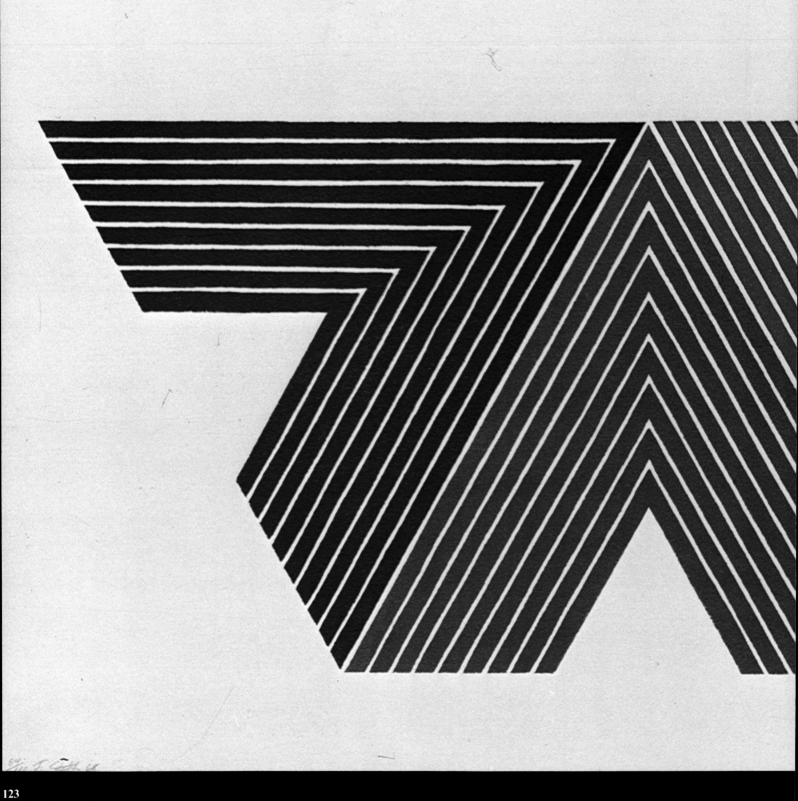

123
Frank Stella, American.
Empress of India.
Colour lithograph. $16\frac{1}{4} \times 35\frac{3}{8}$ in.
Gemini G.E.L., Los Angeles.

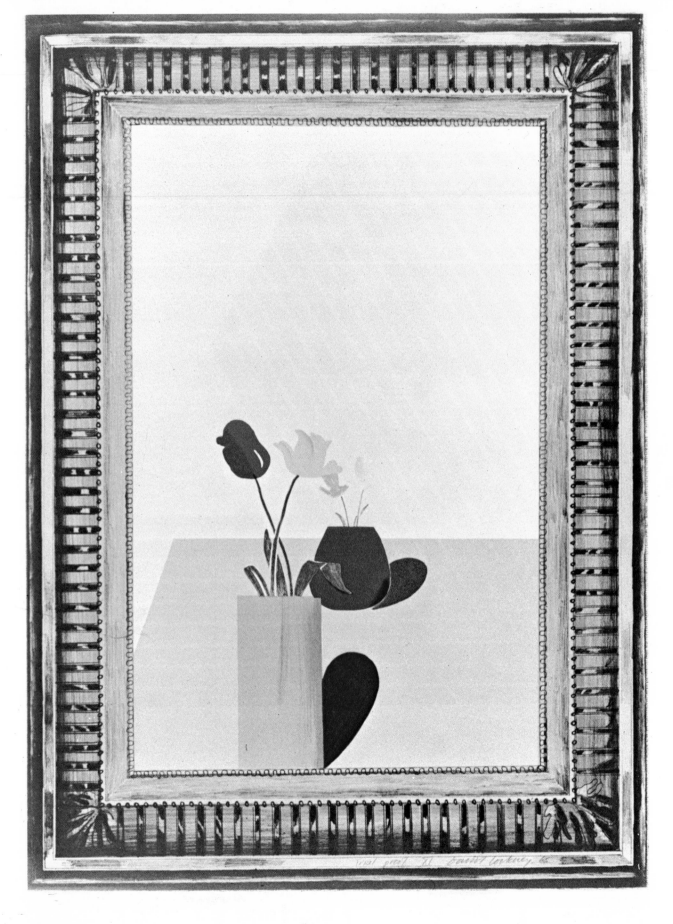

Champagne (1889–90), has become a classic. He made many series of prints; one illustrated book printed by a master printer, Auguste Clot, for Paul Verlaine's *Parallèlement*, included 109 lithographs. Altogether Bonnard made about 300 prints.

Whistler, as I have mentioned, produced quiet and delightful lithographs from 1878/9. Two of his English contemporaries who produced interesting lithographs were Walter Richard Sickert and Charles Conder. Sickert quarrelled with Whistler's methods, claiming that drawings done on transfer paper and put on stone were not true lithographs.

At the end of the 19th century, lithographs were beginning to be appreciated as original works of art. Munch (Ills 67, 68) became involved with the medium, and his work in it was on as high a level as his woodcuts. Many of his lithographs are key works, for instance *The Scream* (1895) and *Self-Portrait with Arm Bone* (1895).

Modern times

The German Expressionists worked in most graphic media. Max Beckman was making lithographs at the turn of the century; Oscar Kokoschka lithographed his first series in 1908. Schmidt-Rottluff made more than 150 lithographs, and Otto Mueller also worked extensively in the medium. Nolde mainly produced single prints of his lithographs. Kirchner produced five hundred lithographs, the colour prints of which have been described as 'the finest achievements of European graphic art in the 20th century'. His earliest print was done in 1906. He believed that only if the artist did the printing itself could the work be

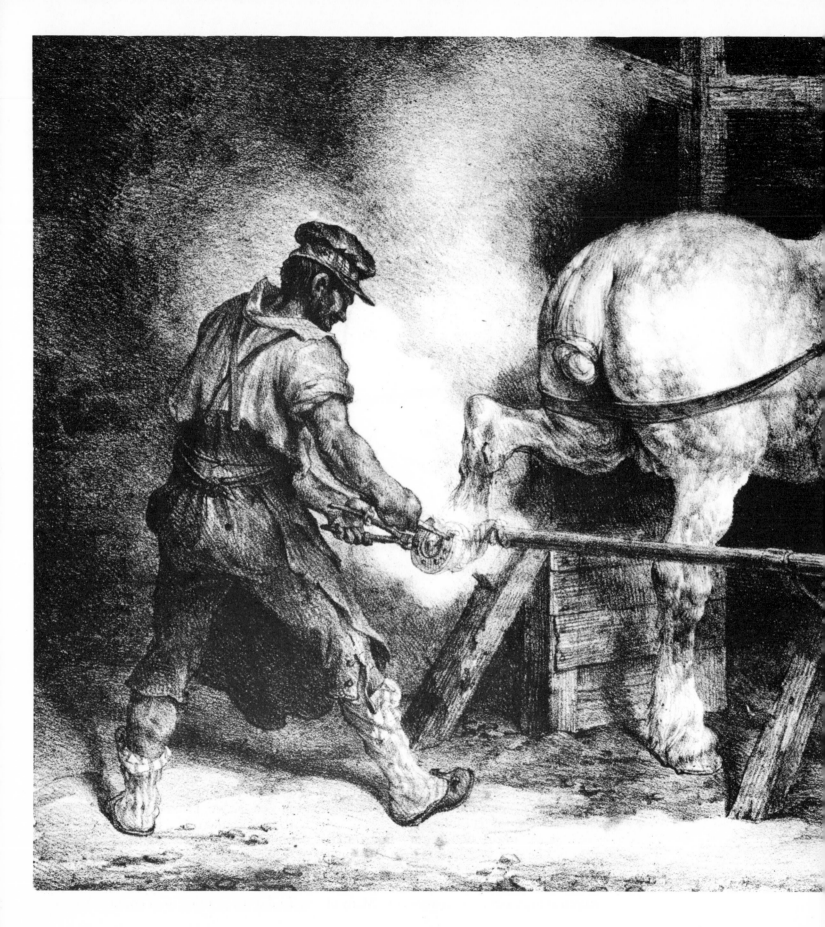

142

126
Jean Louis André Géricault,
1791–1824, French.
The Flemish Farrier.
Victoria and Albert Museum,
London.

called with complete truth an original print.

Members of the 'Blue Rider' group in Germany also made lithographs, and many of them were concerned with albums and publishing. Paul Klee, a delicate and deliberate lithographer, produced forty lithographs. The most influential art college in modern times, the Bauhaus at Weimar and Dessau, produced a master album in 1921–3 in which appeared prints by some of the staff (Klee, Kandinsky, Itten, Schlemmer, Moholy-Nagy); also published were Boccioni and Jawlensky. After 1923 these albums were discontinued, though it was intended to have a French volume with Matisse, Delaunay, Derain, Lhote and Braque.

Matisse made his first lithograph in 1904 (*Nude*). He often drew on transfer paper, and in general took great care with his prints; he was one of the modern artists who went back to using litho chalk or crayon with almost 19th-century care and gradation of shade.

In the 1920s most artists of importance were doing some lithography. Kandinsky said in 1926: 'Lithography is getting closer and closer to the painting by the increasing use of colour, and is, in any case, a certain substitute for painting. This is characteristic of the democratic nature of the lithograph.'

Although he had always been concerned with printmaking techniques, it was not until 1945 that Picasso started his marvellous technical exploration of lithography. He went to Mourlot, a master printer in Paris, and for four months he worked (sometimes a sixteen-hour day) producing lithographs in every possible way. Very often the image would be transformed between the first print and its final state, being rendered in a completely different style. In all, Picasso has made about 270 lithographs.

Georges Braque, like Picasso, really started in 1945, and since then has produced some very fine prints (Ill. 141). Miró (Ill. 138) and Léger also made lithographs, and the sculptor Giacometti produced a few very impressive chalk lithographs. In this country Ceri Richards (Ill. 142) produces sensitive prints in the French tradition. The Australian Sydney Nolan exploits the texture and richness of the lithograph. In America, Jasper Johns, Frank Stella (Ill. 123) and many other contemporary artists are making lithographs, and currently there seems to be a reawakened interest in the medium.

Materials

A press is necessary to print a lithograph (Ill. 119). Certain firms in Europe and America are building new presses which print from both etching plates and litho plates. The departments of art in universities and art colleges that usually own these presses are often willing to let them be used by outsiders. A sink and a bench are other basic necessities in a lithographic workshop or studio.

A list of materials necessary for work:

1. A litho press (possibly power-driven), direct (Ill. 119) or offset (Ill. 120) – and the larger the better
2. Some litho stones (a) to fit the bed of the press; (b) to mix colour on; and (c) to process the work on
3. Zinc plates ready-grained in packets. A useful size is $20 \times 25 \times 0.025$ inches thick. Aluminium can also be used
4. Paper for printing or thin card; also twenty sheets of thin paper for packing
5. Offset litho printing inks
6. Litho crayons, called chalk; liquid and solid litho ink
7. Litho rollers: nap for black, composition for colour
8. Non-greasy red carbon paper for tracing the image on to the plate
9. Offset powder for dusting the key block
10. Gum cloth
11. White spirit or turpentine substitute in conical sprinkler cans
12. Gum arabic, either made up in liquid form or in crystals
13. Victory Etch or zinc plate etch and caustic or Erazol
14. Sponges
15. Clean rag
16. Registration needles (Ill. 134)
17. Drying flags or hand hair dryers
18. Brushes, including one 2 inch decorator's brush for applying etch
19. Rulers or set squares
20. Prepasol
21. Transfer paper
22. Pumice
23. Tallow and oil with which to grease the press
24. Palette knives for mixing ink
25. French chalk or talc and resin
26. Asphaltum liquid
27. Magnesia Carbonate (powder) to mix with the printing ink

127
Eugène Delacroix,
1798–1863, French.
Le Prisonnier de Chillon.
Lithograph. Victoria and Albert
Museum, London.

128
Honoré Daumier,
1808–79, French.
Oh! Absolument comme si on y était...
('Parisian Types'). Lithograph,
1841.
Victoria and
Albert Museum, London.

The offset press
With the offset press the image on the plate is printed on to a cylindrical, rubber-covered surface called 'the blanket', and from there on to the paper. The image will thus print the same way round as it was drawn. Ill. 120 shows a hand-operated offset litho press: the image on the plate in the foreground is printed on to the cylindrical rubber blanket and then on to the paper, which is held still by the round grips (notice the adjustable 'stops' for registration).

The transfer press
The direct transfer press (Ill. 119), motorised or not, is still the press favoured by many artists. The plate, having been drawn upon and fixed (processed), inked and dried, is placed face up on the bed of the press. It is covered by the printing paper face down (if thick paper is used the back could be dampened), and then by several sheets of packing paper, perhaps ten or twelve sheets of soft paper. The tympan is lowered, and by pulling down the pressure lever the bed, the plate,

146

129
Edouard Manet,
1832–83, French.
Berthe Morisot. Lithograph.
Victoria and Albert Museum,
London.

130
Pierre Bonnard,
1867–1947, French.
Le Tub. Lithograph. 13 × 18 in.
Bibliothèque Nationale, Paris.

131
Robert Rauschenberg,
b. 1925, American. *Booster*.
Colour lithograph with
photographic elements from stone,
1967. Gemini G.E.L., Los Angeles.

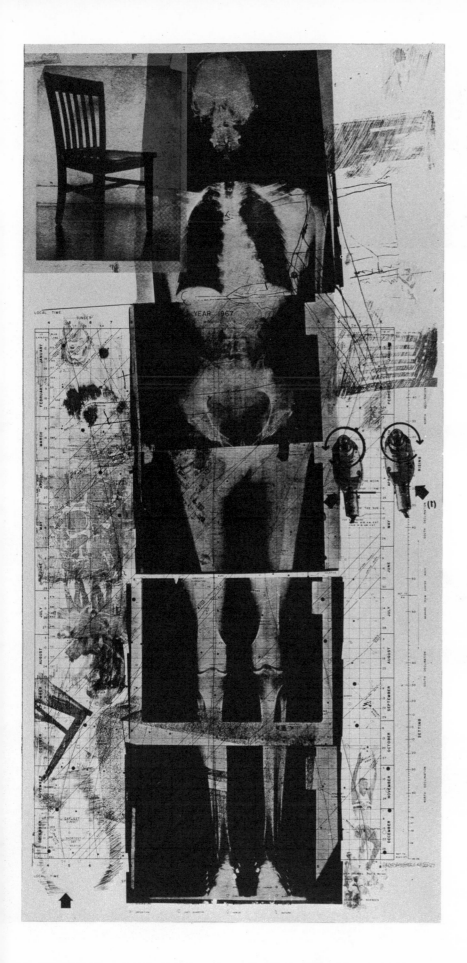

packing and tympan are held in contact. When a handle is turned, the bed is moved under the scraper, made of wood with leather wrapped around it, which exerts an even pressure, and the ink from the plate is transferred on to the paper. The scraper pressure can be adjusted by a screw on top of the press. A power press needs less physical effort.

Plates or stones?

Although I personally consider the use of stones, especially in art departments, an outmoded method of obtaining a lithographic image, I realise that many artists and craftsmen still prefer them. Their argument is usually that the grain on a stone is more organic than that of a plate, producing a richer, blacker image, and that a stone can be scraped and carved. There are many books which cater adequately for those who prefer stones (see the Bibliography)–books which, incidentally, tend not to mention the weight and bulk of a litho stone or the time and physical effort needed for regraining. My preference for zinc or aluminium plates is based on the fact that they are light, easy to handle and store, and can be regrained by the manufacturers quickly and cheaply. There are not many subtleties of drawing which cannot be produced on a plate, and in fact it holds washes and water colour effects better.

One thing that can be done on a stone that is not possible on a plate is scraping out, an example of which can be seen in the masterpiece by Eugène Delacroix, *Le Prisonnier de Chillon* (Ill. 127), in which the highlights and some of the drawing have been done by a knife or scraper of some kind.

Look at the photograph of an old litho stone (Ill. 136), which was used by a printing firm to produce labels. Some of this work would originally be hand drawn by craftsmen. Notice the lettering in reverse. These designs, when needed in large numbers, were transferred to other stones and laid down in repeating rows, rather like the repetitions in some of Andy Warhol's work (Ill. 104). It is possible to take intaglio prints from stone and to reverse drawings, making the image light when it was dark; but these and other intricate methods are for the experienced lithographer.

Processing the plate

When zinc plates have been grained they are usually packed in brown paper packets and

149

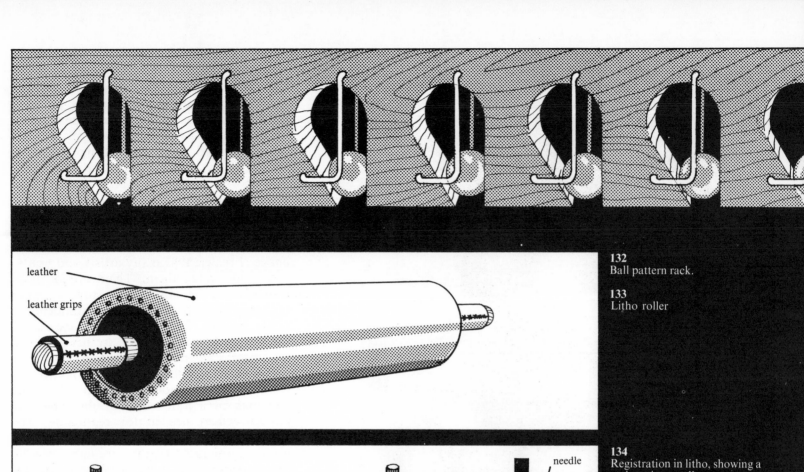

leather

leather grips

132
Ball pattern rack.

133
Litho roller

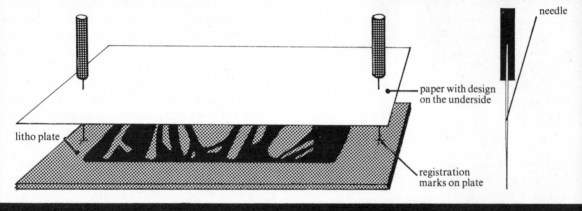

needle

paper with design
on the underside

litho plate

registration
marks on plate

134
Registration in litho, showing a
registration needle.

135
Roller or brayer for inking up
blocks.

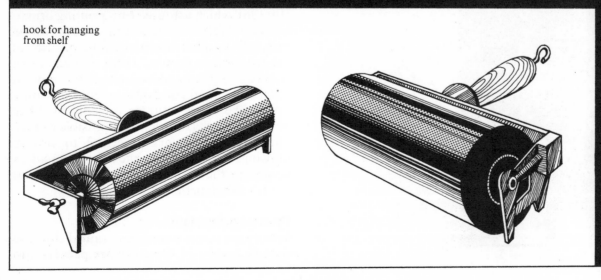

hook for hanging
from shelf

glass ball

interleaved with tissue paper to protect the surfaces from grease. Plates should be taken from the packet only when about to be used. With a stone, once it has been cleaned and grained it is ready for drawing on.

Experiment on the first plate. Try drawing with ruling pens and greasy carbon paper, or even paint objects with litho ink and press them on the plate. After this comes the processing, fixing the design on to the plate so that it is ready for printing. The method tabulated below seems to work best for novices, enabling them to produce technically perfect prints. What these are like can be seen in Ill. 125 of a lithograph being pulled. It shows the image that has been printed from the litho plate on to the paper; the paper is perfectly clean, with no dirty margins, scumming, etc. To achieve this, plates must be handled by the edges, since grease from the fingers will print.

Here then is how to prepare the plate:

1. Gum with a gum sponge a width of approximately 1 inch round the edge of the plate. Gum about 3 inches on one of the longer sides if the plate is to be used on an offset press, retaining the 1 inch width for other sides. This will make the format a little smaller
2. Draw the design in grease (litho chalk, liquid litho ink, etc.) and fan dry. Some heat may be used
3. Dust lightly with french chalk or talc to prevent smudging
4. Gum the whole plate carefully so as not to smudge the work, and dry with a drying flag (Ill. 136)
5. Soften up with a gum sponge by regumming and reduce gum to a thin film by rubbing down and smoothing with a gum cloth. Dry
6. Take out the design with white spirit, using a dry clean rag (this is known as 'washing out'). Dry
7. Put on asphaltum with a pad. Rub down to a smooth thin film with clean dry rag
8. Remove asphaltum with water, sponging gently until the image appears brown. Wash out the sponge
9. Remove surplus water with the sponge so that a damp, even film is left; then, alternately rolling and dampening, charge the plate with proofing black. Dry when the image is sufficiently black

10. Dust the plate with resin and french chalk; wipe off the surplus with a sponge
11. If there is any dirt on the plate, it can now be removed with pumice powder and damp felt. This is when unwanted work can be removed. Use pumice powder in a paste with etch or water. Sponge off. Dry
12. Etch with Victory Etch for $1 - 1\frac{1}{2}$ minutes. brushing round the edges first. Keep the etch solution moving over the plate. Wipe off with a sponge. Wipe the back of the plate and the stone. Wash the etch from the sponge. Dry
13. Spread gum over the whole plate with a sponge and reduce it to a thin film by rubbing with a gum cloth

The processing of stones is very similar, but different etches are employed on them (gum arabic and nitric acid).

Preparing for printing

Wash out the plate again with white spirit and asphaltum as above, reducing both to a thin film. Wash off with a sponge. Dampen the plate and ink it with black, white or a colour.

After printing, apply gum to the plate on top of the colour. (The gum prevents the grease from spreading over the plate and keeps the image sharp for subsequent printing.) Dry the plate and wash out the image with white spirit or turps with a clean rag. Put on asphaltum, and thin by wiping with a clean rag. The plate is now ready for storage or reprinting.

Plate storage

Plate racks have the disadvantage that they buckle and bend the plates. The most satisfactory method of storage seems to be to hang the plates on straight hooks or headless nails, screwed or banged into a wooden strip attached to the walls of the litho room. A small hole for the hook can be drilled through one corner of each plate (see the frontispiece). Several plates can be stored on one hook.

The ideas put forward in the following sections are suggestions only. Most artists and students will in time devise their own methods of experiment and research. Some may find that a stone is ideal, others that paper plates suit them best.

Drawing materials

Besides the traditional litho inks and crayons, lipstick, soap, candles, boot polish, greasy

136
An old litho stone with reverse
lettering and design.

ballpen ink and black carbon paper are all suitable for drawing on plates or stones.

Transfer prints
There are techniques for transferring images on to a lithographic plate. Most relief surfaces or prints (for instance the print of fur, Ill. 59) can be transferred to the plate via transparent 'everdamp' paper. The transfer method can also be used to bring together several original designs on a master sheet, from which they are transferred to a plate for printing.

A gum resist
Gum arabic can be used to draw with; it functions as a white resist. Draw with gum, dry, and then cover with asphaltum (grease). Process in the usual way.

Drawing with pen and liquid litho ink
Ideal for posters, broadsheets or information. One can write in pen and ink as though writing a letter.

The elimination method
The method is the same as that used in lino cutting, except that Erazol is used. Having etched, gum the plate, which is then processed in the normal way, and registered on the same registration marks.

Erasing
Pumice powder and Erazol can be used to take out part of the design, as with a stone.

Registration in colour printing
A separate plate is used for each colour, and it is obviously essential that each plate should be prepared so that each colour is positioned (registered) absolutely accurately in relation to the rest.

Tracing is usually inaccurate. The best method is to make a drawing on a key plate, then draw two small crosses, one at each end of the plate, and take a print from the plate on to offset paper. This is the key print. While it is still wet, dust the print (including the crosses) with a red or purple offset powder.

Put a new plate on the press and dampen it with a clean sponge. Place the dusted key print on top of this plate and put it through the press. In this way the key drawing and the registration crosses are transferred to the new plate as a non-printing detailed design. Draw over the crosses on the plate with litho ink (so

talk Daniels

138
Joan Miró,
b. 1903, Spanish.
A print from 'Album 13', 1948.
Lithograph. Maeght Editeur,
printed by Mourlot Frères, Paris.

137
Harvey Daniels,
b. 1936, British.
Shades and Bikini.
Colour lithograph,
1964. 25 × 17 in.
Collection the artist.

that they will reproduce); then proceed to work on this plate. Process the plate in the usual way and print it in the first colour – say in red.

Repeat the above process – transferring the powdered design from the key print – on a new plate in the press. You now have a second plate with accurately positioned crosses, matching those on the first plate, and can draw in the parts that are to be printed in the second colour. Process, ink the plate in the second colour (say yellow) and put it in

the press. Position one of the prints you took in the first colour (red) on top of the second (yellow) plate by piercing the registration crosses in the paper with holder needles and putting pins through the paper and into the crosses in the plate (Ill. 134). The paper is then accurately positioned, and a print can be taken in which the colours, red and yellow, are properly registered in relation to each other. Any number of colours can be printed by this method, each colour with a separate plate.

139
Allen Jones, British.
Red and Green Baby. Lithograph, 1962. Collection H. and J. Daniels.

140
Henri de Toulouse-Lautrec, 1864–1901, French.
Au Concert.
British Museum, London.

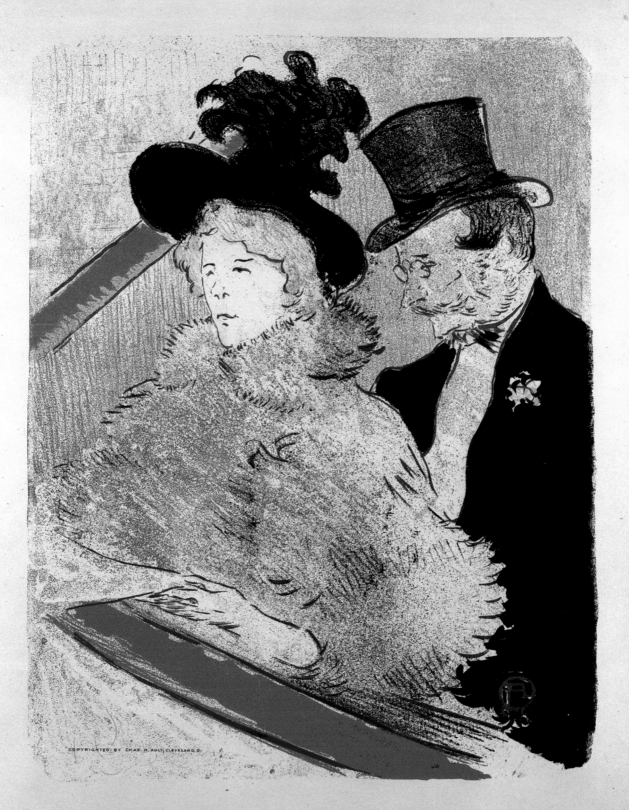

TLautrec.

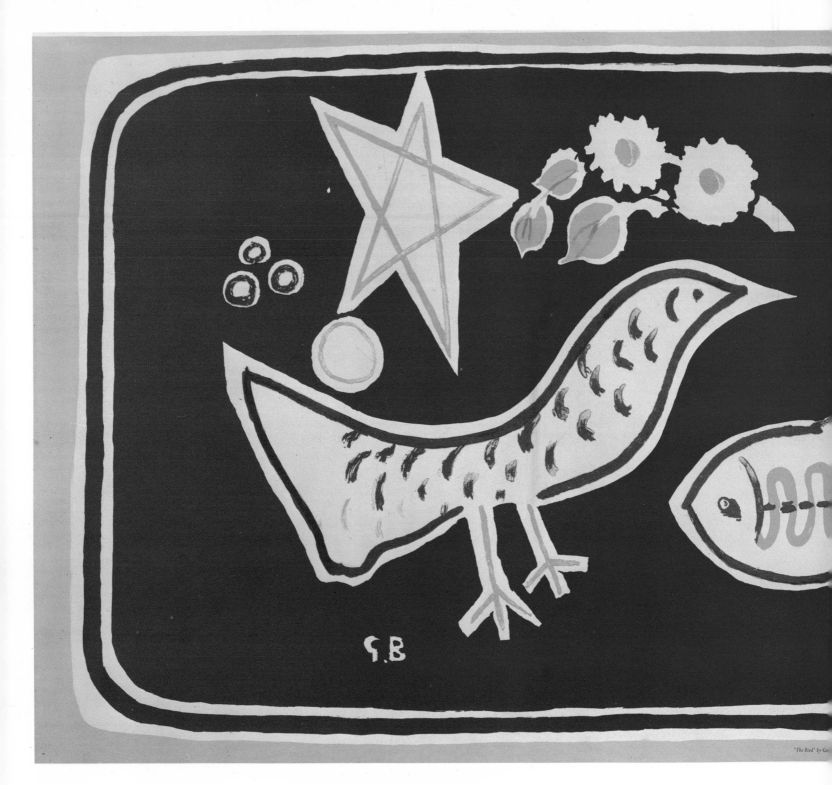

'The Bird' by Ge

141
Georges Braque,
1882–1963, French.
The Bird. Colour lithograph,
1949. 19 × 29 in.
Museum of Modern Art,
New York.

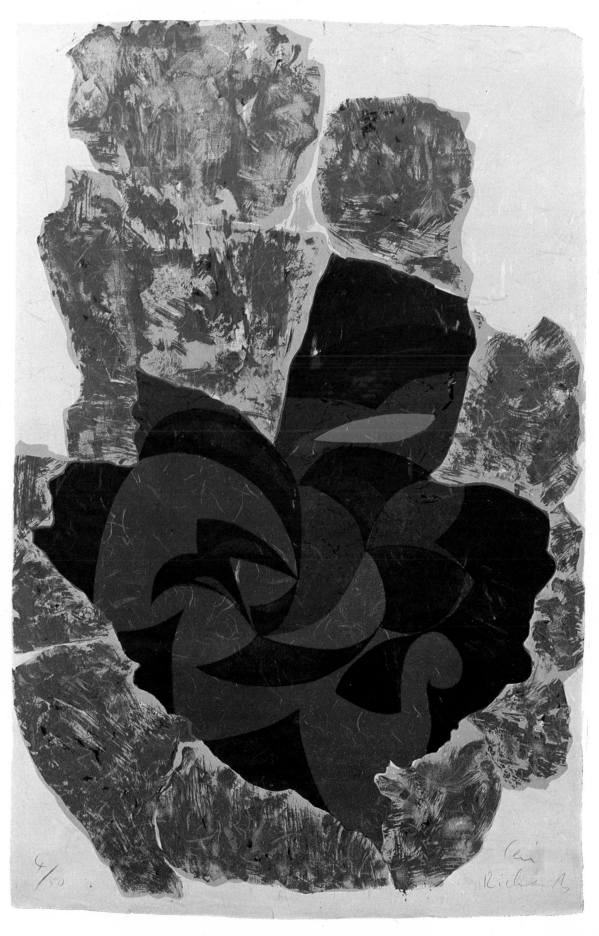

142
Ceri Richards,
b. 1903, British.
The Golden Fish. Colour lithograph
from a series of six prints for piano
music by Debussy, 1959.

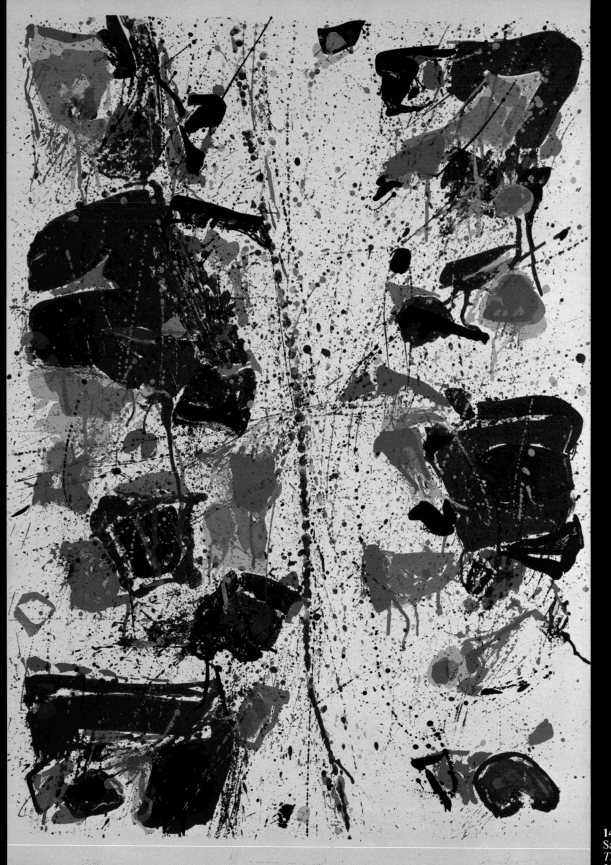

143
Sam Francis, b. 1923, American.
The White Line. Colour lithograph
$35\frac{3}{4} \times 25$ in.

London I / Inside d'Arcy Hughes 1968

Metallic colours

When printing colours such as gold and silver it is best to print in a colour or black, and dust the powder on; the surplus is dusted off when dry. This is a traditional way of using metallic inks, and perhaps still the best in lithography.

Paper

Paper for printing should be comparatively smooth. Hot pressed paper, or lightly sized hand-made paper, is ideal. Smooth cartridge is good for proofing.

Litho inks

Litho inks are usually 'offset' inks, obtainable from any supplier, but one can get direct litho inks. The traditional linseed oil/litho varnish inks are the most satisfactory.

Press black and chalk black for proofing should be non-drying and rather stiff. It is possible to mix on a separate stone a little paste driers with the ink to print in black.

Reducing medium

To make the inks thinner, add a patented reducing medium. Thin varnish is used for Litmask (see Glossary) when the ink must be thinned to a state in which it would not function properly on a normal printing plate. In *Smile Please* (Ill. 122) the yellow is printed in this way. Thick varnish is used to help print difficult colours when they tend to spread.

Lithography has in the past been a painter's medium. During the 20th century, however, the photographic image has become an important part of printmaking. Gestural mark may take second place to the printed photographic image, making a new type of visual impact.

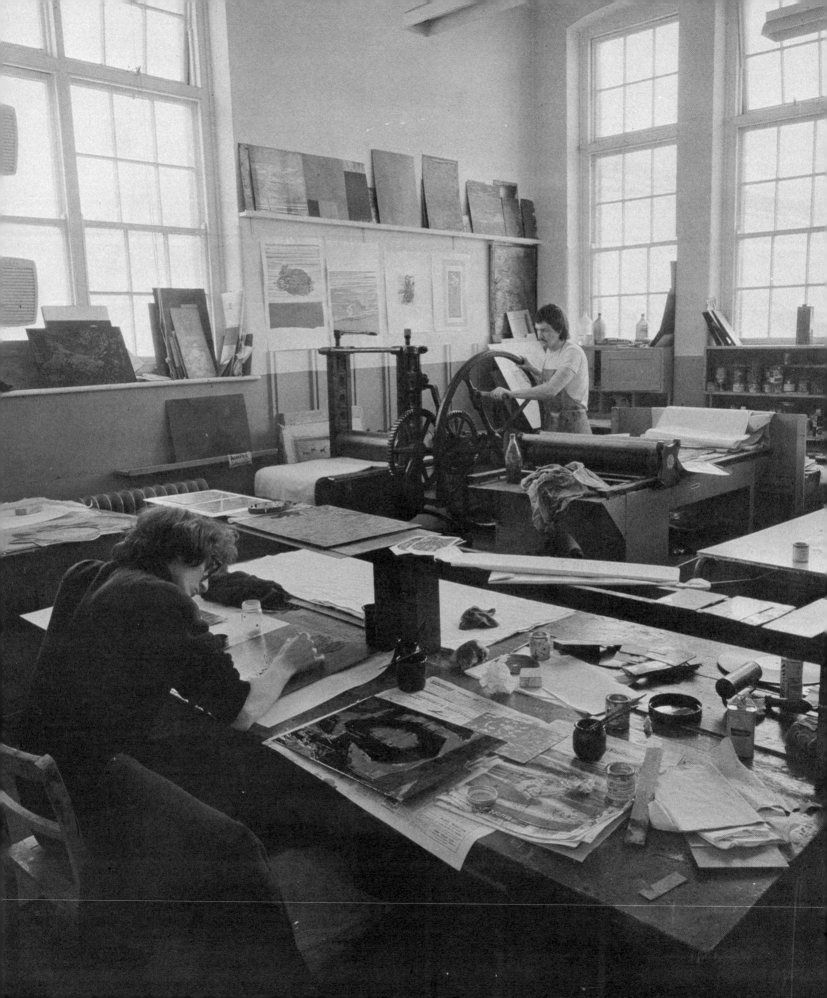

IX
Etching and Engraving

'The strange atmosphere in this print could hardly have been obtained by any other operation, and in my opinion completely justifies the means.' S.W. Hayter, commenting on a print by Karl Schrag

The principle of intaglio or incised printing is the opposite to that of relief printing. It is not the top surface that is printed, but the lines, cuts, scratches or indentations lower than the surface of the plate. The plate, usually metal, is covered with ink, and then the flat surface areas are wiped clean, leaving the indentations filled with ink. After this, damp paper is laid on the plate and printed in a press (Ill. 156).

These lines or indentations are made in various ways. The most common are drypoint, etching and engraving, all of which are printed in a similar way. In all, the print moulds itself to the shape of the plate; or, to put it another way, the plates emboss and make a cast of the paper. This casting or embossing gives the intaglio print its characteristic appearance: the inked areas are raised in relief above the surface of the paper. Sharpness and clarity of line are also qualities of the intaglio print. In etching, the acid, by biting into the plate, controls the depth of line, an important factor in obtaining an accurate and rich final print: Rembrandt worked mainly with this etched line (Ill. 147), as opposed to the engraved line. A press is necessary for intaglio work, owing to the considerable force needed to push the paper into all the indentations to pick up the ink. The mark round the edge of the plate is called the 'plate mark' or 'cuvette' (Ill. 170).

Jennifer Dickson, the English etcher, has written: 'Metal is an inorganic material; it is cool, hard and rigid. It has a granular quality of its own, just as wood has a grain.' The struggle with such an intractable medium as metal contributes to the excitement of the intaglio print: witness the prints of the young American artist John Urban, who creates precise work on a minute scale. A lovely example of light and delicate etching is Whistler's *Thames Warehouses* (Ill. 148). And so much work has been done on the plate of Rembrandt's *A Negress Lying Down* (Ill. 147) that in the print itself there are almost more black lines than white paper.

The image that has been etched and printed in intaglio undergoes a transformation. Not only is the print reversed, but the action of the acid during the printing process changes it into an object apart, with unmistakable individual characteristics. The English artist S.W. Hayter (Ills 151, 185) has been prominent in the revival of etching, his two particular achievements being the reintroduction of the burin (Ill. 13) and a particular method of colour printing in intaglio, completed in one operation, which is described later in this chapter.

The Australian artist Arthur Boyd has demonstrated that it is possible to achieve in contemporary terms a unique and traditional quality with drypoint (Ill. 155). With aquatint, a variety of tones can be achieved, as in the background of Goya's *Los Caprichos* (Ill. 152).

Any texture may be pressed into a soft ground, etched and printed. Gabor Peterdi's

145
The etching studio with work in progress.

163

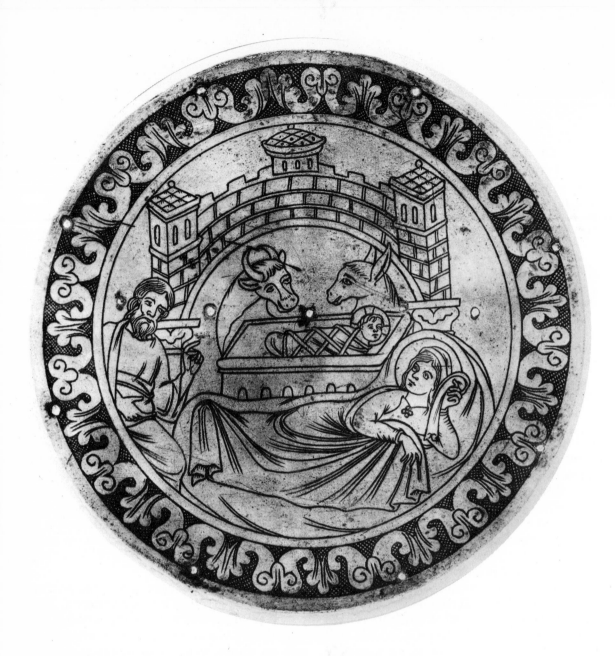

146
German, *c.* 1165.
The Nativity.
Intaglio from the Corona Lucis
in the cathedral of Aachen.
Diameter $7\frac{5}{8}$ in. Museum of Fine
Arts, Boston.

Germination (Ill. 176) shows a range of textures
and shapes from a plate that has aquatint, line
etching, soft ground and stencilled colours. By
contrast, artists such as Mario Avati in France
(Ill. 175) and Eric Marchant in England
continue to use the traditional mezzotint to
produce haunting and delicate images.

Cancelled plates
Many artists are asked by museums and gal-
leries for the plates from which the prints are
taken, not merely for technical interest, but
because they can be regarded as sculptures in
their own right. Some artists will therefore en-
grave marks to cancel them without spoiling
their appearance (Ill. 193).

Three-dimensional work
The main three-dimensional characteristics
are of a low relief type. When the plate is bitten
through entirely in places, the holes make high,
white reliefs on the paper in the course of
printing. By soldering various meshes and met-
als on to his plate, the Norwegian artist Rolf
Nesch gives the print a marked three-dimen-
sional appearance; and his plates are them-
selves prized as works of art.

Intaglio and relief compared
Different printing methods can produce diff-
erent images from the same block or plate, for
example the found piece of wooden packing
case with a design stamped or embossed on it

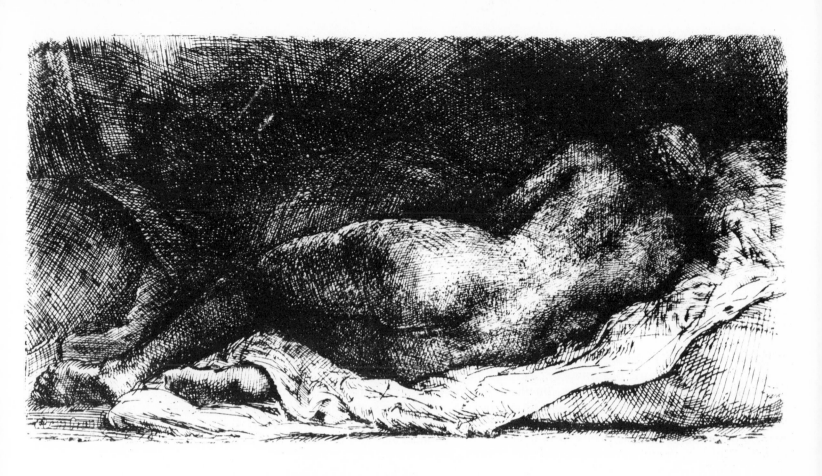

147
Rembrandt van Rijn,
1606–69, Dutch.
A Negress Lying Down. Etching.
Victoria and Albert Museum,
London.

148
James McNeil Whistler,
1834–1903, American.
Thames Warehouses.
One of the Thames set, 1871.
3 × 8 in. British Museum, London.

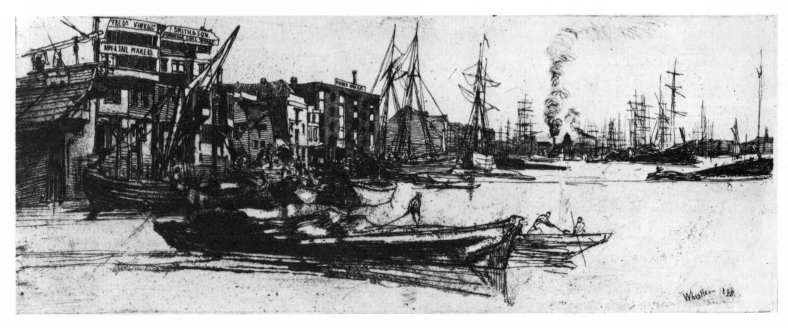

that has been printed and reproduced here in two ways (Ill. 149). The first was done by inking the surface of the plate and printing, the second by dabbing ink into the hollows and wiping the surface before printing. This shows quite clearly the difference between an impression in relief and one in intaglio. The latter was done with lots of soft packing and damp paper which stretched down into the embossing and picked up the ink.

Photographic possibilities

Many artists are now discovering ways of using photography combined with the intaglio process. Often photographic images are screened with a varnish resist on to metal plates, and then etched; some art colleges are experimenting with various emulsions to make photographic plates.

The history of intaglio printing

Engraving is a prehistoric phenomenon, as is proved by incised marks on stones, on the walls of caves and on the tusks of prehistoric animals. Although early engravers of course had no intention of making prints from their carvings, it is sometimes possible to take prints, with interesting results: Carl Zigrosser's *Book of Fine Prints* mentions the 12th-century Romanesque chandelier of the Emperor Frederick Barbarossa at Aachen, parts of which contain metal plates with incised designs from which prints have been taken (Ill. 146).

In real terms, the history of the intaglio print begins in the 15th century—when, as Zigrosser points out, paper had become relatively cheap and Europeans sufficiently wealthy to comprise a market for numerous copies of the same book, sheet or picture. The first dated copper engraving known (1446) is by 'the Master of the Playing Cards'. The earliest copper engravers were goldsmiths, and it is notable that the great Albrecht Dürer, who did so much to develop the art, was originally a goldsmith.

Niello, another form of decoration by engraving, became important at about this time. Silver or gold plate is engraved, and the pattern is filled with niello, a mixture of lead, silver, copper and sulphur. The plate is then polished so that the pattern stands out black against a burnished ground. Before being filled with niello the patterns were sometimes printed on paper, but few original impressions survive.

During the 15th century, engravings were mainly functional models for artists and craftsmen. Kristian Sotriffer says in his book on printmaking that in reproductive work 15th-century artists were able to achieve unusual effects, and he instances white line engraving printed on black paper with white ink.

Germany was an important artistic centre in the 15th and early 16th centuries. Artists and dealers sold directly to a prosperous middle class in such cities as Cologne, Dijon and Salzburg. Martin Schongauer, born about 1450 in Germany, is the first great copper engraver that we know by name. He influenced Dürer, who travelled to visit him, but he died in 1491 before Dürer arrived. Dürer (1471–1528), one of the great masters of printmaking, in both wood and metal engraving, also owed much to engravings by such Italian Renaissance artists as Mantegna and Pollaiuolo. Dürer's work was plagiarised by Marcantonio Raimondi, which may have occasioned his visit to Italy; certainly Marcantonio agreed not to use Dürer's signature. Followers of Dürer included Lucas Cranach the Elder, who made a copper engraving of Luther, and Lucas van Leyden.

Etching originated with armourers, who began to scratch their designs into a protective layer of wax covering the metal, thus exposing them so that they could be etched with acid. Daniel Hopfer (1493–1536) first used an etched iron plate to print on paper, in which he was followed by such artists as Dürer and Altdorfer. The first dated etching (1513) is *Woman Bathing Her Feet* by Urs Graf.

Iron was soon replaced by copper. Rembrandt's work was mostly etched on copper. By continual corrections, additions and reproofing, he created masterpieces using both soft ground and drypoint in his work, and sometimes engraving on to the etched plates. Jean Baptiste le Prince developed a discovery made by Jean Charles François: the aquatint, which made it possible to create tone on a plate. Goya, much influenced by Tiepolo, worked extensively in printmaking; many of his prints were not published during his lifetime. An artist who could not sell his work but is now fast gaining repute is Hercules Seghers, who was a constant experimenter in intaglio and invented many new methods.

William Hogarth turned his thoughts to 'painting and engraving modern moral subjects, a field not broken up in any country or

149
Embossed or stamped wood
printed in relief. Embossed or
stamped wood printed in intaglio.

any age – this I found was most likely to answer my purpose, provided I could strike the passions, and by small sums from many, by the sale of prints which I could engrave from my own pictures, thus secure my property to myself.' The idea worked: Hogarth sold portraits of Lord Lovat, 240 a day for weeks, at a shilling a time, and of course produced the famous series which include *The Rake's Progress* and *Marriage à la Mode*. One of the by-products of his success was a copyright act protecting artists' works, which Hogarth, angered by piracy of his engravings, persuaded Parliament to pass.

In the early 19th century intaglio printing was used mainly for reproductions of famous paintings. Charles Meyron was an artist who helped to revive other artists' interest in etchings. Most of the Impressionists did some etching, in particular Degas and Pissarro.

Modern times
In the 20th century, intaglio prints have been considerably in evidence. The American-English artist Whistler (1834–1903) was more famous for his etchings (Ill. 148) than his paintings, and Whistler's English pupil, Walter Sickert, produced more etchings of a high standard than is generally realised (Ill. 153). Sickert regarded the etching as a way of producing straightforward copies of his drawings and so wanted a 'commercial' standard of

clean sharp lines—'like visiting cards', as he said. He disliked the accidental effects, so prized by some other printmakers, produced by small amounts of dirt 'left on the plate by a skilful printer'.

Munch produced many strange and expressive drypoints and etchings. In Paris, which was becoming the centre for modern printmaking, he made colour etchings as well as prints in other media. James Ensor (1860–1949), the Belgian painter, also made some fine experimental etchings. Many artists worked simply in the drypoint technique until relatively recently, when artists such as Jacques Villon began to work dedicatedly at etching, even making reproductions of other artists' paintings in colour aquatint.

In France, Georges Braque made many important and beautiful etchings, but the most magnificent plates in the 20th century have perhaps been produced by Pablo Picasso in pure etching techniques. He has been a continual experimenter, even using celluloid for intaglio prints. *La Chèvre* (Ill. 154), a sugar lift aquatint, is among the freest and most draughtsmanlike of modern intaglio prints.

Hayter, who has a workshop, Atelier 17, in Paris, and has opened studios in America, persuaded people to take a fresh look at etching and consider its possible technical development seriously (Ill. 151).

Anthony Gross (Ill. 171), a dedicated printmaker and painter, has helped in this revival in Britain, as has Gabor Peterdi in America, with his mixed media prints and his pure etchings and engravings (Ill. 176). Warrington Colescott (Ill. 172), working in a narrative style, sometimes inserts separate intaglio plates.

Much etching is in black and white line, for example as done by Leonard Baskin in America and David Hockney in Britain (Ill. 174). Hockney's suite *The Rake's Progress* shows a masterly use of traditional technique by a contemporary artist.

The prints of Georges Rouault, some of which were originally photographed on to photogravure plates, were published by the picture dealer Vollard, who presented many other suites or albums including those of Bonnard and Vuillard.

Recent artists have made intaglio prints, called 'free form', which have no easily recognisable format, relying on the cutting up and juxtaposition of the plates.

Materials

To make intaglio prints one needs a press, a metal plate, ink, paper, burins, acids and a resist. Here is a more detailed list of materials that will enable the artist to make a print simply in each of the three main techniques—etching, drypoint and engraving.

1. An etching press: it is best to use one as large as possible (Ill. 156)
2. Plates: zinc, copper, steel, iron; plastic, lucite or plexiglass may be used for drypoint, etching and engraving
3. Letterpress and intaglio inks
4. Scrim, gauze, tarlatan or cheesecloth
5. Heavy paper with a 'not' surface that can be damped
6. Engraving tools (Ills 157–166)
7. A scraper
8. A burnisher
9. Files of various grades
10. Sharpening stone, with oil
11. Engraver's charcoal
12. Etching needles
13. A hot plate
14. Acids and acid baths
15. Hard and soft ground
16. Household ammonia and whiting
17. Turpentine or a substitute
18. Drills, jigsaw, roulette
19. A roller with which to apply soft or hard grounds

The etching press

The main types of etching press are the star wheel and the more common type shown in Ill. 156. An etching press is a simple machine, similar in its working to the clothes wringer or mangle. It consists of a bed made of steel which runs between two large heavy rollers. The pressure is adjusted by turning the screws on the sides of the press to lower the top roller towards the bed. The number and thickness of the felt blankets is taken into consideration when printing. It is possible to attach a motor to any of the larger presses, although they are generally operated by hand. Many firms make new etching presses, some to order, and before acquiring one it is best to seek advice from printmakers and engineering firms (see the section on suppliers).

Plates for etching

The three metals mainly used are copper, zinc and steel; occasionally aluminium and

150
Alastair Grant, British.
Mirror Red and Brown. Etching.
Collection the artist.

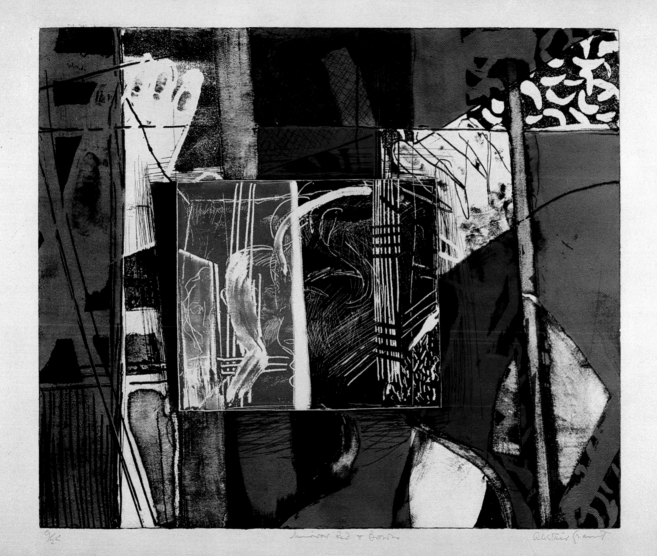

iron. Zinc, the softest and most pliable, becomes granular and textural when bitten; copper, a harder metal, is widely used for detailed line work; steel, which is even harder, is used to produce coloured prints because it does not chemically distort the ink. Acid fumes are harmful, and an extractor fan is a necessity; an etching cupboard with an extractor fan is also a good idea. One disadvantage of iron plates is the poisonous gas, nitrogen dioxide, which is given off during the biting.

Thicker metal is more expensive; therefore try to use an average thickness (16 or 18 gauge). It is possible to buy zinc and copper that not only have a 'jet' mirror finish, but have an enamel backing which is an acid resist. The larger sheets are cheaper, so do your own cutting with a metal guillotine.

Making an etching
When the plate has been cut to size and made ready for use, its edges should be bevelled to a narrow angle for the protection of the blankets on the press. The bevelling is done with files first rough and then fine; after the etching, the bevelled edges can be burnished with the scraper so that they do not pick up any ink.

The plate must be cleaned and all grease removed. Whiting and ammonia are mixed in a saucer to produce a paste and rubbed over the plate with a clean cloth. The plate is then washed or rinsed at the sink. If the water runs smoothly over the plate when it is held under the tap, it is free from grease; if not, the ammonia operation must be repeated. The plate should be heat dried, then left to cool.

A ground must now be rolled on to the zinc plate to form a smooth layer which acts as a resist. The most common form of ground is the solid ball of hard ground which may be bought in any artists' materials shop; it consists of asphaltum wax and resin mixed together, and is black or dark brown in colour. First the metal must be placed on a hot plate at a low temperature, then the ball of hard ground is touched on to the heated plate until it begins to melt, at which point a leather roller is used to cover the whole plate evenly with the ground.

Smoking
Next the plate is smoked with wax tapers twisted together. While it is held upside down, gripped in one corner either in a small hand vice or a pair of pliers (Ill. 161), the lighted tapers are kept moving, about an inch away from the surface. The smoke and the ground combine to form a smooth hard black surface, and any mark now scratched on the plate will show up clearly.

Drawing on the plate
For those who do not like drawing directly on to a plate there are many ways of tracing a design. White chalk or pastel rubbed into the back of a drawing and traced through is one method. A drawing on paper with a soft lead pencil can be placed on the hard ground and run through the press under medium pressure, which transfers the drawing to the plate.

However, many printers nowadays never use tracings. John Urban, whose prints (Ills 173, 178) are so meticulous and detailed, works directly into the ground, which gives both vitality and spontaneity of effect.

Liquid ground
Some printmakers consider it easier to brush on a liquid ground bought in bottles. If you choose to do this, pour the ground into a clean saucer, and use a clean brush to paint quickly all over the plate, which must be laid flat. When covered it is put on the 'hot plate' (not too hot) to even out and dry.

Starting the etching
The best tool for drawing into the ground is an etching needle, which moves around with ease; but any sharp tool may be used. When the image has been drawn, paint 'stop-out' varnish around the bevelled edges of the plate, and on the back if it is not protected. Also use it on any lines or marks made by mistake. The brush must of course be clean. Stop-out varnish can be bought ready for use. Asphaltum dissolved in petrol is a good stop-out varnish. When the varnish is dry, lower the plate into an acid bath or tray (Ill. 167).

Acids
All acids are dangerous and should be handled carefully. All bottles should be clearly labelled, and acid should always be poured into water, not vice versa. Acids are temperamental; it is only by practice, experiment and research that one learns how to control them with complete success.

151
William Hayter,
b. 1907, British.
Pelagic Forms.
Zinc plate inked in intaglio black and violet, and on the surface with yellow and blue inks of differing viscosity for printing in one operation. Victoria and Albert Museum, London.

A quick-biting acid for zinc is nitric, which may also be used for steel; one part nitric to six parts water is a rough guide for dilution, but the proportions should vary according to conditions and the effects sought. The plate is left so that the acid bites into the lines exposed (Ill. 167). Bubbles of hydrogen gas are thrown off by the action of the acid; wipe these away with a feather. The plate may be bitten all over in one operation, as was done in Walter Sickert's *Mother and Daughter* (Ill. 153).

To obtain different depths of bite, the plate is taken from the acid at various stages and the parts that are sufficiently deeply bitten are protected with stop-out varnish. The plate is then returned to the acid bath, which will bite the remaining exposed lines still more deeply. The whole procedure is repeated until the deepest lines have been etched. It is possible to do this in reverse – that is, bite the lines that are required to be deepest, protect them and then needle out lines which will print lighter. Nitric acid can be used for both copper and zinc, but the acid used for a given metal should be kept in a separate bath. Nitric acid turns blue when used with copper, while Dutch mordant, which is generally used for delicate work on copper, turns green.

When lifting the plate out, use rubber gloves. Acid baths should be kept near a tap: if your fingers come in contact with the acid, wash your hands at once in running water.

Dissolve the ground with turpentine, alcohol or petrol, and you have a flat shiny sheet of bevelled metal on which can be seen etched lines below the surface.

Inking in intaglio

Now place the metal on the hot plate (to be warmed but *not overheated*), and spread a small quantity of ink over the surface of the printing plate. Use a dabber for this (material in a ball or cotton pad covered with cloth or leather). Spread the ink all over the plate, making sure that it is forced down into all the lines and indentations. The whole surface of the metal must be covered.

With scrim, cheesecloth or tarlatan folded into a pad, wipe the ink from the surface. It is important that the plate should be kept turning when you are wiping off; if the ink is removed in one direction the whole time, too much is taken from the lines. Start with a pad with ink on it; then use a second pad with

less ink. The last wipings clean the surface of the plate. Finally, use the 'hand wipe' with the edge of the hand (the lower, meaty part of the palm), which must be done very lightly. After each wipe put a little French chalk on the hand, which makes it cleaner and less sticky. Instead of hand wiping, some printmakers use newspaper or newsprint, which they smooth over the plate, finishing with tissue paper. The bevelled edges of the plate can be wiped with rag, leaving the plate ready for printing.

Printing

The paper should be dampened, either by soaking in a tray of water or with a sponge, and then placed between sheets of blotting paper. The plate, slightly heated, is positioned on the bed of the press. The dampened printing paper is placed on the plate and then tissue and blankets are carefully laid on top of them.

The bed is rolled through the press by turning the handle (Ill. 156). The blankets are thrown back and the print is lifted up carefully from one corner (Ill. 168). As it is damp it should be placed beneath a board to keep it flat. Tissue or blotting paper protect it and should be changed periodically as it dries.

Engraving and drypoint

The essential difference between etching and engraving and drypoint is that the first is a chemical process and the other two are manual processes. The engraver actually carves the lines on the plate. Ill. 13 shows the copper being cut with a burin, taking a curl of metal away from the plate. Ill. 12 shows how the tool should be held. The blade-edge angles of these tools vary for making different lines. They must always be kept absolutely sharp and the end must be straight. They vary in size; and sometimes the shaft is lozenge-shaped, sometimes it has four flat sides. It is the plate that is usually moved during cutting, not the hand or tool. A scraper is used to get rid of the burr raised by the engraving tool; a burnisher is used to eliminate marks or to polish surfaces. Light machine oil is put on the plate before burnishing. Dürer's *The Four Witches* is a fine example of copperplate engraving.

Metal plates have a shiny surface. It is possible to draw lightly on a plate with a wax crayon, and then dip it quickly into a very weak solution of acetic acid, which dulls the plate and leaves the drawing as a guide.

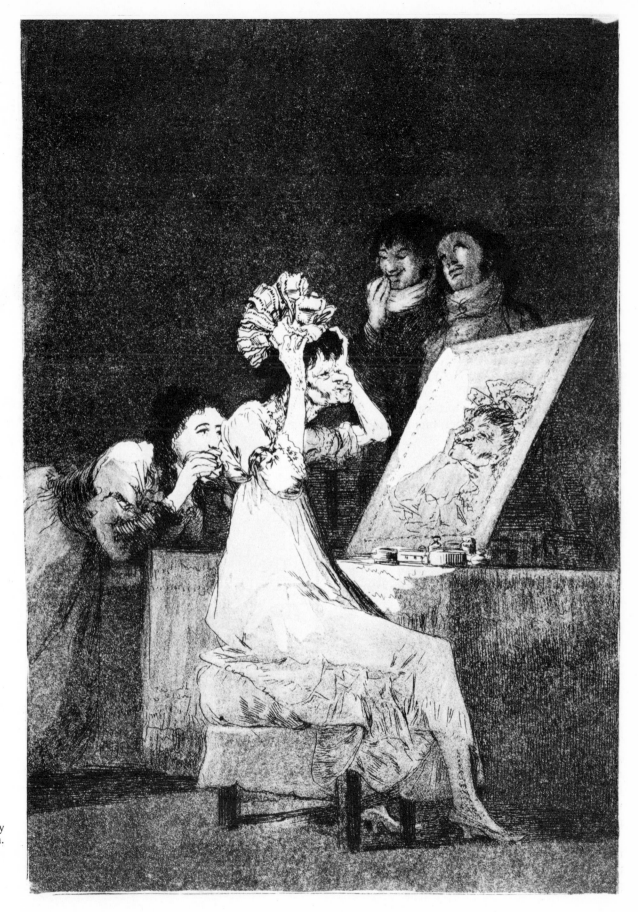

152
Francisco de Paula José Goya y
Lucientes, 1746–1828, Spanish.
Hasta la muerte (plate 55 from
'Los Caprichos'). Etching and
aquatint. Victoria and Albert
Museum, London.

Drypoint

Drypoint is the simplest intaglio process, done by scraping straight on to the plate with a tool such as an etching needle, nail or diamond point. This will produce a burr which holds the ink. No grounds, acids or processing are necessary. This method produces prints of a particularly rich and charming character, as in the drypoints of Rembrandt. It does not stand up to much printing, as the burr tends to flatten, so the first prints are the best.

A method called 'steel facing' can be used to put a thin coat of steel on the drypoint plate by electro-chemical means. The plates can then be printed in large editions, but lose a certain quality by this process.

Open bite

Open bite is a plate without any ground, drawn on with varnish or another resist and put directly into acid. With this method it is possible to flick and throw varnish on to a plate with complete freedom. Turn to Ills 169 and 170, showing a 'blind' intaglio print and the etched plate from which it was taken: the plate was made with the open bite method.

Aquatint

Aquatint is used to give tone on a plate. A ground of resin powder is dusted on to the plate and fused with heat; the acid bites into the spaces between the dust and so produces tonal areas. The amount of resin powder determines the texture and the tone (Ills 152, 173). The use of a very fine powder, for example bitumen (asphaltum), produces a more delicate tone.

Materials for aquatint
1. Dust bag or dust box
2. Stop-out varnish
3. Brushes
4. Resin
5. Wiping gauzes

The aquatint dust box

A dust box is a box with resin at its base. The resin is agitated with a small fan or a pair of bellows. The plate is put in the box and the resin allowed to settle on it. The smaller the particles of dust the finer the aquatint.

Dust bags are often used; the resin is placed in the material, perhaps a silk stocking, and the top tied. The dust is then tapped on to the plate through the material.

MOTHER AND DAUGHTER

153
Walter Richard Sickert, 1860–1942, British. *Mother and Daughter*. Line etching, 1915. Collection H. and J. Daniels.

154
Pablo Picasso, b. 1881, Spanish/French School. *La Chèvre*, 1942. Illustration for Buffon's *Histoire Naturelle*. Lift ground aquatint.

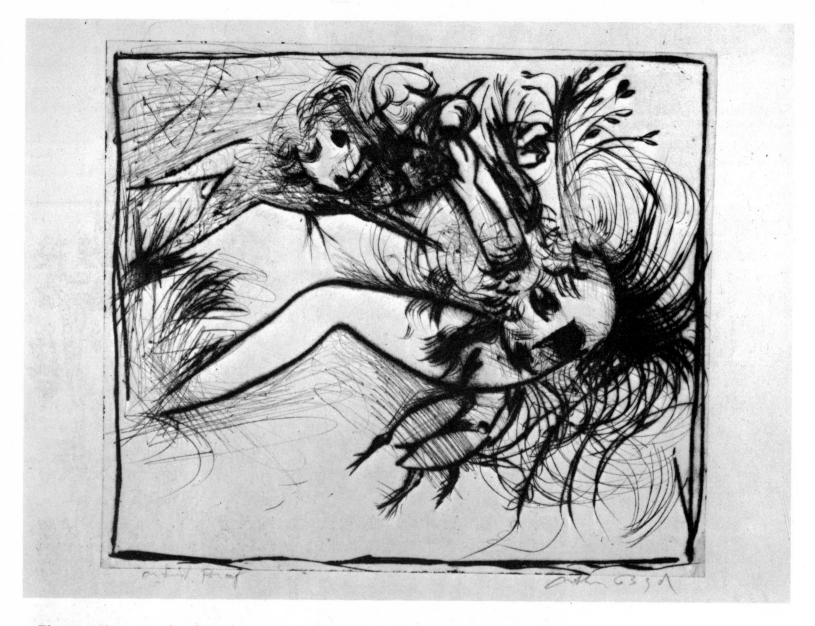

The aquatint must be done in a room without draughts, and the plate must not be covered with too much resin. The resin is heated until it becomes transparent; while this is being done the plate is kept moving over the heat. When the plate has cooled it is stopped out, put in an acid bath and bitten in the usual manner.

Mezzotint

Mezzotint (Ill. 175) was invented in the 17th century to reproduce half-tone. A rocker tool is used all over the metal plate. At this stage it will print in a uniform velvety black. Working on this surface with a scraper and burnisher will produce a range of tones from black to white.

Sugar lift or lift ground

There are various ways of using aquatint on to which a direct drawing may be made. A mixture of sugar water and litho ink is used to draw on to the plate, and when dry is covered with asphaltum varnish. The plate is left in water for some time, and the sugar swells and lifts. The metal exposed is etched in acid (see Picasso's *La Chèvre*, Ill. 154).

Inks

Black copperplate inks come in five qualities: warm, cold, strong, medium and light. Not many firms produce inks for colour etching, so it may be necessary to experiment with colour letterpress and litho inks (see the list of suppliers).

155
Arthur Boyd, b. 1920, Australian. *Figure and Flying Beast*. Dry point. Maltzahn Gallery, London.

156
Etching being put through the press.

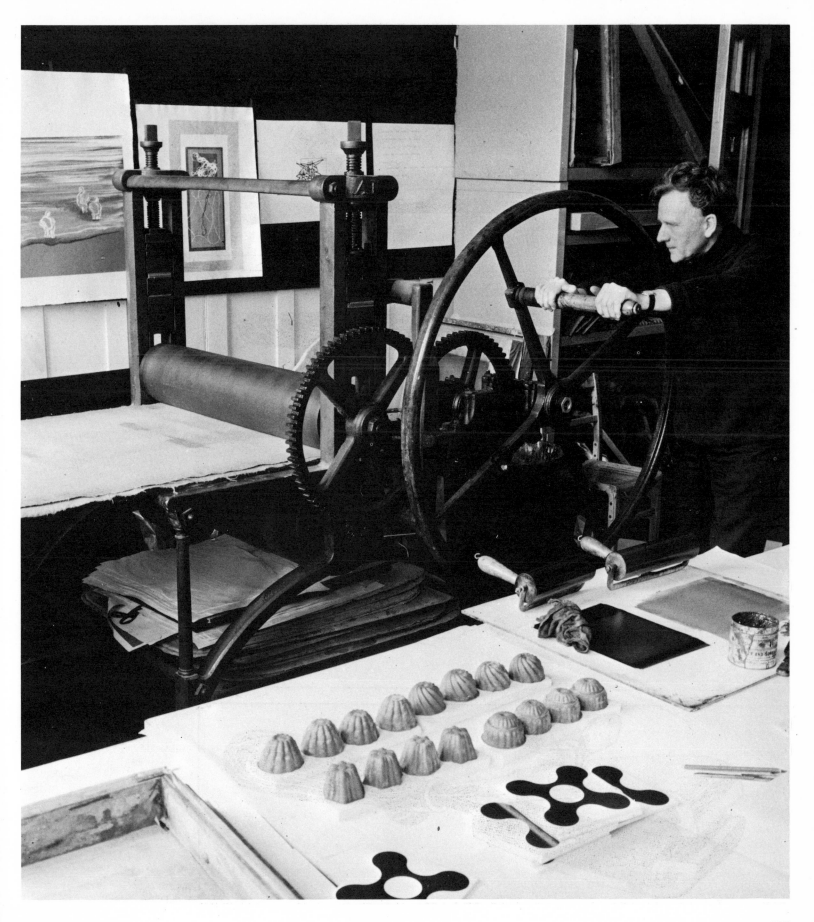

these angles vary

157
Burin or graver for engraving.

158
Scraper.

159
Burnisher.

160
Etching needle.

161
Hand vice.

162
Roulette.

163
Small gouge for woodcutting.

164
Stanley knife.

165
Multiple tool for wood engraving.

166
Spitstick for wood engraving.

Soft ground

A soft ground is rolled on in the same manner as a hard ground, but without 'smoking'. Leaf, lace, string, straw and similarly textured objects can be laid on the plate, which is then put through the press. The materials are lifted off and take some of the ground with them. The plate is then etched and the impression of the textured object is printed.

A soft and slightly blurred line similar to that of a pencil drawing may be made with soft ground, by laying a sheet of thin paper on it and drawing with a pencil or pen. The pressure transfers some of the ground from

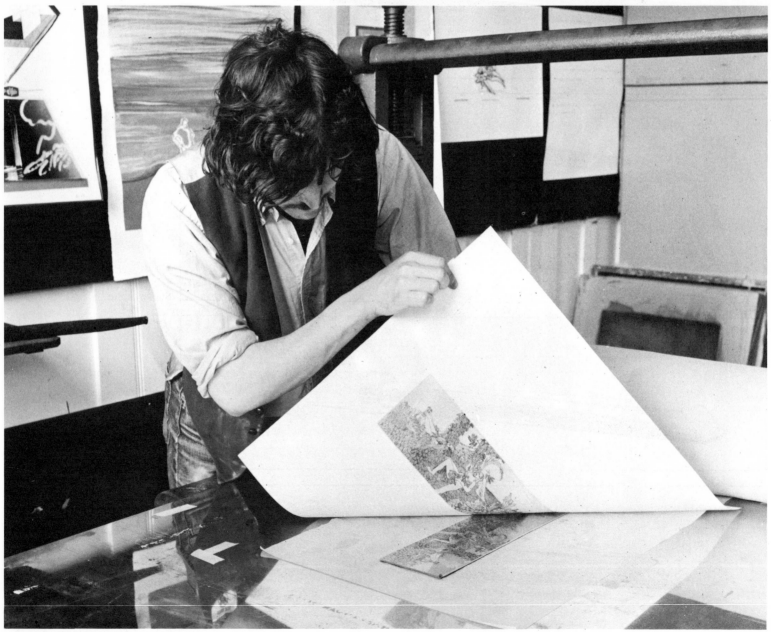

167
Etching plate with needled design in acid bath. The bubbles collecting round the needling are being brushed away with a feather.

168
Lifting a print from long thin etching plate using paper 'fingers'.

169
A plate screened with varnish; etched with open bite.

170
A 'blind' print (i.e. from the uninked plate) taken from it, showing the sculptural quality.

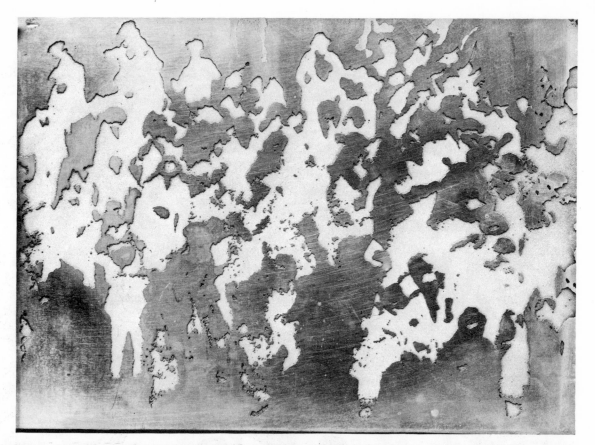

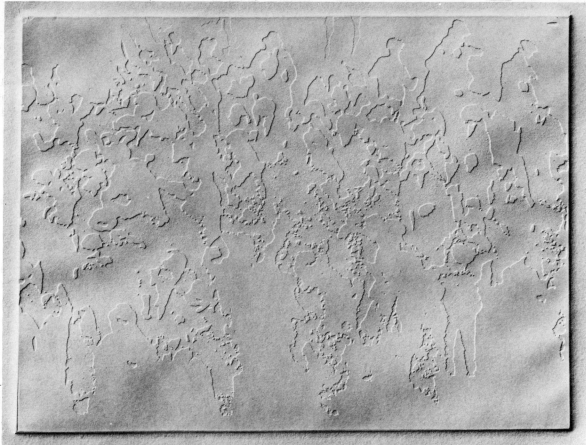

the plate on to the paper, and the etch bites into those parts from which the ground has been lifted.

Colour etching

One method of colour printing is to have an intaglio plate inked up in the usual way with a colour, and then roll another colour on to the raised surface, preferably by using a large rubber composition roller. Ill. 10 shows the pink intaglio plate being rolled over with a thin film of blue ink. This means that both surface and intaglio are coloured and can be printed in one operation. The roller should be large enough to cover the plate in one rolling.

If the plate has incisions of many different depths, it is possible to roll one colour over another without the colours merging and muddying. This is done by varying the oil consistency (viscosity) of the inks; the viscosity keeps the colours apart. This aspect of colour printing has been developed by William Hayter in Paris and by Jennifer Dickson in Brighton, England. Hayter's *Pelagic Forms* (Ill. 151) is an example of a plate inked in intaglio with a mixture of black and violet, and on the surface with yellow and blue inks.

The more traditional way of making colour prints is to have several plates, each printing one colour. This is done by the key plate method described in the chapter on lithography; a print is taken in black from one

171
Anthony Gross, b. 1905, British.
Shadows 1. Etching.

172
Warrington Colescott, b. 1921,
American. *Thetis*. Etching printed
from two plates. Victoria and
Albert Museum, London.

plate and transferred to another of the same
size. The plates can all be drilled with minute
holes, one at the top and one at the bottom.
The paper can then be pricked through these
holes with a needle for registration purposes.

The stencil method
Another method of using colour on intaglio
plates is to stencil the colours; stencilled
colours are seen in *Germination No. 1* by
Peterdi (Ill. 176). The two most popular
methods are silkscreening on the plate and
stencilling through card.

Using thin metal
One interesting experiment, done in order to

incorporate small flat areas of pure colour on
a normal etching plate, has been described by
Peterdi. After inking the plate (say in black)
he inked several extremely thin sheets of
copper, each in a different colour, and then
placed them on top of the basic printing plate.
Plate and copper sheets were then printed in
one operation, with very successful results.

It is also possible to cut up the plates and
ink each piece separately. Cut-out intaglio
plates may be inset into a main plate, as in
Colescott's *Thetis* (Ill. 172). Notice also
Gretchen and the Snurl (Ill. 174) by David
Hockney – a black and white print made up of
five different metal plates, three roughly the
same size and two of other sizes.

1/20 1969 *the Lizard* Urba

173
John Urban, b. 1941, American.
The Lizard. Line and aquatint,
1969.

174
David Hockney, b. 1937, British.
Gretchen and the Snurl. Etching,
1961. Collection H. and J. Daniels.

175
Mario Avati, b. 1921, Monaco.
Nature Morte à la Feuille Timide.
Mezzotint. Victoria and Albert
Museum, London.

176
Gabor Peterdi, American.
Germination No. 1. Aquatint,
etching and engraving, printed in
black with offset colour, 1952.
20 × 24 in. Gift of Mr and Mrs
Walter Bareiss, Museum of
Modern Art, New York.

artist proof IX Germination, No I Petlin '52

épreuve d'artiste. 1/7 Ève Jennifer Dickson '65.

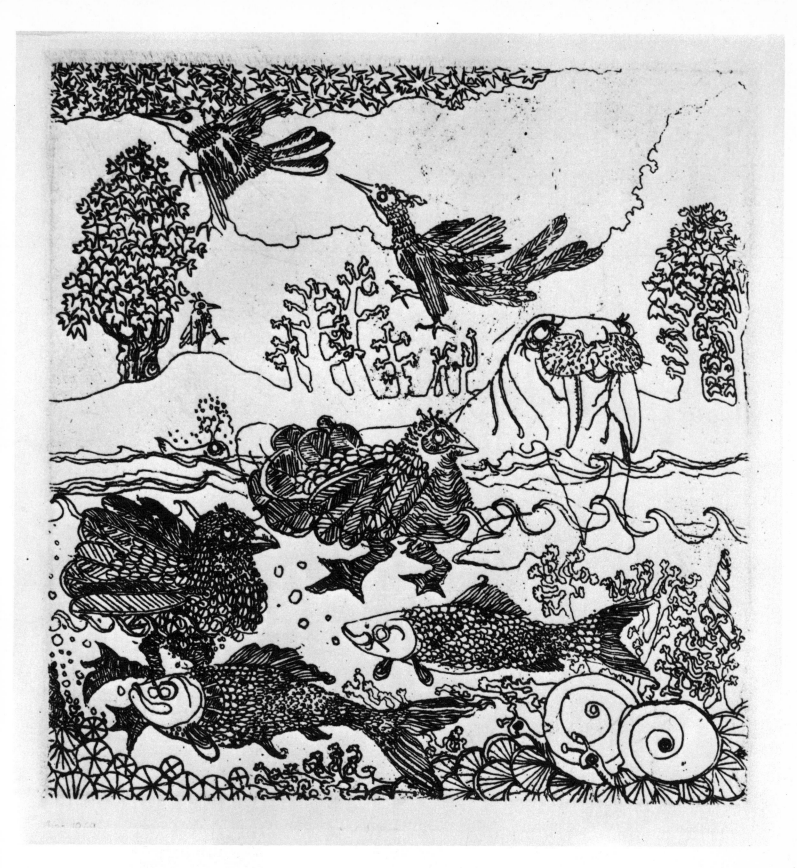

177
Jennifer Dickson, British. *Eye*.
Part of a series of colour etchings,
'Genesis'. Victoria and Albert
Museum, London.

178
John Urban, b. 1941, American.
The Walrus. Line etching, 1969.

X
Mixed Media

'Why did Seghers do all this? Why was he not content with the existing techniques of etching as practised so successfully in the next generation by such figures as Rembrandt and van Ostade?' Julian Trevelyan, artist/printmaker

A mixed media print is a print that has been executed with more than one of the various printmaking techniques. For example, in *Chequerboard* (Ill. 180) the print includes etched and shaped lino printed in relief, as well as pure lithography and cut lino. In the lower part of the print, a rectangular area of black, printed by lithography, is overprinted by cut lino squares in dark green.

Strictly speaking, an etching combined with drypoint or aquatint is a mixed media print and is sometimes referred to in catalogues as such; but it is not so regarded for the purposes of this book. The two elements are, after all, printed in one operation by the same intaglio method; whereas the techniques described in this chapter are those not traditionally thought of as going together–etching with monoprint for example, as in Carole Stephens's print (Ill. 181).

Artists use new materials, methods and combinations because they cannot make the required final image in any other way. For example, to achieve a particular effect it may be necessary to ink up a wood block and print it over a line print in order to add texture. But often tensions are created in the work by accident, as a result of employing two media on the same sheet of paper, and the artist who works with mixed media may surprise himself by discovering relationships that were not previously apparent, and which prove to be both unusual and stimulating.

Collage is very closely related to printmaking, and especially in the field of mixed media. A lively, experimental approach to these forms of creation was largely pioneered by Picasso and Braque, who found they could achieve startling juxtapositions by combining different elements.

One important feature of the mixed media print is that it may encourage the printmaker to stop working in watertight compartments and making a fetish of technical virtuosity. While the artist must be professional in all aspects of his craft, technique is not the most important thing of all. Once, when I remarked how badly a particularly eminent artist had printed, a curator of prints of a famous public gallery replied, 'I rather prefer them badly printed.' Sterile perfection in execution is certainly a poor substitute for creativity and lively ideas.

A good example of a successful contemporary mixed media print is *Collection No. 7* (Ill. 187). This is a straightforward work by a young English artist, Peter Hawes, who has made a subtly coloured yet vigorous print. Some parts of it were printed from cut lino (the butterfly drawing in white); there is some flat colour, taken from an inked piece of cardboard, at the top of the print; and parts are printed from various pieces of worked and etched metal, both in intaglio and from the raised surface; this is an excellent example of many methods and techniques forming one

179
Student drawing with a flexible toolmaker's drill on a metal plate with other power tools in the background.

complete statement. In Ill. 184, tables are seen cluttered with various items, some of which have been mentioned or shown earlier in this book; they are all objects from which impressions can be taken. In the centre of the table is a traditional wooden fabric or wallpapering block, and near the front is the woodblock *Australia*, which has figured in several illustrations. In the background a mixed media print is hanging up.

Complacent assumptions about what a work of art should be are often destroyed by looking at this type of print. Attitudes and boundaries are questioned and redefined. One of the ways printmaking develops is to push ideas to their limits and by doing so redefine not only the print but also art itself.

Tom Wesselman has developed a technique of combining an embossed print with pencil work. The paper can be seen to be moulded or deeply embossed, while the precise compass and ruled lines, done with a hard pencil, can easily be repeated with a template.

In *Shake* (Ill. 182), by the English artist and illustrator John Lawrence, the media of lino and hardboard have become so integrated in the image that, unless the print itself is seen – and looked at closely – it appears to be a lino cut in its entirety.

Students in colleges of art and the art departments of universities are experimenting with the mixed media prints; an example is Carole Stephens's monoprint combined with etching (Ill. 181). Many of these experimenters will be the mature artists of the future, and we may perhaps be approaching a time when the print, painting and sculpture will share the same status; the artist will produce a three-dimensional printed painting and similarly unclassifiable creative objects. *Flowers* (Ill. 104) by Andy Warhol, an image screened on to canvas, already goes part of the way. Is it necessary to compartmentalise, and insist that this work is either a painting or a print?

The history of the mixed media print

The history of mixed media prints is closely related to the history of other media, as in the case of the stencils with which 15th-century woodcuts were coloured. Hercules Seghers (1590–1640) was until recently one of the forgotten figures in the history of printmaking. He was an artist whose urge to self-expression overcame all technical difficulties; he even printed two plates, one on top of the other, which had no apparent connection. He would also print on many materials and colour these by hand. William Blake (1757–1827) was also an experimental printmaker and frequently mixed his media. Edgar Degas (1834–1917) combined media by colouring his prints with pastels and paint; so did Daumier, for example in *J'ai trois sous* (Ill. 183), which is a black and white print coloured by hand. Degas would also combine monoprint with etching or lithography (see the chapter on monoprinting).

Modern times

Mixed media printmaking has been given a tremendous boost in recent years by S.W. Hayter, working in France, by Gabor Peterdi and Warrington Colescott in America in their intaglio prints combined with stencils, and by Michael Rothenstein in England in his relief prints combining photogravure, wood, lino and metal. Colescott's *Thetis* (Ill. 172) is an etching printed from two plates in intaglio, including colours stencilled on the surface, then with two cut-out intaglio plates set in the main plate. *Cinq Personnages* (Ill. 185), by Hayter, is called an engraving but is in fact made with soft ground etching and three-colour offset from silk screens.

Many *avant-garde* artists are using completely new methods of printmaking. The print by the Pop artist Oldenberg (Ill. 188) is a serigraph printed in colour on felt, plexiglass and white plastic, with felt bag, plastic disc and rayon cord encased in the plexiglass. Jim Dine has on occasion attached mass-produced plastic strips to his prints (Ill. 107). An extension of the blind embossed print (Ill. 170) is the vacuum-formed print. A sheet of plastic, heated to make it pliable, is forced by vacuum over a mould of wood or metal. The plastic may be printed in colour before being formed.

Materials

The materials for mixed media printmaking are those which are basic to printmaking of all kinds. The artist should be primarily concerned with the idea and the image, rather than with technique. It is advisable for the printmaker to find his own way of combining media and materials, and this must come out of creative necessity. The exploitation of and familiarity with modern technology is what is changing the face of printmaking: see Claes Oldenberg's *Teabag* (Ill. 188) and Robert Rauschenberg's *Booster* (Ill. 131).

180
Harvey Daniels, b. 1936, British.
Chequerboard. Lithography, etched
and cut lino, 1965. 40 × 26 in.
Kemptown Gallery, Brighton.

181/*page 194*
Carole Stephens, b. 1946, British.
Etching and monoprint. 30 × 22 in.

182/*page 195*
John Lawrence, b. 1933, British.
Shake. Lino and hardboard, 1967.
Collection H. and J. Daniels.

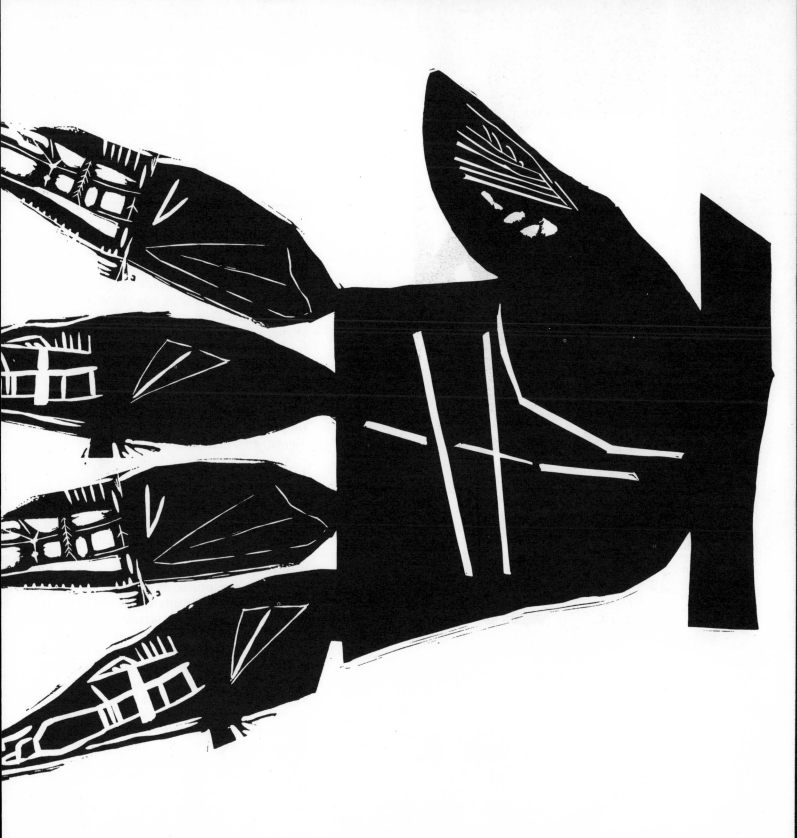

Methods

It is important to realise the possibilities of the media involved – the inherent potential of their particular characteristics in the context of what you are trying to achieve. Remember too that there are certain simple technical points which should be borne in mind. For example, in combining etching and lithography it is usually impractical to print the etching first, because the pressure of the lithographic press would flatten the embossing done by the etching process. Scissors, nails, etc. will ruin the tympan of a lithographic press. Many mixed media prints can be improved by the use of a hand roller.

Of particular interest is the print by Carole Stephens (Ill. 181), who was a student when she made it. Until it was possible to achieve the desired result, she made monoprints from perspex; not until then was the etching plate incorporated. The care needed to adjust the shape, colour, rolling, registration, etc. was formidable. The vast amount of work involved is evidence that the print is the result of a genuine search for an appropriate solution.

In Ill. 179 a student can be seen making marks in a metal plate with a flexible-drive toolmaker's drill which could be used on almost any material.

Litmask

An offset press can be used to transfer ink (reduced with varnish) on to the rubber blanket, and then on to the print. The print is covered with a paper stencil (Litmask) that masks out non-printing areas. This is an ideal way to add flat colour to photographs, lino and silkscreen prints. It requires no preparation other than cutting the paper mask and applying colour with a roller to a flat zinc plate.

I do not think that traditional methods of printmaking such as lino cutting will ever die out, though all types of printmaking suffer periods of comparative neglect owing to the vagaries of fashion. Artists who feel the need to work in a particular medium or tradition can do so with confidence; the time has passed when a lithograph or etching automatically commanded greater respect than other types of print. And I hope that the illustrations in this chapter convince the most conservative reader that one of the many ways in which art can be created is by combining seemingly incompatible media.

183
Honoré Daumier, 1808–79, French. *J'ai trois sous*. Lithograph coloured by hand. From the series 'Parisian Emotions', 1839. Victoria and Albert Museum, London.

184
Some of the blocks, materials and tools used in the experimental prints in this book (including wood block, 'Australia'). A mixed media print is hanging in the background.

185
William Hayter, b. 1901, British.
Cinq Personnages. Engraving, soft
ground etching and three-colour
effect from silkscreens. Victoria
and Albert Museum, London.

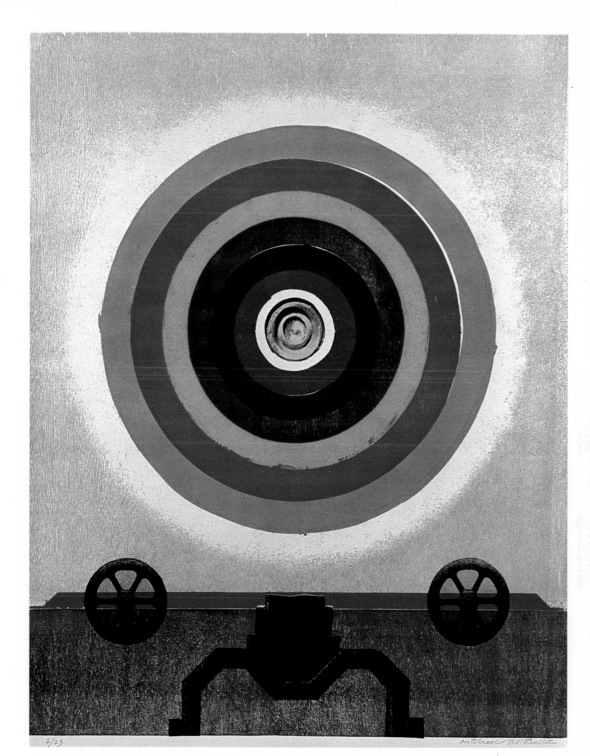

186
Michael Rothenstein, b. 1908,
British. *Black Wheels*. Wood,
linoleum and letterpress half tone
blocks, 1969. 31 × 23 in.

Collection No. 7. ½ Peter Hawes '66

187
Peter Hawes, b. 1940, British.
Collection No. 7. Etched metal
combined with cut lino and card,
1966. Collection H. and J. Daniels.

188
Claes Oldenberg, b. 1929,
American. *Teabag*. Serigraph
printed in colour on felt, plexiglass
and white plastic, with felt bag,
plastic disc and rayon cord encased
in plexiglass, 1966. 39 × 28 in.
Museum of Modern Art,
New York.

3
Collecting and Caring for Prints

189
Sir William Nicholson, 1872–1949,
British. *The Exhibition*. Woodcut.
William Weston Gallery, London.

PHOTOGRA
PHIE
ARTISTIQUE.

LES HBC CONQUET
EDITEUR

GRAVEURS
DU XIXᵉ Siècle
par HENRI
BERALDI

TOM
IV

Hᵗ BER
TOND LES
COUPE LES CHAIS
ET VA TEN VILLE

FELIX BUHOT inv. sc.

PHOTOGRA
PHIE

XI

The Artist and the Collector

'Buy prints because you love them and not because you calculate they will earn money for you.' Zigrosser

This is excellent advice, and not even as unworldly as it sounds: prints acquired out of love or conviction are often the very works which appreciate in value, since other people tend to feel the same way about them. However, art collections are built up for a multitude of reasons, some of which will be examined here.

The artist

There are two main types of artist/printmaker. The studio printmaker works mainly, if not exclusively, within the printmaking media. He probably prepares the blocks or plates and does all the printing of editions himself. As this is time-consuming work, he will probably produce only small editions, and the largest rarely exceeds seventy-five copies. Editions over seventy-five are liable to be taxed as 'fancy goods for domestic use'. The usual edition size is twenty-five prints. The printmaker may do some other work, such as teaching or printing, and this will enable him to be fairly independent in his business relationships with dealers and retail outlets.

The other type of printmaker is an artist who already has an established reputation in another of the visual arts–perhaps a painter or sculptor. This kind of artist usually accepts commissions from dealers to produce original blocks or plates from which prints can be taken in comparatively large numbers–over

seventy-five copies and more commonly 150–250 copies. The artist or dealer employs a specialist to do the printing, which is overseen by the artist. He will sign his approval and number each print when the job is finished. The artist often accepts a fee for his work, and the edition then belongs to the dealer to dispose of as he chooses. These prints compete for the same market as studio prints, but as there are more of them they are also distributed more widely. There are excellent and worthwhile prints of both types available.

The collector

One important reason why collections of prints are built up is that their low cost makes it possible for people who are not rich to acquire vital, creative and genuine works. The variety of work available, for example ranging from a lithograph by Daumier (Ill. 128) to an experimental mixed media print by Peter Hawes (Ill. 187), attracts people with widely different interests. An ordinary framed reproduction of a bad, or even a good, modern oil painting, which can be seen in so many houses, seems to me an indication of both lack of visual awareness and an unadventurous spirit. Collectors – and indeed anyone who buys a print can be considered a collector – discover that there is a special excitement in acquiring an original work of art.

Specialist collections

Having acquired a few prints and gained some experience, a collector may see fit to specialise. There is, for example, the German collector

190
Remarqué by Félix Hilaire Buhot (1847–1898, French) in the margin of his etching for the frontispiece to *Les Graveurs du XIXe siècle*. British Museum, London.

Price one Shilling. Defign'd and Engrav'd by W. Hogarth. —— Publifh'd According to Act of Parliament. 1747.

191
The lower edge of a Hogarth print that he engraved himself showing the signatures engraved in the metal.

who has the largest collection of Pop Art graphics in Europe. And apart from a commitment to one style of art, collectors often find that they are taken by particular techniques. There are significant collections of modern American silkscreen prints, of suites of etchings as illustrations, and so on. Another buyer may be looking for a special proof, or for a print called a remarqué, on which the artist has drawn round the edges (Ill. 190), and which will probably have a rarity value.

Old Master prints
Old Master prints are usually very expensive, and before embarking on a collection it is advisable to make a special study of the subject. Information is published in catalogues, and museum curators and specialist dealers will also give expert advice. A study of paper is necessary, as in some cases the paper may be the only evidence of the date and authenticity of the print. A magnifying glass is generally a useful accessory.

The multiple
Many contemporary artists and printmakers are venturing into the field of the multiple. The multiple is a work of art that is not produced singly or in limited editions, and which therefore does not have the rarity value of the traditional fine art object. It is as near to being a mass-produced item as possible while still being original, and is sold unsigned. Artist/printmakers moving into this field include Claes Oldenberg in America and Joe Tilson in England. Fine-art dealers are encouraging this trend because it helps to publicise artists and introduces people to the idea of collecting. At the present time the word 'unlimited' usually means hundreds rather than thousands, but even this enables work of very high standard to sell for comparatively low prices.

How to find the print: study and acquisition
Before starting a collection of original prints, it is obviously advisable to make a study of them. No book can define completely the exact feel of the print, nor can reproductions show its quality and richness. S.W. Hayter has written: 'We are trying to describe a species so completely different from the actual means of description that clear definition and statement become almost impossible.'

London I / Inside d'Arcy Hughes 1972

Therefore:

1. See how they are made (possibly make some yourself)

2. Look at as many prints as possible

3. When buying, be adventurous and in the final analysis buy what you like because you like it. Do not hesitate to sell or dispose of early 'mistakes' as your taste develops

One of the quickest ways to learn about prints is to come into contact with artists themselves. Artists are not always as silent as romantic tradition has it, and often like to talk about their work, especially if given an opportunity to show it. They will frequently discuss the work of other artists and give freely the benefit of an experienced eye and sound knowledge. To see prints being made, visit a printmaker's workshop. Do not hesitate to ask questions. Artists, especially in the United States, sometimes join together to rent a studio to work co-operatively; they are usually very pleased to show visitors around, if only because work is often sold on the premises. The head of printmaking in a college of art or the art department of a university is often helpful to the amateur printmaker or interested visitor.

Exhibitions

As there are several copies of each work, a print can be shown to the public at the same time in different parts of the world. There are touring exhibitions of prints in the museums and municipal and other galleries of many countries. Galleries also often house permanent collections of modern prints, and these are available for study. If your local gallery does not have such a collection, suggest to the curator that he found one! Permanent collections are frequently enlarged with new work and often complement an established collection of traditional masters. The major national museums usually have a special print room which is organised on a reference library system. These house rare and important prints of historical significance as well as modern work. The keeper of these collections is normally welcoming to the interested amateur, and as all the works are catalogued in detail, it is easy to select individual prints for special study.

Printmaking societies continue to be set up

192
The title signature and date of the lower edge of Ann d'Arcy Hughes' print with some of the print showing.

in America and England and for a nominal fee or annual subscription these often send collector members a guaranteed number of prints each year. Your local municipal museum will probably keep a list of the addresses of these societies. Art dealers have often published prints (see Vollard's *Recollections*), and many book dealers and book shops have suites of original prints for sale. Recently there has been a rapid rise in the number of books on printmaking being published, which demonstrates that public awareness has increased. Much more information is now available about what used to be a rather sparsely covered subject.

Authenticity

Ill. 192 shows the way in which modern printmakers sign their work. Ill. 191 is a Hogarth signed in the metal. Reproductions will usually, like the reproductions in this book, dissolve into half-tone dots on close examination. Often a richness in the original compares favourably with a thinness in reproduction. With experience one quickly recognises certain signs: the intaglio, the relief and the plate mark all indicate that a print is an original.

At one time the printer and the artist were both acknowledged. Nowadays the artist signs the print, conventionally in pencil, on the right hand side. This is not just an autograph; it indicates that the artist has approved the work as it has turned out. Therefore the signature should not be written on the stone or plate, but added after the work is printed. The date is usually written after the name, which is useful as a record for the artist, for the biographer or art historian, and for the information of the curator and collector. On the left the artist writes the number of the print over the total in the edition, like a fraction: for example $\frac{5}{8}$ signifies that the print so marked is the fifth in an edition of eight (see Ill. 192). If the print has a title, this is written in the centre between the edition number and the signature.

Sometimes one finds particular prints marked 'artist's proof' and followed by a Roman numeral. These are special prints that the artist keeps, usually between five and ten per cent of the total number in the edition; if the edition is fifty, the artist may keep up to five additional prints which will be marked in this way.

Selling

Having made, numbered and signed his work, the artist will sometimes sell it outright to a dealer. In this case, the artist may well receive only a small proportion of the final selling price; on the other hand, it is the dealer who then has the trouble and risk of retailing the edition. Sometimes a dealer will buy the idea or plate and have it printed on behalf of the artist, who will usually supervise the printing and sign his approval. The dealer will then negotiate terms for retailing the prints with the artist.

Alternatively, the artist may take or send examples of his work to private galleries, who may accept it for sale 'on consignment'. This means that if the work does not sell, the artist is free to take it back and try again elsewhere. If it does sell, the gallery will charge a commission, usually between twenty-five and fifty per cent.

Artists also sell their work from exhibitions organised by art societies and foundations. Many of these exhibitions are competitive and the work which is sent in is subjected to the decisions of a selection committee.

The cancelled plate

After the edition has been made, the block or plate is usually cancelled. The cancelled plate illustrated here (Ill. 193) has been scored across with a burin or sharp instrument, so that no more impressions can be taken. However, some dealers find these plates and then nonetheless make prints from them which they then sell. This is called a restrike. It is tempting for someone who wants a work by a master, even flawed (cancelled), or for a student; for restrikes sell at very low prices. An unsigned modern print should be viewed with suspicion, unless it is very cheap or comes from a known album of prints which is probably catalogued.

Apart from collectors and dealers, the people or institutions that may buy prints include interior designers, architects, education authorities, museums, universities and hotels. Some collectors wait until critics and magazine writers, the daily press, catalogues and books proclaim an artist famous, before buying his work. This seems a rather expensive way of collecting, as well as depriving oneself of the pleasure of indulging one's taste and the excitement of taking a risk and of backing one's own judgement.

A last and, I hope, a cheering word. It is still possible to find a good print by a master at a low price. Hayter writes of a contemporary finding a Schongauer, and a friend of mine in America found an original Blake etching while rummaging; he told the owner, who sold it to a museum.

Almost all contemporary prints in exhibitions are for sale. Do not hesitate to ask for the catalogue of prices.

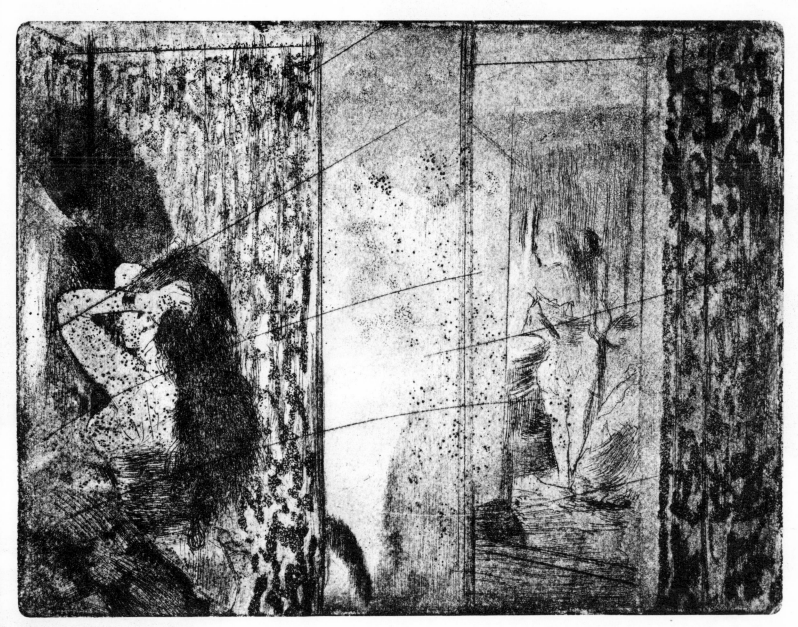

193
Cancelled plate. Print from etching plate of Degas with cancelled work. Victoria and Albert Museum, London.

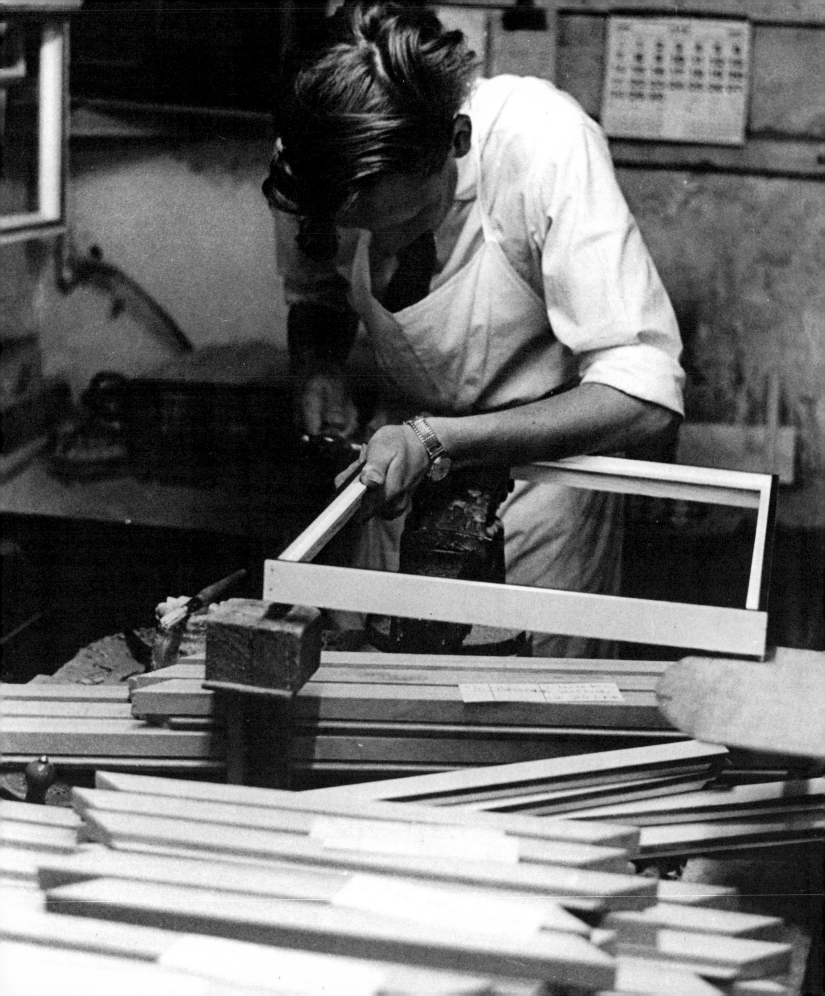

XII
Mounting and Framing

'Now that it is framed, we can appreciate it.'
W. Parks, frame-maker

As has been stressed throughout this book, an original print is the product of the same creative force as a painting or sculpture. The artists whose prints are illustrated here often work in other media, realising the same artistic theories and impulses with different means. If it is the ideas and imagination of the artist that the collector wishes to take possession of, an original print will satisfy his desires as well as any other art object. And it is surely more desirable to own a vital and exciting original print than to acquire a more expensive picture by a third-rate painter.

As an increasing number of people are beginning to collect prints, it is of considerable importance that information about the care, handling and presentation of collections should be widely published. Although we have a heritage of fine prints which have been kept in good condition over the centuries, a vast number have not survived or have been extremely badly damaged; paper is fragile, and neglect, carelessness and ignorance have been largely responsible. Very few copies have survived of most primitive woodcuts, and those mainly by accident. Even in more recent times, works which were mass-produced, like Daumier's lithographs in newspapers (Ill. 128) and Toulouse-Lautrec's posters (Ill. 8) have not been preserved in great numbers and are therefore becoming exceedingly expensive collectors' items. The lessons of the past must be learned and care must be taken of original prints, whether they are of historical significance or straight off the press.

Handling
All paper is fragile and should therefore be handled as little as possible. When this does become necessary, hands must be clean and free from grease. Paper also creases easily, so a print should always be held by the edges with both hands. Delicate Japanese papers and filter paper must be treated with even greater care. Unsized papers dirty more easily than sized papers. When prints are stacked on top of one another, they should be interleaved with acid-free tissue paper to protect the printed surface.

Mounting/matting
A mount surrounding a print makes it easier to handle. If the print is to be framed or exhibited, it is advisable to protect it with a mat or mount, a covering of some kind of glass or clear plastic, and moulding that will hold the whole together and exclude dust. The frame or presentation, as most artists and galleries realise, enhances the appearance of a work.

Mats with a window or square hole cut in them (Ill. 197) protect the print margins and keep the glass, perspex or plexiglass away from the surface of the print. (If it is allowed to touch the surface, condensation may form and cause the paper to stick to the glass and damage the print.) It is a sensible rule to use only white mats, but some artists and collectors prefer to use the coloured cards which

194
Making a frame at the Robert Savage Gallery, London.

211

are now sold on the market, and there is one artist I know who uses only black.

The mat should be made of suitably heavy all-rag fibre board, as this is usually safe from contamination by microbiological organisms which can cause mildew. The window should be cut in the optical centre of the board to display the print to its best advantage, and should show as much of the print as possible – sometimes the whole sheet of paper. Certainly the artist's signature, the title and the edition number should be visible. The edge of the aperture should be cut with a bevel which is then lightly filed to make sure it is not sharp and will not damage the surface of the paper.

The print should be hinged on a backing board with a paper strong enough to hold the weight of the print but weaker than the printing paper, so that in case of strain it will be the weaker paper that will tear. Stout Japanese paper is recommended; the various sticky tapes – sellotape, scotch tape, gum strip – should never be used since they will inevitably damage the paper. An expert restorer, Christa M. Gaehde, says that white library paste is adequate, and that a paste made up in proportions of one ounce of rice starch to one pint of water is best. 'The starch is mixed with a little of the cold water to a thick cream in a clear aluminium or enamel pan. The rest of the water is brought to the boil in another pan and – under continued stirring – added to the mixture over moderate heat until the paste thickens and takes on a glassy appearance. This paste is safe to use for about two days if kept covered in normal temperatures of about 65°F. It should be thrown away as soon as it becomes sour and watery.'

Mount-cutting is a knack which can be acquired with practice, but generally speaking a skilled frame-maker should be employed for this purpose. Badly cut mounts detract from the appearance of a print more than most other details of presentation.

Coverings

Plexiglass coated with antistatic is the best material to put directly on top of a print if no mount or frame is being used. If it is not treated with antistatic it tends to attract dust, and in any case has the disadvantage of becoming scratched easily.

If a mount is being used, then glass is suitable. Care must be taken, however, that no moisture is trapped behind the glass, since a change in temperature will cause condensation, which damages the print.

Frames

The paper margins of a print should never be cut, unless the permission of the artist has been obtained. If the margins of an old print have been trimmed, its value is usually decreased. The intention of the artist is of prime importance in these matters.

On the other hand, the choice of moulding for framing rests with the owner. A simple, standard fillet of gold or silver, surrounding a white mat, usually shows off a print to advantage. However, if the print is to be exhibited and has to be packed for travelling, then a stout plain wood moulding is more appropriate. Some collectors like to take into consideration the decor of the room where the print will hang before choosing from the vast selection of mouldings available today. However, whether the moulding is simple or elaborate, the disciplines already mentioned must be observed.

It is possible to frame a print without a mat and still not have the glass touching the print, as can be seen in Ill. 199. If a standard size frame is made with the print carefully hinged on backing boards, the backing of the frame can be taken out. Thus by changing the backing board you can change the print – and be able over a period of time to display far more prints than you have frames. Two hinges at the top of the print are sufficient.

When the backing board, print, mat, glass and frame have been fitted together, the whole unit must be sealed with gum strip to exclude dust. Dust is a carrier of microbiological organisms, and it also has an abrasive effect on the surface of the paper.

Framing is very much a matter of personal preference or fashion. One collector I know has designed a thin perspex box for displaying prints; others use aluminium or plastic mouldings.

Hanging

Unmatted prints that have been framed should be hung with a piece of cork placed between the frame and the wall. This allows air to circulate and minimises the risk of condensation forming under the frame.

It can be interesting to experiment with positioning prints on the wall, for example, by hanging a lot of small prints together like

cameos, or by hanging a large print on a small wall. Old prints seem to hang well even in modern houses, while modern prints can look very impressive in a traditional setting. In the half title page of this book, a number of modern works are hung on a wallpaper which might at first seem totally unsuitable for prints. In fact they fit in splendidly, as do the three small Victorian fashion plates. As can be seen, some of the prints have a window mat and a simple, flat, silver moulding.

Storage

If prints are not protected by mat and frame, they must be stored carefully if they are not to deteriorate. Keep them well out of the way of dust, which causes the most damage. It is wise to have a dust-free set of drawers or a plan chest of the type that architects use. If prints have been mailed to you in a postal tube, take them out immediately, unroll them and flatten them out between flat sheets of clean card with a light weight on top. Avoid creasing by putting them in drawers straight away, interleaved with sheets of acid-free tissue to prevent rubbing. The Tamarind workshop devised an effective method of storing prints that are

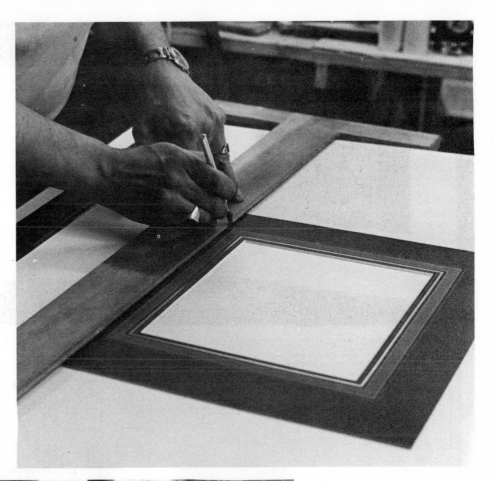

195
Making a decorative mount.
Robert Savage Gallery, London.
196
Assembling the mounted print and the glass in the finished frame.
John Campbell Ltd, London.

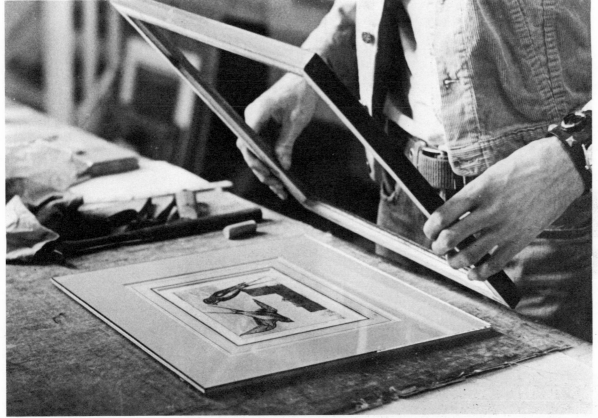

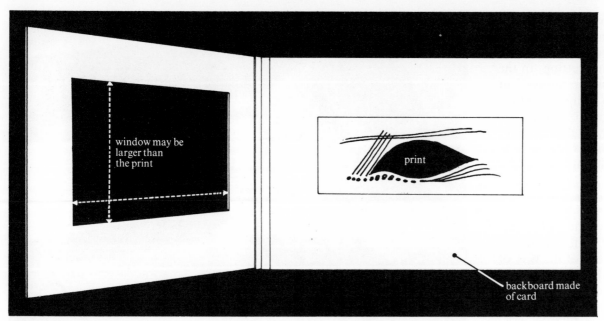

window may be
larger than
the print

print

backboard made
of card

197
A mount for a print.

198
The finished mount, showing the
proportions.

199
The mounted print in its frame.
The backing board with the print
attached may be removed and
another inserted in its place.

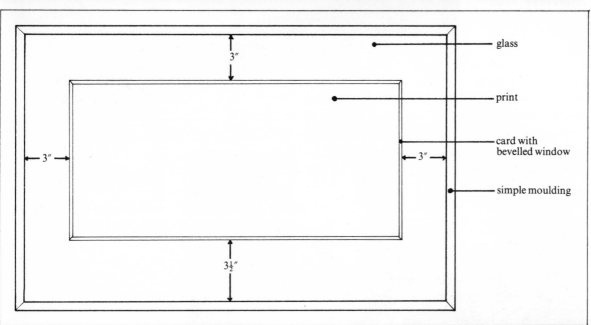

glass

3″

print

card with
bevelled window

3″

3″

simple moulding

3½″

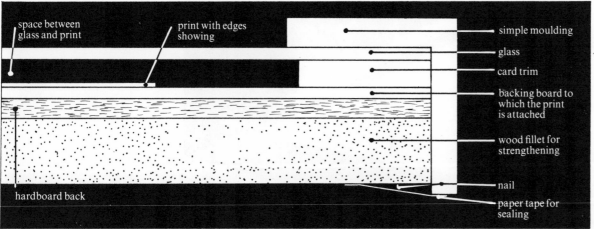

space between
glass and print

print with edges
showing

simple moulding

glass

card trim

backing board to
which the print
is attached

wood fillet for
strengthening

nail

hardboard back

paper tape for
sealing

200
Examples of simple wooden
mouldings.

201
An aluminium moulding.

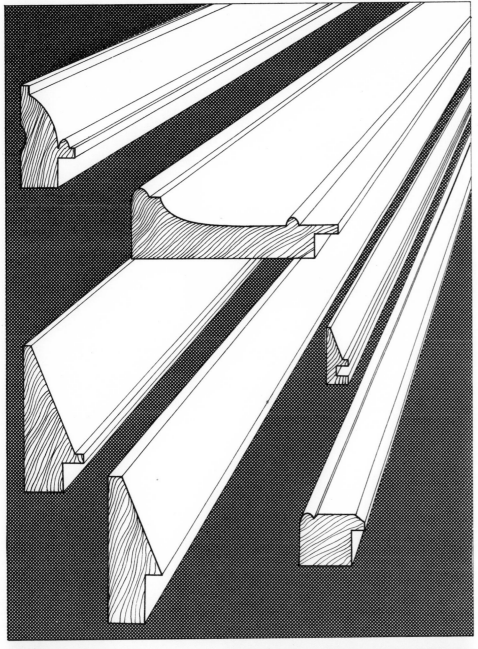

likely to be handled very often. The prints are laid on a backing of board which is the same size as the print, and print and backing are enclosed in clear plastic or cellophane. Any acrylic sheeting which has been coated with antistatic can be used. Many dealers and gallery owners display their stock in this way.

Conservation

The conservation of prints should generally be left to specialists; if the advice given in this chapter is observed, the need for it can be minimised. However, there are certain precautions the collector can take, and in certain cases remedial measures are possible at home.

Some transparent materials, such as celluloid, may darken on exposure to light and free small amounts of nitric acid. Some technical information on these problems is available in the excellent guide by Zigrosser and Gaehde (see the Bibliography). Unwanted pencil marks can sometimes be removed from really stout paper with a soft putty rubber, but care must be taken not to disturb the surface of the paper itself. With some Japanese papers it is possible to remove light creases by covering the paper with tissue and using a warm iron. As paper is an organic substance, it responds differently according to climatic conditions.

It is generally safer to leave a print alone, or take it to an expert, than to attempt an amateur restoration. Bad restoration eventually leads to added expense, so it is wise to buy the best advice you can afford; most museums will be able to recommend an expert in the vicinity.

Certain rules are worth bearing in mind:
1. Try to keep glass and other covering materials away from the surface of the print
2. Keep dust away, as this scratches the surface of the paper, carries microbiological organisms and is almost impossible to remove
3. Keep prints away from too much direct sunlight, as some colours may fade, especially if they are printed on cheap paper
4. Whenever sending prints by post, use a really large, stout postal tube. Filter paper and Hosho both crease when rolled too tightly. Put the prints in plastic 'envelopes' or bags for protection
5. Never paste or glue a print down to a backing board: always use hinges
6. When a repair job is necessary, take it to an expert

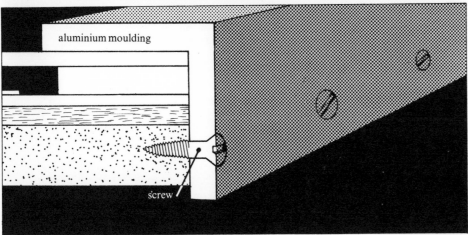

aluminium moulding

screw

Glossary

ACRYLIC — Vehicle used for carrying colour, based on Polyester Resin, called Polymer in the U.S.A.

AQUATINT — A method of making tones on metal plates.

ARTIST'S PROOFS — *PROOFS,* between five and ten per cent of the total edition, which are retained by the artist.

ASPHALTUM — A greasy liquid which may be used as a resist in intaglio. Also employed in lithography for drawing and processing.

BALL PATTERN RACK — A drying rack for hanging prints.

BAREN — Traditionally Japanese: a hand tool, slightly convex, for burnishing paper as part of printing in relief.

BATH — Acid bath, an acid-proof trough in which plates are etched; may be enamelled, hardened rubber or plastic.

BEVEL — The edge of the plate, filed at an angle to protect the etching blankets.

BLANKET — Felt used in printing intaglio; also the rubberised covering on the cylinder of an offset litho press.

BLIND PRINTING — Also known as gauffrage or kara-zuri. Printing from uninked blocks or plates which gives a three-dimensional form.

BRAYER OR ROLLER — Hand roller made in rubber, plastic or gelatine; for inking blocks and plates.

BURIN OR GRAVER — An engraving tool with a half-round wooden handle with either a square or a lozenge-shaped metal shaft.

BURNISHER — Polished metal tool used in intaglio to remove or reduce lines or smooth out the metal.

BURR — The drypoint line that holds the ink, made by scratching a furrow into the surface of the plate.

CHIAROSCURO WOODCUT — Originally imitation of drawings, mainly 16th century. Several blocks are used, some tonal.

COLLAGE — Pictures made by sticking objects, paper, etc. on to a background. From the French verb *coller*, to paste, stick, glue.

COLLOGRAPH — A relief print from objects and textures glued to a surface.

CRIBLÉ — A traditional printmaking technique, done with holes punched into the block or plate.

CLICHÉ VERRE — A print made on photographic paper from a design needled on to coated glass.

CUVETTE — See *PLATE MARK*

DECALCOMANIA — A mirror image produced by folding a piece of paper covered with wet paint, and then pulling it apart. (*Double Decalcomania*: the same process repeated on decalcomania.)

DEEP ETCH — A plate that has been bitten in considerable depth.

DIAMOND POINT — A drypoint tool with a diamond tip.

DRYPOINT — Scratches made directly on to metal; the burr created has a soft velvety look when printed in intaglio.

DUST BAG — A bag made from a fine material containing powdered resin for use in aquatint.

DUST BOX — A box to serve a similar purpose to the dustbag giving an even finer dusting of resin.

DUTCH MORDANT Acid. Potassium chlorate and hydrochloric acid used for delicate biting on copper.

EMBOSSING See *BLIND PRINTING*.

END-GRAIN Block for wood engraving fashioned from the end-grain of wood.

ETCHING OR BITING Eating into a metal plate with acid; intaglio process.

ETCHING GROUND An acid resist coated or rolled on to the surface of the plate. *Soft ground*: for impressing textures to be etched in the metal. *Hard ground*: to be drawn into with an etching needle.

ETCHING NEEDLE A steel point used to draw the design on to the resist-covered metal.

FROTTAGE Direct print taken from a surface pattern by rubbing.

GOUACHE Painting medium: finely ground opaque water paint.

GRAVER See *BURIN*.

HEELBALL Used by shoemenders; widely used for taking rubbings.

IMPRESSION A print taken by any method.

INTAGLIO A print taken from indentations below the surface of the block or plate.

KEY BLOCK The master drawing or block from which subsequent blocks are made.

LETTERPRESS Printing from type high or relief blocks; also a form of commercial printing press.

LINO CUT Linoleum gouged, cut, and printed in relief.

LITHOGRAPHIC CRAYON Usually known as chalk, for drawing on litho stones and plates.

LITHOGRAPHY A planographic (flat) process for producing prints.

LITMASK Stencil used on offset litho machines.

MATTING Known as mounting in England. The cutting of a hole or window in cardboard placed around the print for protection.

MEZZOTINT Intaglio print from the surface of a roughened plate that has been worked on with a scraper and burnisher.

MONOGRAPHIC A 'one off' print (see *MONOPRINT*) which could be duplicated but is not.

MONOPRINT A 'one off' print which cannot be repeated.

MONOTYPE See *MONOPRINT*.

NITRIC ACID Used in etching metal plates (usually zinc) and lithographic stones.

OFFSET To transfer a design from one surface to another.

PLANK WOOD The material from which woodcuts are made; the grain runs across the surface of the block.

PLANOGRAPHIC Printed from a flat surface (lithography, serigraphy).

PLASTER PRINT A print (usually only one) taken from an etching plate in plaster.

PLATE MARK The mark of the edge of the plate on the paper, known as 'cuvette' in intaglio.

PLEXIGLASS A plastic sometimes known as lucite, which is used by printmakers, mainly in intaglio.

PROOF, TRIAL	A print made by the artist to check on the progress of the work. It may have little connection with the final print.
P.V.A.	Polyvinyl acetate. Emulsion Polymerised Resin.
REGISTRATION	The placing or positioning of block and paper so that the print is exactly as intended by the artist.
RELIEF PRINT	A print taken from the top surface of a relief block.
REMARQUÉ	Drawing or doodle on the margin of any block or plate, usually removed before editioning.
RESIN	Used in intaglio for aquatints.
RESIST	Material applied to parts of a metal plate to prevent acid biting them.
ROULETTE	A tool used to make small dots in the ground of a metal plate.
SCORPER	Tool for clearing white spaces in wood engraving.
SCRAPER	Part of a lithographic press; usually a wooden bar covered with leather.
SCRIM	Cloth used for wiping surplus ink from a plate.
SPITSTICKER	Curved tool of the graver or burin type.
SQUEEGEE	Used in serigraphy to draw ink across the screen when printing.
STENCIL	Perforated material over which ink is rolled or dabbed, so that the shapes of the perforations appear in ink on the surface below the stencil.
STOP-OUT VARNISH	Acid *RESIST*.
SUGAR LIFT	A mixture of sugar and *TUSCHE* which will lift up covering ground.
TRANSPARENT BASE	Substance used to improve the transparency of colour.
TUSCHE	Liquid ink/grease used in lithography and serigraphy.
TYPE HIGH	About 0·9 inch – the height of lettering type used in commercial printing.
WOODCUT	Plank wood cut with gouges and knives, printed in relief.
WOOD ENGRAVING	A delicate engraving process on end-grain wood.
XYLOGRAPHY	White line wood engraving.
ZINCOGRAPHY	Printing aquatints or mezzotints on zinc, usually in relief. The term is also applied to lithographic printing from zinc plates.

Printmaking Materials and Suppliers

AUSTRALIA

Camden Art Centre Pty Ltd,
188 Gertrude Street,
Fitzroy, Victoria 3065.
General artists' materials.

Oswald-Sealy (Overseas) Ltd,
263 Clarence Street,
Sydney, N.S.W. 2000.
General artists' materials.

Winsor & Newton Pty Ltd,
102–104 Reserve Road,
Artarmon, N.S.W. 2064.
General artists' supplies.

Max Wurcker Diazo Pty Ltd,
33 Twin Street,
Adelaide, S.A. 5000.
General artists' materials.

CANADA

Rowney (Canada) Ltd,
Downsview,
Ontario.
General artists' materials.

FRANCE

Arjomari-Prioux,
3 rue du Pont-de-Lodi,
Paris 6.
Printing papers, Ingres, Rives, etc.

F. Charbonnel,
13 Quai Montebello,
Paris 5.
Inks, etching materials.

ITALY

Hendini, Oliviero,
via Saragozza,
157 Bologna.
Etching presses.

JAPAN

Yamada Shokai Co. Ltd,
5–5 Yaesu, Chuo-Ku,
Tokyo.
Hand-made printing papers.

UNITED KINGDOM

Algraphy Ltd,
Murray Road,
Orpington, Kent BR5 3QR.
Lithographic supplies and servicing.

Ault and Wiborg Ltd,
Standen Road,
Southfields,
London, S.W. 18.
Inks, composition rollers.

Black & Decker Ltd,
Common Lane,
Maidenhead, Berks.
Power tools and equipment.

Burgess Products Co. Ltd,
Electric Tools Division,
Sapcete, Leicester LE9 6JW.
Vibro engraving tools.

R. K. Burt & Co. Ltd,
38 Farringdon Street,
London, E.C. 4.
Hand-made and mould-made papers.

Essex Printers Supply Co.,
Elektron Works,
Norlington Road,
Leyton, London, E. 10.
Machinery and equipment, home and
export.

J. Barcham Green Ltd,
Hayle Mill,
Maidstone, Kent.
Makers of hand-made, mould-made
and filter papers.

Thomas Hardman & Sons Ltd,
Fernhill Mills,
Bury, Lancs.
Etching blankets.

Hardun & Sons Ltd,
Horton Road,
West Drayton, Middlesex.
Large plan chests for storing prints.

Hunter, Penrose, Littlejohn Ltd,
7 Spa Road,
Bermondsey, London, S.E. 16.
Printmaking chemicals and sundries.

John T. Keep & Sons Ltd,
15 Theobalds Road,
London, W.C. 1.
Paints, varnishes, etc.

T.N. Lawrence & Son Ltd,
2–4 Bleeding Heart Yard,
Greville Street,
Hatton Garden,
London, E.C. 1.
Hand-made papers, wood blocks, and
cutting tools.

E.T. Marler Ltd,
191 Western Road,
Merton Abbey,
London, S.W. 19.
Silkscreen inks and machinery.

Harry F. Rochat, A.M. Inst. B.E.,
Cotswold Lodge,
Stapylton Road,
Barnet, Herts.
Printers' engineers.

Alec Tiranti Ltd,
72 Charlotte Street,
London, W.1.
Artists' materials for printmakers.

Unibond Products,
Camberley, Surrey.
Unibond P.V.A. adhesive.

Geliot Whitman Ltd,
16a Herschell Road,
Brockley Rise,
London, S.E. 23.
Plan chests, general artists' materials.

UNITED STATES OF AMERICA

Andrews, Nelson, Whitehead,
Boise Cascade Corporation,
7 Laight Street,
New York, N.Y. 10013.
Printing papers.

Apex Printers Roller Company,
1541 North 16th Street,
St Louis 6, Missouri.
Rollers (gelatine, plastic, rubber: all sizes).

Charles Brand,
84 East 10th Street,
New York N.Y., 10003.
Custom built etching and litho presses.

The Challenge Machinery Company,
Grand Haven,
Michigan.
Proofing, hand rollers, presses.

Continental Felt Company,
22–26 West 15th Street,
New York, N.Y. II.
Etching blankets and other felts.

The Craftool Company,
1 Industrial Road,
Wood-Ridge,
New Jersey 07075.
All printmakers' materials.

Cronite Co. Inc.,
Kennedy Boulevard at 88th Street,
North Bergen,
New Jersey.
Etching materials, inks.

Graphic Chemical and Ink Company,
728 North Yale Avenue,
Villa Park,
Illinois 60181.
Area Code 312 832 6004.
All printmaking materials and
machinery. Completely comprehensive
illustrated catalogue.

Ideal Roller,
W.R. Grace & Co.,
21–24 Thirty-Ninth Avenue,
Long Island City,
New York 11101.
Lithographic rollers and other
materials.

Inko Screen Process Supplies Mfg Co.,
1199 East 12th Street,
Oakland 6,
California.
All silkscreen materials and equipment.

E.C. Muller,
3646 White Plains,
Bronx, New York.
Most printmaking tools, burins, etc.

Peerless Camera Stores,
415 Lexington Avenue,
New York, N.Y.
Acid trays.

Harold M. Pitman & Co.,
515 Secaucus Road,
Secaucus,
New Jersey.
General supplies.

Process Supply Company,
726 Hanley Industrial Court,
Saint Louis,
Missouri, 63144.
Silkscreen materials.

Winsor and Newton Inc.,
555 Winsor Drive,
Secaucus,
New Jersey, 07094.
General artists' supplies.

Index